Women of Walt Disney Imagineering

12 Women Reflect on Their Trailblazing Theme Park Careers

Women of Walt Disney Imagineering

12 Women Reflect on Their Trailblazing Theme Park Careers

Contributing Authors

Maggie Irvine Elliott, Kathy Rogers, Katie Olson,
Julie Svendsen, Paula Dinkel, Elisabete (Eli) Erlandson,
Tori Atencio McCullough, Pam Rank, Becky Bishop,
Karen Connolly Armitage, Lynne Macer Rhodes, and Peggie Fariss

Foreword by Ginger Zee

Edited by Mel Malmberg

Los Angeles · New York

The following are some of the trademarks, registered marks, and service marks owned by Disney Enterprises, Inc.: Aulani, A Disney Resort & Spa; Adventureland® Area; Audio-Animatronics® Figure; Disney®; Disney California Adventure® Park; Disney Cruise Line® Ships; Disney Springs™; Disneyland® Hotel; Disneyland® Park; Disneyland® Resort; DisneyQuest® Indoor Interactive Theme Park; Disney's Animal Kingdom® Lodge; Disney's Animal Kingdom® Theme Park; Disney's Animal Kingdom® Villas—Kidani Village; Disney's BoardWalk Inn and Villas; Disney's Contemporary Resort; Disney's Grand Californian Hotel® & Spa; Disney's Grand Floridian Resort & Spa; Disney's Polynesian Village Resort; Disney's Hollywood Studios®; Disney's Wilderness Lodge; Disney's Yacht Club Resort; Downtown Disney® Area; Dumbo the Flying Elephant® Attraction; EPCOT®; Fantasyland® Area; FASTPASS® Service; Fort Wilderness; Frontierland® Area; Imagineering; Imagineers; "it's a small world," It's a Small World® Attraction; Magic Kingdom® Park; Main Street, U.S.A.® Area; Space Mountain® Attraction; Tokyo Disney® Resort; Tokyo Disneyland® Park; Tokyo DisneySea® Park; Tomorrowland® Area; Walt Disney World® Resort; and World Showcase.

Styrofoam™ is a registered trademark of the Dow Chemical Company

Masonite™ is a registered trademark of Premdor Corporation

X-Acto™ is a registered trademark of Elmer's Products, Inc.

Play-Doh™ is a registered trademark of Hasbro

Coca-Cola™ is a registered trademark of the Coca-Cola Company

Essays and personal images Copyright © 2022 Margaret Irvine Elliott, Elisabete Erlandson, Peggie Fariss, Paula Dinkel, Karen Connolly Armitage, Katherine Olson, Rebecca Ann Bishop, Pam Rank, Lynne Macer Rhodes, Kathleen Rogers, Julie Svendsen, and Victoria McCullough.

All other images Copyright © Disney Enterprises Inc. All rights reserved.

Published by Disney Editions, an imprint of Buena Vista Books, Inc. No part of this book may be reproduced or transmitted in any form or by any means, electronic or mechanical, including photocopying, recording, or by any information storage and retrieval system, without written permission from the publisher.

For information address Disney Editions, 77 West 66th Street, New York, New York 10023.

Printed in the United States of America
First Hardcover Edition, March 2022

10 9 8 7 6 5 4 3 2 1

ISBN 978-1-368-02195-1
FAC-034274-22028

This book is for everyone—most especially the hardworking women of this world—who dream it, and do it.

Contents

ix **Foreword**
Ginger Zee

xiii **Preface**
Elisabete (Eli) Minceff Erlandson

xix **Introduction**
Mel Malmberg

xxv **The Authors**

xxxvii **A Short Glossary of Our Shorthand**

1 *Maggie Irvine Elliott, Senior Vice President*
From Tiki-Bird Builder to Senior Vice President

25 *Kathy Rogers, Executive Show Producer*
Learning on the Job I Never Knew Existed

39 *Katie Olson, Principal Color Concept Designer*
A Brush with Disney

55 *Julie Svendsen, Concept Show Designer*
Finding My Way to Disney's Lands

69 *Paula Dinkel, Principal Show Lighting Designer*
Lighting Is Magic

Contents

97 — *Elisabete (Eli) Minceff Erlandson, Principal Concept Architect*
One Smart Woman, and Three Idiots

121 — *Tori Atencio McCullough, Executive, Interior Design*
Designing Woman, Managing Mom

143 — *Pam Rank, Principal Show Lighting Designer*
Stories from the Field

165 — *Becky Bishop, Principal Landscape Architect*
The Tree That Eclipsed Discovery Mountain

169 — *Karen Connolly Armitage, Concept Designer*
I Made My Career

179 — *Lynne Macer Rhodes, Producer*
Trust the Journey

199 — *Becky Bishop, Principal Landscape Architect*
How a 2:00 a.m. Phone Call Nearly Cost Me My Job

207 — *Peggie Fariss, Executive, Creative Development*
From Monstro the Whale to Marne-la-Vallée

225 — Acknowledgments

229 — Bibliography

Foreword

Ginger Zee

"Aren't you the weather girl?"

Whenever I hear that, I smile. The fine lines around my eyes squeeze into a pronounced confirmation that my face is not that of a girl, but definitely a woman. A woman who—despite hearing a slight she has heard her entire career—does smirk to think, at this age, she could still be thought of as a "girl."

The smirk fades quickly as I think about what being called "weather girl" means. It means we have a long, long way to go. I always politely correct the slight: "Meteorologist, but yes, that's me."

I am no longer a girl and I am not a *weather girl*! I am a meteorologist. A scientist. The title "meteorologist" is not often applied to me because the people who held my position before I did were not always scientists (and were never women). I am the first female chief meteorologist at a major network.

Foreword

But I did not get here all on my own. My way was paved in part by the tears and strength of five decades of female meteorologists in smaller markets and at other networks. They climbed steadily, chipping away at the meteorological "mountain," carving out the footholds and digging in the hand grabs that were imperative for my success. I gratefully stand on the shoulders of my meteorological sisters and am poised to propel the next woman even higher—hopefully with fewer obstacles.

With each tornado I chase, or eye wall of a hurricane I brace myself in, I am driven by my passion to figure out the puzzle that is Earth's atmosphere. The women featured in this book were driven by a similar zeal.

The stories you are about to read were written by women who worked in a different era and in very different careers from mine, but they made footholds in a mountain all the same—the Disney mountain. Some of them worked on constructing, lighting, or painting the parks' actual mountains, such as Splash Mountain, the Matterhorn, and Expedition Everest. One of the women literally climbed Splash Mountain to remove some truly atrocious plastic yellow poinsettias that had been placed on the majestic site by an outside marketing team who questioned her authority before shooting a commercial.

For Disney nerds and casual fans alike, this book will be beyond entertaining; it is a true "backstage pass," as well as a journey back in time and around the world. There are stories from the beginnings of EPCOT, Disneyland Paris, Disney's Animal Kingdom, and more. The voices recount the days when women were told, "Don't compete with men, compliment them," and when clients shook the hands of the men in the conference room and ignored the women. Yet despite the nepotism and obstacles they encountered, these women persevered with astounding fortitude and patience. The lessons they learned—and now share—as they gained those first footholds are lessons for life and career that still apply today.

I fell in love with meteorology when I was eight years old watching thunderstorms blast across Lake Michigan. My passion was sparked then, but I didn't have a clue how I could turn that passion into a career. Painfully shy, I didn't ever dream that I could be on TV; plus, most of the network meteorologists were men, so that career path seemed closed to me. I also really couldn't see myself in any of the government positions I knew were available in this vital field. Then, I saw Helen Hunt in *Twister*. She gave me the image of what I could be: a badass storm-chasing woman calling the shots.

Granted, *Twister* was a laughable film from a scientific perspective . . . and the science was almost as far-fetched as having a woman lead a group of scientists in the 1990s; but it gave me confidence and a vision of what I wanted to become.

The women profiled in this book became role models for other women who would later work for Disney. Each of them injected her own talents into Imagineering, creating an important piece of the larger Disney puzzle. The fabric of this book is woven from such inspiring stories. For example, Paula Dinkel, whose boss once told her it was just not possible for her to be the head of the lighting department, was driven to become the first woman to do just that.

But the story that hit me hardest was that of Lynne Macer Rhodes. After being sidelined for speaking up in a meeting, Rhodes writes, "We women may have a hard time bouncing back when we stumble. We may take it to heart . . . men move on." Her words hold true for me; *bouncing back* is something I have not mastered. Working on stumbling and being okay with it is not easy for a recovering perfectionist. One way I have found growth in this arena is through mentoring. And I loved reading the stories of mentoring within the book. That's what this book is, really: a compilation of mentors for all of us.

In the spirit of mentorship, here are some of the career advice gems that readers will encounter in these pages:

> Be smart and strategic about it, but speak up.
> It's not always just about you.
> Praise in public. Admonish in private.
> I had to make myself an ally, not an antagonist.
> My strategy was to always ask questions.
> Step into your largeness, not your smallness.

Disney, and especially Imagineering, is known as a group that ventures constantly into the unknown—trying and doing things differently because they dream. It only makes sense that this would be one of the first places bold enough to think women could have a voice, a brain, and a strong enough kick to get to the top of the mountain.

Preface

The How and Why of This Book

Elisabete (Eli) Minceff Erlandson

In 2019 I moved to Hong Kong, feeling comfortable that I had turned in the manuscript of this book for publication, helped with its design, and had even donated my construction helmet and some of my well-used art and architecture tools for a cover concept. My husband was working on an expansion for the original Hong Kong Disneyland and we happily returned to a city that we both love. I planned to paint, explore the surroundings, and hike (while he worked!); we would also travel around Asia during 2020 and possibly 2021 on weekends and holidays. So much for plans.

Creating a book in the middle of a pandemic was a new one for me. Even though I had worked in Hong Kong during the SARS epidemic in 2002, this was different. By March 2020 it was grim in Hong Kong and the USA, as well as the rest of the globe. The worldwide deaths from COVID-19 were unfathomable; the economic fallout promised to be devastating; the required lockdowns, quarantines, mask wearing,

Preface

disinfecting, and social distancing to stop the spread, demoralizing. Further demoralization grew as I watched family members lose their jobs; and then Disney employees, some of whom are our close friends, were furloughed and laid off. The book went into suspended animation for months. The authors, all over sixty, were marooned at home. We kept in touch via e-mails with the publishing team.

As Imagineers we have seen delays and cancellations of projects due to finances, politics, shifts in corporate priorities, and even weather. In our work, you learn to be flexible, find creative solutions to anything that comes your way. But we had never experienced anything like this.

The book coming to a stop due to a global pandemic was an unexpected hiatus, a surreal time with many difficulties—but it shows our resilience, our ingenuity, and our faith in our creative process. I believe that these positive traits are present in all of humanity, but they are especially important for Imagineers.

Before the unexpected happened in 2020, let's go back to where this book started. This book started as a personal project in 2014 to record my forty-plus years working in the architectural profession. It was intended to be for the benefit of the present and future generations in my immediate and extended families. This idea morphed into a different and larger project when young professional women I had mentored asked me to write about my life in the field of architecture as a woman. They voiced their concerns about preferences given to men in their professions when it came to equitable recognition and promotions. At the same time, some of the young male professionals also requested to hear my story, which is that of a woman architect.

I realized it would be a far more useful and interesting book if other women I had worked with also included their stories. Before reaching out with invitations, I set some criteria to qualify as a writer for this book:

1. A woman who had retired from Walt Disney Imagineering with a minimum of twenty years' work experience in the Imagineering arm of The Walt Disney Company.
2. A woman who was a team player and team leader.
3. A woman who wanted to encourage future generations and would write about the challenges they faced and how they managed them.
4. A woman who was no longer a Disney employee.

The authors of this book were slowly recruited over the course of two years, from diverse professions. We congregated as a group to discuss this book and its intended content.

During the course of developing our stories, we came to realize there were some common threads in our experiences. We all came into the workforce at an interesting time of change, and we all noted we did not make a big deal about being women entering male-dominated environments. We just did not think that way; it was naive, but it worked well for us. We thought of ourselves as simply "people" who were willing to work hard and grow, never thinking about our gender. Some of us had professional degrees, and some did not; nonetheless, through the years, we gained the respect of others for our work ethic, integrity, and competence.

While we shared such experiences with each other, the authors of this book wanted to add more women to diversify our group. It bothers us that we are all white women authors, but we also realize that this fact is a sign of the times when we were starting our careers between forty and fifty years ago. Doors were opening for white women in the professional world, but not yet for women of color.

Fortunately, since then, a number of Black women, Native American women, Asian women, and other women (and men) of color

have become Imagineers. They are still in the middle of their careers, and we hope these women will write their stories. They will encourage future generations, too.

We also noted that all the authors except one were American-born and raised. I am the exception. As an immigrant, I approached things a little differently, and I had some unique challenges—some with positive results, and some with negative effects. (You will find out more about these in my chapter.)

As a group, we also came to the conclusion that the prejudices some of us endured were not occurring only at Disney; it was the same at other companies. We lived through a time of change as a very male-dominated world and workforce began to shift. We have witnessed changes within Disney that have opened doors to more women from all backgrounds. We are also aware that the road to equity is still being traveled. We hope that books like this one will move the world further in that direction, where merit is measured in terms of knowledge, experience, performance, and contribution.

As a woman in a male-dominated profession, at first, I tried to emulate the male ideal. As I gained experience and wisdom, I realized that I could be a woman and an excellent professional. Some of the other authors like me came to realize that our viewpoint as women enriched the teams and the projects we worked on. This being said, it was a growing process for us and for the men we worked with; some came to accept us as professionals to be trusted and thus became an example for others to do the same.

The authors have agreed that the proceeds we receive from this book will be donated to charitable causes. Our goal is to give women the means to further educate themselves in the fields that interest them.

I thank all the authors of this book for agreeing to go on this journey together. As we developed our chapters, we shared our varied

experiences with much laughter, a few tears, good meals, and some wine. We came to the clear and palpable realization we all traveled incredible paths in our chosen fields. We inadvertently helped change the world a little bit.

I also thank our editors and publisher and all of the staff who got this book published for their resilience jumping back into the production of this book as soon as some of the furloughed staff were called back and allowed to work remotely, through still disheartening COVID-19 times.

My father, who always encouraged me to reach for the stars and never gave me a hint of any prejudice, said to me on his deathbed, "Thank you for teaching me that girls can do anything they set their minds to do, just like boys." I am sure that he influenced the thinking of some of his own contemporaries.

Years before that comment, Walt Disney was coming to his own conclusion in 1941 when he said, "If a woman can do the work as well, she is worth as much as a man. The girl artists have the right to expect the same chances for advancement as men, and I honestly believe that they may eventually contribute something to this business that men never would or could."

We have! Here are a few stories from only twelve of us women (not "girls"). We know many more women with their own stories of perseverance, and we hope theirs will also be told, showing that obstacles can be overcome and one can positively and successfully create her own path.

Introduction

Mel Malmberg

This book covers an extraordinarily dynamic era in the history of Walt Disney Imagineering. Founded in 1952 to create Disneyland, it was originally known as WED Enterprises. The company employed people (all called Imagineers) from a list of disciplines that would expand to at least 140 fields: artists, engineers, designers, technicians, financial experts, librarians, producers, architects, secretaries, audio specialists, writers, and programmers.

WED grew and changed in the expansive era when the women in this book contributed their considerable design and production talents. From 1968 to 2016, the number of parks mushroomed from one in Anaheim (Disneyland) to twelve worldwide. Meanwhile, Imagineers were also creating hotels, new themed lands, and other projects around the globe.

Yet from its inception, WED was shrouded in mystery, hidden in the bland former Studio Girl Cosmetics factory near the Los Angeles River, between a defunct airfield and a coffin manufacturer. Imagineering's distance from the Walt Disney Studios (less than three miles to the north) added another layer of isolation. Deep in-

Introduction

side their scruffy, nondescript workshop, Imagineers were inventing a brand-new field.

There were few cameras pointed at Imagineering in the early days; infinitely more were aimed at its products: parks, attractions, water parks, resort developments, and cruise ships. Imagineering was a Skunk Works, an underground playground, an informal culture of excellence where, as its Senior Creative Executive Tom Fitzgerald would urge, "If you can dream it, you can do it."

In the earliest days, you had to know a Disney insider—or be one yourself—to know that WED existed. By the mid-1970s, as they made plans to build more theme parks around the world, WED began advertising, recruiting outside people to join the ranks of Imagineers. The workforce would expand to meet demand, then shrink down to a skeleton crew as parks opened. It was unpredictable, demanding, exhilarating, exhausting, and most of all, deeply satisfying. Imagineers shared a vision, a language, a "hallway culture" of free-flying critiques and collaboration as people moved fluidly among projects and disciplines, offering an idea here, a raised eyebrow there. There was camaraderie born of an intense, in-the-trenches, the-park-opens-tomorrow mentality. Everything they did was unique in all the world and was a product of "the Imagineers" as a group.

The rest of The Walt Disney Company often saw Imagineering as hermetic, radical, and a bit out of control. It was full of artists and technicians who arguably delivered a superior, one-of-a-kind experience for millions of guests each year.

Unlike cast members at the parks and the Studio, Imagineers by the late 1970s could wear what they pleased: flashy earrings and long unsecured hair, jeans, and T-shirts. Few Imagineers of any gender wore suits unless it was to meet outsiders. But Imagineering was still a part of Disney, a conservative corporation that stood for family values,

Mom, and apple pie. There was a feeling among Imagineers, no matter how personally or politically outside the mainstream, that they had a responsibility for an American icon, a global brand. They also recognized that they were passengers on a huge steamship of a company that was steered slowly, with deliberation, through the potentially turbulent waters of change.

On the whole, women at Imagineering felt fortunate to be there, at the top of their crafts, in a well-regarded company, working alongside equally smart and accomplished peers. Though greatly outnumbered by men, they persisted, showing (like the good storytellers they were) that they were as good as or better than anybody else in their fields, inside or outside Disney.

Imagineering's group ownership ethos was problematic for women who were underrepresented in number, and though there were lots of projects, each one could take five to seven years to be designed, built, and opened. It could take years to be recognized for your work. In the late 1980s, Disney moved toward individual recognition of Imagineers both within and outside the company. But given the long timelines for projects, it was even tougher for the few women to get a hearing, to get ahead. They had never been in the pipeline; how did they move forward now?

Cultural change at Imagineering arrived slowly, but no more slowly than it did for the rest of corporate America. In the outside world, as barriers for women began crumbling and glass ceilings began to shatter, Imagineering began to show a few cracks. Women could and did slip through, widening those cracks ever so slightly for the next underrepresented Imagineer.

Imagineers never entered their fields to get rich, but they did want to be treated, respected, and compensated like the experts they were. To this end, Imagineering women formed alliances, created

Introduction

new ways to manage workflow, and performed at the top of their fields. They may have been few, but they were good. And they persisted.

Most of the women who contributed their stories to this book have said they weren't feminists, they weren't radicals, and they weren't out to shake up the order of the world—they were merely interested in doing an excellent job, at an excellent company, creating excellent experiences for guests. But they *were* feminists—simply by showing up to work each day.

Each woman considered herself a representative of her craft, pure and simple. When they encountered unfair treatment, inappropriate behavior, or uncomfortable situations, each woman had her own calculations to make. Should she point out discrepancies in treatment? Endure it? Ignore it? Or try to work around it, gain power, and see that it never happened again, to her, to her teammates, her subordinates, or her supervisors?

With each step in their careers, each creative solution to a problem, each promotion, each project accomplished, the Imagineers who wrote their stories for this book opened doors for other women to walk through.

Although it was once top secret, Walt Disney Imagineering has come into the public consciousness. Books have been written about it; it has a Khan Academy channel, its own series on Disney+, websites (official and unofficial), an official Instagram account, and fans. Theme park design is a college major, and people recognize the word *Imagineer* as a job and may know more or less what an Imagineer does.

Wandering the halls of Imagineering today, you'll see that there are more women represented than ever before, in more fields, and in higher-level positions. There's been progress, but there is definitely more to achieve. All over the world, people dream of being Imagineers, and the doors have cracked open for everyone.

The contributors to this book set out to tell stories that would inspire

girls and women to keep striving for equality and balance, recognition, transparency, and equity. Let them see your dreams become a reality. You can do it—and hopefully, fully enjoy the ride.

The Authors

Maggie Irvine Elliott
**Senior Vice President,
Creative Development Administration**

Maggie calls herself a "true Disney kid," and her roots in Imagineering are deep; her father, a Disney Studio art director, headed Imagineering after Walt Disney's death. Beginning as an apprentice model maker in 1968, Maggie was the first woman to ascend the ranks of Imagineering management, rising from manager of the Model Shop, to director of creative development administration, to VP of creative development administration, retiring as senior vice president in 1994.

The Authors

Kathy Rogers
Executive Show Producer

*Kathy Rogers's career began in the Disneyland parking lot, where she made $1.70 per hour. She became an attractions lead and then was tapped to work for Imagineering at Disneyland in 1983. Working first as a coordinator, she rose through the ranks to the producer level, retiring as executive show producer with attractions as diverse as Muppet*Vision 3D and Expedition Everest to her credit.*

Women of Imagineering

Katie Olson
Principal Color Concept Designer

Katie Olson originally wanted to be a cop, but her summer job in Imagineering's Model Shop changed everything. She began as "the juniorest of juniors," painting models, color boards, and anything else that needed a coat of paint, discovering a knack for color design that enabled her to lead many projects for color at WDI. She contributed to every Disney park during her thirty-six-year career, including being on the opening teams for Tokyo Disneyland, Disney's Hollywood Studios, Disneyland Paris, Disney's Animal Kingdom, Tokyo DisneySea, and Hong Kong Disneyland.

The Authors

Julie Svendsen
Concept Show Designer

Julie Svendsen's father, Julius, was a Disney animator. He helped her land a job as an accounting clerk at WED Enterprises in 1970, as plans for Walt Disney World were in full swing. This glimpse fueled Julie's ambition to become a professional artist; after several years of art school and a BFA, she returned to WDI to work on the design teams for New Fantasyland at Disneyland, EPCOT, Typhoon Lagoon, Blizzard Beach, Disneyland Paris, Disney's California Adventure, Disney Stores, and Shanghai Disneyland.

Paula Dinkel
Principal Show Lighting Designer

Paula came to Imagineering from academia and spent thirty years as a lighting designer for parks (Magic Kingdom, Walt Disney Studios Paris, Shanghai Disneyland), Disney Stores, and other projects, including DisneyQuest and Club Disney.

— The Authors —

Elisabete (Eli) Minceff Erlandson
Principal Concept Architect

Eli wanted to study art, but her immigrant parents insisted she study anything else and encouraged medicine or engineering. She chose architecture, which had its own challenges in a male-dominated profession. For many years, she was the only woman at Imagineering who had an architectural license. She worked on eleven of twelve Disney theme parks and has lived in Hong Kong and Paris; she is also an accomplished set designer and art director.

— Women of Imagineering —

Tori Atencio McCullough
Executive, Interior Design

Tori Atencio McCullough is another Imagineer with deep Disney roots; her father, X Atencio, was a legendary Disney artist and writer. Tori spent her forty-year career at Imagineering in the interior design studio as both a designer and manager, and in those two roles worked on every Disney theme park.

The Authors

Pam Rank
Principal Show Lighting Designer

Pam Rank transitioned to theme park design in 1987 following a career as a theater lighting designer and professor. In her new home at Imagineering, she designed lighting for attractions, shops, restaurants, exteriors, and landscaping. During her years at WDI, she oversaw the installation of her projects at Disneyland, Walt Disney World, Tokyo DisneySea, and Hong Kong Disneyland.

Becky Bishop
Principal Landscape Architect

Becky Bishop is a landscape architect who began her career with Imagineering as an intern in 1982. Her first major project was Splash Mountain at Disneyland, and in her thirty-year career she was responsible for landscape and hardscape design and installation at every Disney theme park location.

— The Authors —

Karen Connolly Armitage
Concept Designer

Karen Connolly Armitage brought her background in theater performance and design to Imagineering in 1977; her first assignment was with Disney Legend Dorothea Redmond. She was instrumental in the overall design of Disney theme parks around the world, including attractions at EPCOT, Disney's Hollywood Studios, Frontierland at Disneyland Paris, and Main Street at Hong Kong Disneyland.

Lynne Macer Rhodes
Producer

Lynne Macer Rhodes's background in political science and public affairs, and her program management experience in the public sector, gave her Imagineering career a broad scope. From manager of research and planning to producer, she had a ringside seat as Imagineering developed theme parks around the world, including EPCOT, Tokyo Disneyland, Disneyland Paris, Walt Disney Studios Paris, and Disney California Adventure.

Peggie Fariss
Executive, Creative Development

Peggie Fariss began her fifty-year career at Disney as an attractions hostess on the Storybook Land Canal Boats. She was instrumental in the research for EPCOT's Spaceship Earth and later became WDI's liaison to corporate sponsors. Her experience representing Imagineering's artistic vision led to her final assignment as the creative development executive for Disneyland Paris, where for five years she led a team that doubled in size from twenty-five to fifty.

A Short Glossary of Our Shorthand

Imagineering has no shortage of acronyms and special terms. Here are a few you will encounter in these pages.

BLUE SKY: *The earliest stage in Imagineering project development. The phrase suggests the idea that almost any concept is permissible and a future possibility. Further phases such as feasibility, schematic design, design development, and production generally follow.*

DLP: *See **EDL**.*

EDL: *Euro Disneyland, the original name for the first Disney theme park outside Paris. The name was changed to Disneyland Paris in 1994, and the resort is now home to two parks: Disneyland and Walt Disney Studios.*

EPCOT CENTER; EPCOT: *EPCOT Center was the original name for the Orlando theme park (EPCOT is an acronym for Experimental Prototype Community of Tomorrow). The park is now known simply as EPCOT.*

MAPO, OR MAPO, INC.: *Acronym for the Imagineering Manufacturing and Production Organization. Originally located in the WED Research and Development building (now known as the "MAPO building") on the Imagineering campus, the division was created in the fall of 1965 to provide an in-house Audio-Animatronics and general production facility for exclusive use by the Imagineers. The acronym also served as a portmanteau of the 1964 film* Mary Poppins; *the company logo featured a silhouette of the film's title character.*

TDL: *Tokyo Disneyland, opened 1983.*

TDS: *Tokyo DisneySea, opened 2001.*

WDI: *Acronym for Walt Disney Imagineering. WED Enterprises was given this name change by The Walt Disney Company in January 1986.*

WED OR WED ENTERPRISES, INC.: *Acronym for Walt Disney's theme park research and development, planning, design, and engineering laboratory (WED stands for Walter Elias Disney, Walt's full name). Established on December 16, 1952, as Walt Disney, Inc. (and renamed WED in 1953), the privately held division was created mainly to design Disneyland outside of the shareholder-owned Walt Disney Studios. In late summer 1961, the organization moved to its current headquarters at the Grand Central Business Center in Glendale, California. WED was purchased by Walt Disney Productions on February 2, 1965, and folded back into the company.*

Maggie Irvine Elliott
Senior Vice President

From Tiki-Bird Builder to Senior Vice President

An artist's heart with a manager's brain. How does a woman work in a man's profession? More than fifty years ago, I found myself in the world of theme park design at Walt Disney Imagineering.

The best way to tell my story is to start from the beginning.

I had a special relationship with my father, Dick Irvine. Dad first met Walt Disney in the 1940s. He was on loan from 20th Century Fox studios and worked on Disney war films (like *Victory Through Air Power*) as an art director.

In the early 1950s, Walt called and asked Dad for a meeting to talk about an idea he had. Walt asked Dad if he would head up a design team to build this big project. With five kids and motion picture union benefits, Dad had a difficult decision to make. He gambled and said yes—and Disneyland was born.

During the 1960s, Dad led WED Enterprises in developing the pavilions and shows for the New York World's Fair. When Walt died in

1966, his brother and partner Roy Disney met with Dad to review the status of the work for Walt Disney World. Dad convinced Roy that WED had enough of Walt's concepts and designs for work to continue. Dad took the lead and became executive vice president, chief operations officer, and vice chair of the board of WED Enterprises.

My siblings and I all watched Walt on TV showing the progress of Disneyland, and my family kind of understood why we didn't see much of Dad growing up. I was five when Disneyland opened, and we were the most popular family in the neighborhood. Disney films for our birthday parties, trips to Disneyland with "special" ticket books for any attraction . . . we even got Christmas presents from Walt! As the fifth child of ten (six boys, four girls), I had a fairy-tale childhood!

My introduction to art was watching Dad do scale drawings for hooked rugs. He would make a drawing and color it with markers. (I got plain paper with colored pencils to draw alongside him.) He sent the drawing to England, and then a canvas with precut yarn would arrive in the mail. I couldn't figure out how this huge piece of canvas came from that small drawing. I was learning about how small things could become full-scale.

Herb Ryman, a Disney Legend, worked with my Dad at 20th Century Fox; they were good friends. Herb did the original drawing for Disneyland—the famous concept art that Roy Disney took to bankers to get funding to build the park. But to me, Herbie was just my godfather; at afternoon family barbecues, while my dad cooked, Herb sketched us kids. Dad loved the sketches and framed and hung them. As adults, we laugh at how accurately Herb captured us: one brother with a halo, another with devil horns, and me with a pencil and paper.

Since both of my parents were artists (Mom was a pianist), I was surrounded by art and music, as well as brothers and sisters. I loved art, and because of that, I started working with crafting materials.

In ninth grade, I took a home economics class and learned to sew. This became my new favorite hobby. For my sixteenth birthday, Mom and Dad gave me a wonderful portable Singer sewing machine. After I graduated from high school, my plan was to take the summer off to prep for college. I was planning on going to Santa Monica College for two years to get all my general courses out of the way, and then go to Immaculate Heart College in Los Angeles and study fashion design.

Mom and Dad insisted I do something for that summer of 1968, and getting a job was at the top of their list. I was stumped. Dad told me WED had a summer hire program and he would see if there were any openings. I was lucky; there were two spots left—one in the library, and one in the Model Shop. I asked for the Model Shop for obvious reasons; I could never forget my first visit.

It was 1962, I was twelve, and I had just won my division in Los Angeles's citywide girls' tennis tournament in Griffith Park. It was exciting because my dad was there. He picked me up (along with my trophy and new tennis racket), and we went to WED so that he could review something for the New York World's Fair. (WED was then located nearby at 800 Sonora Avenue in Glendale.) We went into the Model Shop and—wow! It was full of all kinds of stuff for "it's a small world." What a treat for the senses. Color, sparkles, smells, and happy people having fun. I loved it, and I got to show off my trophy to everybody. Then I went to wait for Dad in his office. Walt came in looking for him. He spotted my trophy and asked about it, and we chatted. It was the best day ever: having my dad all to myself, winning the tournament, seeing the Model Shop, and talking with Walt Disney.

I started my summer job in WED's Model Shop in June 1968. As it was a long commute from Pacific Palisades to Glendale, Dad did the driving. We talked about what my job might be. He reminded me that I was the boss's daughter and told me I would be treated like any

temporary employee. I understood what he was saying: Don't try to take advantage. Be respectful and work very hard. He let me know that he had spoken to my supervisor and told him that if he did not think I could do the work, he just had to say the word, and that there was no pressure. Dad's philosophy was "sometimes things work, sometimes they don't—and that is okay."

Upon my arrival, Dad introduced me to his secretary, Edie Flynn, who took me to the personnel department (now human resources) to get signed in. While there, I learned I would be making $2.00 per hour, I would be punching a time clock, and my hours were 8:00 a.m. to 5:00 p.m. Since I didn't have a car and Dad worked later than I was allowed to, I had to wait for him to finish work or change my hours to reflect his, which is what I did.

As I was walked down to the Model Shop, my stomach was churning and my nerves were on edge. But as soon as I arrived, I felt pure excitement. I was introduced to my supervisor, and we talked about what I thought I could do. I explained that I was a good craftswoman, could sew, was good with my hands, had taken art classes in high school, and was eager to learn. We talked some more about the types of crafts and materials I had used.

My supervisor took me to meet Leota Toombs. I was assigned to work with her on the Tropical Serenade attraction (now known as Walt Disney's Enchanted Tiki Room) for the Magic Kingdom at Walt Disney World. I was given a smock, and I sat across from Leota. Our worktables were four-by-eight-foot sheets of plywood covered with brown butcher paper, set on sawhorses. My first job was to cut feathers to fit the backs of the Audio-Animatronics birds who "performed" in the show.

Cutting a feather is not as easy as it sounds. Feathers slide out of the scissors. There are right- and left-sided feathers. We had to select warm colors and cool colors depending on where the bird was staged

in the room. I was learning how to tell a story and how that story was important to the overall show. I finished my first day and talked all the way home. Dad laughed and seemed glad that it might work out for me.

In the WED Model Shop, we had gotten word that the front of the tiki birds' fur cloth was wearing out. These were early generations of Audio-Animatronics figures, and everything we did was trial and error, invention, and application. A group of women, all in our corner of the Model Shop, were talking about how to solve this. Lots of ideas were bandied about, but one got some traction: how about some kind of stretchy material, like a piece of a girdle, sewn onto the fur cloth backing?

I didn't wear a girdle, but some of the other ladies did and volunteered to bring in an old one the next day. I worked with Harriet Burns. She cut up the girdle, and I sewed it to the fur. It was a little thick, but its stretch was adequate and did not inhibit the mechanics. So Harriet talked to the assistant supervisor, who also acted as a purchasing agent, to research and get some samples of thinner, girdle-type stretchy material so we could continue to experiment. He found something that worked perfectly and could be purchased in bulk.

The atmosphere was exciting. The team was inventing and innovating, and there was no pride of authorship.

The end of my summer internship was closing in, and I didn't want to leave. I had learned so much. I had many conversations with my parents about continuing to work until Walt Disney World opened in October 1971. I promised to go back to school and finish my education after its opening. Finally they relented, but only if my supervisor agreed. I had a talk with my boss and proposed staying on. He agreed I was doing a good job and could become a full-time employee, which was great because I'd start getting benefits.

That's when my twenty-six-year Disney career began. I was assigned

the same desk as Leota. I went to the warehouse to sign out supplies and was issued a smock with my name embroidered on it. (We didn't have name tags in those days.) It was a great feeling to have "Maggie" instead of the generic "Model Shop" on the smock.

I continued to work on Walt Disney's Enchanted Tiki Room and also began to work on "it's a small world," painting the rubber faces of the dolls. Those faces were a challenge because the paint (which was proprietary, developed by the guys in MAPO, the Audio-Animatronics division) dried on contact with air. We got only one try to paint an eyebrow with one stroke; if you messed up, the head was ruined (and there were *lots* of heads). I was given a sample head to practice on. This poor sample was covered in eyebrows of every shape and size. I finally found the right-size brush and a stroke that was acceptable.

The reward for taking on this painstaking work was the creativity we brought to the props throughout the attraction. We would go back to Disney artist/Imagineer Mary Blair's sketches for her fun patterns and colors and embellish with stuff we purchased with petty cash at the bazaars in and around Southern California. I remember taking the legs for Alice in Wonderland to a shoe store to buy black Mary Jane shoes. The poor shoe clerk thought I was nuts. I explained I was from Disney, and he just laughed.

As we headed toward Opening Day, my skills continued to be challenged. My supervisor knew that I sewed, and assigned me to work with the folks creating the Mickey Mouse Revue costuming. This was interesting, because wardrobes for Audio-Animatronics figures were usually done by the Disneyland costuming department. WED wanted to keep the art direction for the Mickey Mouse Revue in-house because it was a new show. We did not have enough sewing machines, so I brought my trusty Singer portable with me—a funny sight when I think back.

After about a month on this assignment, my sewing machine was not working very well, so it was sent out for cleaning and oiling. In the meantime, we persuaded our supervisor to rent some industrial machines. I assured him I was capable of working a fast machine, and that I had worked at a uniforms manufacturing company one summer, but he was worried I would get hurt. (There was liability, and then there was liability for the boss's daughter!) My coworker, a professional costumer, assured him she would keep an eye on me. I was resentful at first, because I took it personally that my word was not good enough. I realized I had to let go of my annoyance and get back to work. My coworker also thought the whole thing was dumb, but to prove I could handle it, she gave me a couple of samples to sew while she watched me. My skills were not questioned after that.

As the summer of 1969 approached, another studio executive's daughter came to work in the summer hire program. I could tell right away that she did not want to be there. If she did not want to do something, she just said no. I was shocked. I would never have thought to refuse an assignment.

She didn't last long; she used her father as a crutch and didn't like the work. But around this time, some of us "girls" heard the nickname "daughter-land" for our corner of the Model Shop. It wasn't exactly mean, but it wasn't exactly nice. We took it as humor and moved on, but for me, it was the first awareness of how women in general were viewed. We weren't considered a second-class group, but we were not perceived as having the abilities of the men. Like anything else, there were exceptions.

There was an unwritten dress code at WED; my father thought we should stick close to the famously strict dress code for Disneyland employees. Women (aside from the dozen or so of us in the Model Shop)

mostly held jobs as secretaries, interior designers, graphic designers, and librarians and wore dresses, stockings, and heels; you could change your shoes at work. In the Model Shop, your smock protected your clothing—but it didn't conceal anything when you climbed a ladder to paint something out of reach.

Pantsuits were starting to come into fashion, so I talked to my dad about loosening up on the dress code. He said he would think about it. Years later I realized it was dumb to talk to him, and that I should have gone to personnel. But I did talk his secretary into wearing a nice pantsuit to help us illustrate that pants could be acceptable in the workplace. Edie's example of how pants could look professional worked wonders, and finally we could wear pants. This was my first adventure in experiencing how administrative decisions were made. It was an ad hoc process; as issues came up, they were addressed.

The staff increased as the needs grew to meet our Opening Day schedule. Although we were extremely busy at WED, we continued to have a great time in the Model Shop. You were never pigeonholed. You worked on what was going to be crated for shipment on the next truck scheduled to go to Florida.

My life would change dramatically during the summer of 1971. Dad spent more time in Florida than in California and was not feeling well. When he came home for Labor Day weekend, he ended up in the hospital and was diagnosed with a dangerously enlarged heart. He never made it back to Florida and missed Opening Day.

This was a very sad time for our family and a difficult time for WED. There were many last-minute decisions needed. Who would make them? Marty Sklar and John Hench took over where Dad had left off.

(Dad had to "officially" retire that year, and he died five years later in 1976. In his last five years, he barely left our house; he was weak and incapacitated. Marty Sklar gave the eulogy at his funeral, and naturally,

Disney music was played. My family was doing okay until the end, when they played "When You Wish Upon a Star." What a beautiful way to send off our family's own Disney Legend.)

Just after Opening Day, I had a long talk with my supervisor and asked if I could stay on as a full-time employee at WED. There was plenty of work anticipated post–Opening Day, and he understood my decision not to return to school. He liked my work ethic and attitude, and said my skills were good enough as long as there was work.

Soon after Opening Day, I was assigned to make what we called "bear suits" for the Country Bear Jamboree. The face fur was glued to the fiberglass "skull," and all the rest of the fur went on each Audio-Animatronics figure with zippers—for easy removal for cleaning. We were sewing the fur on the power machines, but the material would eventually get caught in the feed. We researched alternatives and finally found a 1930s furrier machine used to make fur coats (on a regular sewing machine, the needle goes up and down in a vertical direction; on a furrier's machine, the needle moves horizontally, making an overlap stitch). This was a great find, and our boss rented two machines. This was progress and increased our productivity by a lot.

After Walt Disney World opened, the work in the Model Shop had its ups and downs. Layoffs were happening, and we all worried we'd be next. You just didn't know until someone was called into the office on a Friday afternoon. Those days were tense.

During this time, if we did not have an assignment, the "girls" made trees for the models. This was boring, tedious work, but the trees were needed. Note that the "boys" did the actual model making, reading blueprints, and translating 2-D drawings into 3-D models. We women were not thought capable of such advanced thought, so we were left with "dressing" the work of the men.

But in between the tedious stuff, we had what we called specialty projects, including one-of-a-kind displays. For example, there were wall niches in the Contemporary Resort. To fill them, John Hench sketched cute Mary Blair–style dolls, and we sculpted them out of Styrofoam and covered them with thin plaster. Then, working directly with John, we painted them. He would spend time with us discussing color, and why he chose which color. It was always fascinating information. I learned a tremendous amount from John; if you showed interest and asked questions, he was always happy to share.

The dolls were installed, but a strange thing happened. Some of the dolls were melting. The maintenance department couldn't figure out why the dolls were caving in. Then they figured out that those dolls were in niches next to a kitchen with microwave ovens. The microwaves were melting the Styrofoam dolls from the inside out! They replaced all the dolls with ones made of fiberglass, molded from the originals. They sent the surviving originals back to WED. The mother doll carrying her baby on her back stayed with me for the rest of my career. When I retired, John and Marty gave her to me as a farewell gift.

Another specialty project that exemplifies "women's work" in the Model Shop at the time was a series of Disney character sketches by X Atencio for the Contemporary Resort's kids' fun room. The sketches were blown up to life-size as determined by X. (For instance, Daisy Duck was about three feet tall.) The character was drawn on a piece of quarter-inch Masonite and taken to the carpenters' shop to be cut. The carpenters would cut out the figure, sand the edges, and take them to the "girls" for painting.

When painting a Disney character, the colors had to be an exact match to X's sketches. X also explained that if you did not get the correct width of a line around an eye, you could distort the shape and expression, which were vital in maintaining the look of Disney

characters. At such a large scale, your line painting was critical, and X was exacting.

Women painted; men sawed. My inner rebel was rebelling. I still punched the time clock and had not received a raise in three years. (I was still making $2.00 per hour.) I went to my boss and asked what was required to get a raise and move to the next level—whatever that was. He told me I had to be able to use the saws to cut out a character. He chose Goofy.

Now, I didn't read anything into cutting Goofy out of a four-by-eight-foot sheet of Masonite other than the fact that I didn't have the size or strength to lift such a huge piece of material. My intuition was saying that maybe he was sabotaging me, so I was determined to get Goofy cut out.

I asked the carpenter if he would rough-cut the general areas around the figure, and I would do the rest. He did and showed me how to use the jigsaw. I also found out that Goofy required a lot of sanding around his edges. I think I was still vibrating when I took it to my boss and showed him my work.

A quick aside about me: when I'm frustrated, I tend to become very sarcastic. When my boss was done reviewing my work, I suggested he have the carpenter do the painting and make sure X reviewed his color matching and line work.

I made my point, but my boss was not happy with me. When I shared this story with my dear friend and coworker, she laughed and told me I would be making trees for a long time. But I got my raise—all the way to $2.80 an hour. And that carpenter became my husband—and he never had to paint a Disney character cutout.

As EPCOT Center became real, the Model Shop was again the hub of WED. The 3-D small-scale model development for the overall layout of the park, the architecture of individual pavilions, and individual

show concept designs were in full swing. The design development models were often quick paper studies, rough layouts for show ideas. They were not in color or finished; they were like sketches in three dimensions.

At the same time, we created marketing models. These were not necessarily accurate, but they looked good and gave the concept three dimensions for whoever was presenting the ideas to the corporations that wanted to sponsor a pavilion (General Motors and the Transportation Pavilion, for example). Again, the "girls" painted and added landscaping and any other decor that looked good. These models were crated and sent wherever the marketing presentation might be happening.

Frustration was developing among some of the folks in the Model Shop around this time, however. We were getting information from the architects late and had to work overtime to meet the ship date for the marketing models. I became a sounding board for that frustration. I decided to put together a written proposal to add a coordinator for the Model Shop. The proposal outlined what a coordinator would do to help the information flow in a timelier manner so that we could get the models documented, crated, and shipped on time. I gave it to my boss for his consideration.

After about a month, I asked my boss if he'd reviewed my proposal. He said yes, but he didn't think the position was needed. I asked if he would object if I gave it to our director. My boss pulled it out of the bottom drawer of his desk and said to go ahead. It was the summer of 1978. I met with the director, and he said he would review it and get back to me. At this point, I had no hopes that the idea would go anywhere.

In November, Marty Sklar (who by now was the head of the entire creative division of WED) called me into his office and asked me if I would consider becoming the *manager* of the Model Shop. To say

the least, I was tongue-tied. A coordinator was junior to a manager—and I never even considered that my recommendation to create a coordinator position would make it to Marty. "What happened to my idea of a coordinator?" I asked. He explained that my boss was planning on retiring. Upper management liked the ideas I had outlined in the proposal and thought I could do the job.

If I accepted, I knew instinctively that it would be trial by fire, because the pace was picking up for design and production. But remembering my dad's leap of faith, and more stories of Walt casting people in roles they had never considered before, I accepted. I had nothing to lose and everything to gain. Marty wrote a memo announcing the change effective in December; that month would be a transition period, but I would start officially as manager in January 1979.

I walked out of Marty's office, still stunned, and went to meet with my boss. He was waiting for me.

I don't remember what really went down, but my boss was cordial and polite . . . maybe a little too polite. But he mentioned that, in his opinion, I would not be successful because I was a woman, and because my face gave away all my thoughts. I had no idea what he was talking about. Why did being a woman make any difference? (Maybe growing up with six brothers made a difference in how I viewed gender.) I had been taught that skills were important and that what you, as an individual, could accomplish was what mattered. My boss also told me that the current Model Shop supervisor was resentful (he thought the manager's job should have gone to him), and that he would not work for or with me. Again, not a hopeful or helpful transition. I was on my own.

With my learning curve getting steeper, I met with a supervisor in personnel. She was wonderful. She helped me with all the things a

manager has to consider. She was thrilled that I was the first woman in a managerial position at WED, and she helped me hire the support staff needed.

I met with the division director, and we reviewed the work in progress and the work anticipated. I met with all the folks in the Model Shop and developed a needs list. While pulling this information together, I realized that many in the Model Shop who had worked directly with Walt Disney viewed me as "Dick's daughter," even after ten years of working with me. This made life difficult; there was a subtle "Who is this 'manager' who never worked directly with Walt?" attitude. I am sure they didn't like me making the assignments. But my contemporaries were kind of okay, and I believed they would give me some time before judging me.

When you move into management, all your previous relationships change—sometimes dramatically.

I had been manager for about six months when personnel notified me that federal Occupational Safety and Health Administration (OSHA) officers would be coming to WED to ascertain whether we were meeting their guidelines. It was my responsibility to make sure that we followed the rules, but that was difficult to enforce. We had a carpenter who refused to wear safety glasses. I had written him three memos, with copies to his file in personnel, but he was defiant. I told him he could lose his job, but he just laughed at me. A week later he shot a nail into his eye with a nail gun. He lost his eye and sued WED. My first adventure in management: a hard-nosed employee, a paperwork trail, a tragedy, a lawsuit, labor attorneys, and depositions. It was a traumatic introduction to managing and working with difficult personalities.

Soon the Tokyo Disneyland project was also in high gear. It had become a difficult time to determine priorities among the new parks,

the established parks, and our ever-expanding operations. Everyone wanted their work done first. A scheduler was assigned to the Model Shop, and while we were working with him, it became obvious that the current staffing levels could not meet the anticipated requirements.

I worked with the division director to prepare a presentation to upper management for our needs. I talked with other managers, who said there were major budget problems and that they were evaluating how to cut costs. Labor was the highest cost on any WED project and was the first place the bosses looked to trim budgets. My proposal asked for a large increase in staffing levels and additional work space—not what anyone wanted to hear. I was very nervous.

It was a very tense meeting: nobody had anticipated my recommendations. We were instructed to come back with a plan to get the work completed in the most cost-effective way. This was another hard lesson: never go to upper management with a problem for which you don't already have the solution.

The answer we came up with was to create and fully staff a satellite facility in North Hollywood, about seven miles from WED. We provided an estimate of all the costs tied to setting up a big new warehouse that could handle the construction and finishing of full-scale sets and props, separating the functions of 3-D design and model making (design development) from finished walls, sets, and props that would be set up in the parks (show production). The monies were approved, and we moved forward with the capital investments, like creating a carpenter shop from scratch.

They had also approved new people, and hiring became an urgent priority. We tripled our staff quickly and searched for people with both specific skills and the willingness to tackle new things. I was looking for inventiveness, nimble thinking, the ability to work in a team—all the things I had learned as a newbie in the Model Shop myself.

It was around this time that I found out that my nickname was "witch lips." (Today this might be a variant of "resting bitch face"—but it was more pejorative, and I was hurt.) I wondered if this was what my ex-boss was talking about when he told me that my face gave me away. I wasn't sure what to do. I talked to some of the folks who called me that. They told me that I always looked so stern when I walked around the Model Shop, and they found that look offensive. I realized that I was carrying so much information in my head, and was so focused on what I had to do next, I was not conscious of my expression. After this episode, I tried to smile whenever I was "onstage." Maybe this is where my new nickname came from: "Maggie's wearing her Mona Lisa smile, what's up now?" After earning a new sobriquet, I decided not to dwell on nicknames or rumors and just get on with the job. The trials and tribulations of a new manager can play on your mind, but only if you let them.

For me, the change from working directly on projects to being in management was dramatic, and the volume of work, for the artists and for me, was enormous. I traveled from Glendale to North Hollywood often, constantly adjusting workflow, employee needs, and upper management's expectations. I often stayed late, and so did Marty Sklar. We could meet and review the projects that I felt needed his attention. This was the beginning of a good working relationship as we developed a shorthand means of communication—and a lifetime friendship.

The work in the field—assembling, installing, and painting the full-size pieces in the park—was moving fast. People were not assigned to single project teams. For instance, if you built the Alice in Wonderland scenery, you would not install it. Instead, our work was skills-based, with the painter painting whatever came her way in North Hollywood, be it Alice, or a mural for a shop on Main Street, or a prop, which was sent on to the proper park attraction to be installed. But the installation

had to be sensitive, artistic, and also carry out the creative intent of each attraction. This was the finished product, after all. As the time for installation approached, how best to assign talent to the field became very challenging. Not only my Model Shop employees, but engineers, architects, and managers were going to have to move, perhaps for years, to Florida or Japan.

I made a point of discussing the potential impact of relocating on personal lives and families. I think I was among the only managers who took the time to have these conversations. We tried to balance the time needed in the field with time needed both back in Glendale on the job, and back in California with family. We tailored a variety of solutions from taking long business trips to moving spouses and kids to another country, balancing skills with the willingness to make a temporary move. If my ideal candidate could not relocate, I found another way.

Managing is not as sexy as project work, but I loved it. I enjoyed the challenge of learning about differing communication styles, how people wanted to be challenged, what their interests were. I worked with personnel to develop a new salary structure that better reflected the skills and diversity of the work done in the Model Shop.

After my personal experience of asking for a raise and seeing no clear way to move ahead, I wanted more clarity for our employees. Personnel had to research other companies' salary structures, and we worked hard to come up with a list of other businesses they could look at for some comparisons. (After all, at the time, there really was no comparable business.)

To actually make changes to existing salary levels was excruciating. We put together a presentation of the analysis showing why the changes were needed and how to implement a new structure for the current staff. I found out that change is not always welcome, especially when dealing with money. Any upward labor cost changes had a profound

effect on all the costs charged for a project, and most already had a budget. The changes had to slowly evolve over time. It was not what I had hoped for, but it was a start.

After the successful opening of EPCOT, we still had a "punch list" (the small things that need to be finished) and work to finish for Tokyo Disneyland. But things slowed from a sprint to a walk to a crawl. It was a difficult time, and the staff were running out of work. After many meetings, upper management directed middle management to reduce our staff. What a dramatic and traumatic time this was, and this time I saw it from the other side.

We wrote up lists and lists of employees, their current assignment completion dates, their skills, and how those talents could be applied to any future work—which we did not have at the time. We looked at seniority, too. Every employee was evaluated for layoff.

I argued that the talent in the Model Shop was unique. Most everyone could work on new concepts, and they were very versatile. Most could draw, sketch, work in three dimensions, and work conceptually; in true Model Shop fashion, they did what they were asked to do. We also had specialists, who were almost like masters of medieval guilds—model makers and puppet makers, scenic artists with years of experience on movie sets, sculptors, miniature makers, and animators. We had a master wood-carver whose pedigree went back generations. These people had knowledge that they passed on to colleagues, and also used their skills when asked to do something they'd never tried before. Sadly, I had to lay off many of our multitalented Imagineers; there was no work.

As managers, we were coached by personnel on how to handle laying off employees. They had us rehearse differing situations that could come up. I *hated* this part of the job. I had an employee faint and had to call the company nurse. I had my car tires slashed in the

parking lot of the North Hollywood facility and got obscene phone calls at home. I lost sleep, and it was rough both at work and at home. I also suspected that it would not be the last time we had to face layoffs.

During the mid-1980s, there was much activity going on at the Disney corporate level. We all knew something was up over at the Studio. It was also at this time that some minor changes were happening at the new, leaner WED. I was promoted to be the first woman at the director level. My title was Director of Creative Development Administration—a mouthful. My boss wanted it to be obvious that I would not be involved in design. I would be a manager of talent and take an administrative role. I was essentially doing the same job of managing as I had for the Model Shop and show production departments, but on a larger scale. I would make sure illustrators, show set designers, graphic artists, art directors, writers, and all our other creative employees were productive, happy, and on well-matched teams.

I had concluded the round of layoffs in the Model Shop and was promoted for my trouble, only to find myself faced with the biggest employee reduction *ever* for WED. Corporate wanted WED to work on concepts only, and not much more. WED was not a profit center, it was a cost center—so they wanted us to be as small a cost as possible.

We worked for hours and hours, justifying every individual. It was difficult, because we did not know what we would be working on; there were no new parks on the horizon. My boss took our arguments to the Studio; I wrote reports from different perspectives, depending on who his audience would be. Eventually, three of us were assigned to do the layoffs for the creative group.

We learned there was a major shake-up at corporate and more big changes were on the way to WED. Before the changes hit us, there was

an off-property workshop planned for people at my level and above. I was not invited. I learned that the "workshop" was a weekend of ocean fishing.

This was among the only times I felt at a great disadvantage being a woman. I was furious at being excluded. I went to the boss who was organizing the weekend and asked him why I was excluded from this trip, and he responded that he "assumed" I would not want to fish. My renowned sarcasm surfaced faster than a billfish on a circle hook (or a shark rising for chum). I told him that I had grown up with six brothers and that I could handle men peeing off the side of a boat. I also told him that, if asked, I would have declined, knowing my presence would have made the men uncomfortable. I made it clear that I should have had the opportunity to make my own decision. He was embarrassed and apologized. Leaving his office, I was sure I was done for.

The rumored change happened in September 1984 when Michael Eisner and Frank Wells came to Disney. WED soon came under the corporate microscope. There had been significant cost overruns on EPCOT Center. We wrote reports justifying every decision from every direction, explaining our processes, why we did what we did, the way that we did it, and how we maintained it. We wrote a glossary of WED terms to make things easier for Frank and Michael. We had to do a lot of explaining to describe our unique way of creating unique experiences for our guests.

A new corporate executive was assigned to WED to enforce what the Studio wanted: more organization and efficiency. Before he arrived, I was promoted to vice president (again, the first woman at WED to hold that title). It was a similar job but with more responsibilities—and now I was senior management and onstage. I was the one who would have to defend the work and the way we worked.

The development of Disneyland Paris was in full swing by this

time. It was a fun project with a multicultural audience. The new "big boss" (as I politely called him) developed a way of doing business he called the Triangle of Success. Management was assigned the task of presenting the concept to all employees. We had to prove that everyone had attended by keeping sign-in sheets. Even now I feel my sarcasm bubbling. It was very difficult for me to just go along.

To add insult to injury, the new boss believed we had no idea how to control costs. Trying to do the best I could for the survival of WED, I worked through my anger. There were very few people I could talk with confidentially, but I developed a friendship with two women who became my sounding boards. We had a code: "choir practice" meant going out for drinks to talk about how best to work in the environment we found ourselves in. It was a huge help to me. I could gain both perspective and some distance from what was becoming a very difficult situation.

After much debate, I was assigned to manage a new fund at WED—a "blue sky" fund of five million dollars to develop ideas for future projects. There were restrictions for accounting purposes as to how this fund could be used. I had to report monthly on where, what, and how the monies were spent. It was a great idea and in great demand; everybody wanted that money to help develop their great ideas. Then somebody went over budget, and I was called on the carpet for it. This situation was rife with office politics; I was caught in a power struggle between my two bosses, the creative head and the business head. When another overage hit the books, I was sure I would lose my job.

By then I'd had it with the drama. I tried to quit. I went to Marty and told him I would be resigning; the timing would be up to him. We had a long, good relationship, but I could no longer work with or for the other executive. I had never cried, yelled, or cursed at work in all

my decades at Imagineering, even though there were plenty of times when I wanted to. But at this meeting, I choked up and tears welled in my eyes; I thought a quarter century of my life was evaporating. Marty asked me to wait. In a week things would change; that was all he could tell me at that time. It was the most difficult time of my long career.

A week later, that problematic executive, my nemesis, left the company, and a new executive vice president came to work. So here we go again, I thought. Pull out all the justifications for WED's existence from the files. Make a copy of the glossary of terms and anything else he would need to get up to speed, and get ready to teach him all about our business.

I was pleasantly surprised when we learned that this guy had a design and building background. That was one hurdle cleared, because he spoke our language, except for show development. As a builder, he caught on immediately. He took over the troubled Disneyland Paris project and steered it in the right direction. He also understood that a good way to solve a budget problem was to include the designer.

His appointment was a relief. I was finally working well between these two bosses; I knew who wanted an executive summary and who wanted detail. My new boss promoted me to senior vice president (again, the first woman) and took care to adjust my salary to be more in line with the other senior staff. Come bonus time, he was much more generous than anyone had been to me previously.

All was going well until Frank Wells died in a helicopter crash. I knew changes would again be on the horizon, and I just didn't have another reorganization in me. I met with my two bosses and turned in my resignation, and this time, it happened. I was going to leave.

This was a very difficult decision for me: Imagineering had been a huge part of my life. I asked myself a lot of questions about life after

Disney. My brother Dave told me to look at Disney as the runway, and retirement as the place to spread my wings. My wonderful spouse, Jim, was more than eager to leave Los Angeles permanently and move to our little piece of heaven in the Yosemite foothills. I was ready to take up art and crafts again. Imagineering gave me a terrific retirement party and a wonderful send-off. I left, then kept a busy schedule packing up our home and selling it. It was good to be occupied, and I had no time to be sad. I was on to a new adventure and looking forward to it.

Life after Disney has been fabulous for my husband and me. I started painting, joined a gallery, and met many wonderful artists. We went on painting trips with a group to Paris and Hawaii. I was president and a member of the board of directors for a nonprofit organization called Vision Academy of the Arts, which gives art scholarships to local high school seniors. I became an art activist in our small community. Jim was the president of the board for the Children's Museum of the Sierra. He set up programs with schools throughout the San Joaquin Valley to visit this wonderful interactive facility.

The era in which one lives has a special nuance. My time at Imagineering gave me many things I use every day: Thinking outside the box. Embracing change. Being self-confident when trying something new. Understanding communication differences; our English language has so many meanings for the same word that you have to work hard to really understand what someone is trying to say to you. Learning to listen has helped me throughout my life.

There are many stories of women in professional jobs that had been mainly worked by men. Fifty years from the time I started working, the opportunities for women in business have improved tremendously. And yet, of course, there's still a long way to go.

I don't want you to leave this chapter thinking I am a "man-hater"—quite the opposite. My work experience began at a difficult but exciting

time of cultural change. Women burning their bras. My contemporaries being drafted to fight in the Vietnam War. Rioting in the streets and at universities. Civil rights struggles. Women everywhere were learning how to speak up and challenge the status quo.

Here are some thoughts for women, working or not, executive or not, ambitious or not, to consider: trust your woman's intuition. It will be accurate most of the time. If you run into a condescending male bully, work around him or find a way to punch him in the nose, metaphorically speaking. Find the way that works best for you. If you add to any idea in a way that is positive, you can avoid a conflict. And of course, use humor, and have fun—for life is too short.

Kathy Rogers
Executive Show Producer

Learning on the Job I Never Knew Existed

I had an absolutely exceptional and exciting forty-four-year adventure with The Walt Disney Company.

I look back at my career and I am in awe of the diversity and the talent of the people I worked with. We experienced cultural and technological changes inside and outside of the company. I relished the fascinating complexity of each of my many design projects at WDI and the teamwork that achieved the highest level of storytelling. I got to travel around the world, meeting fascinating people. Yet my career was built on a strong foundation of simple, everyday experiences—and my ability to recognize and act on those experiences. And all of this because I took a summer job at Disneyland in 1972.

I never knew I'd become an expert in anything, but through my career, I became a student of everything, soaking up Disney knowledge that became second nature. Even now I'm surprised when some long-internalized concept will come in handy. Recently on a rainy

afternoon in a parking lot, I quickly analyzed how the asphalt was sloped so I could find the driest parking space. I laughed at myself as I rushed inside the store. I knew about civil engineering and grading because I had worked on projects in Florida where assuring the daily summer deluge of rainwater would flow quickly away from buildings and into the drainage system was a crucial part of my work.

I grew up as the fifth child of eleven children, just a few miles from Disneyland in Anaheim. My father was working at Disneyland as a food supervisor in 1972 and suggested that I apply for a job so I could help support myself through college. I was hired in June 1972 to work as a parking lot attendant. I worked part-time at Disneyland while I attended California State University, Long Beach, and received my bachelor of arts degree in home economics with a focus on child and family development. I had no idea that starting in the parking lot at Disneyland would open so many doors.

My starting wage was $1.70 an hour, with a nickel raise at the end of the first summer. I worked at Disneyland through college. After graduation, I realized that I had the potential to make more money—along with health and pension benefits—with Disney than I ever would in the field of home economics. I made the decision to become a full-time Disneyland cast member.

I had envisioned myself working with children and making their lives better. I now see that although I never worked directly with children, my work with Disney impacted children of all ages in so many positive and fun ways.

I enjoyed my ten-year role as a cast member at Disneyland. I understood that on every shift, I played a small part in the magical day of every guest I encountered. I believed—and still do—in the magic of the Disney experience, and that a smile and a kind word can have a positive impact in any situation.

When I started in the parking lot in 1972, the job responsibilities were divided into male and female roles. The men directed the cars in the parking lot sections and drove the guest trams; women took the money at the tollbooths and stood on the back of the trams to give the safety and information spiels. A couple of years later, there was a cultural push to reduce the rigidity of gender roles and allow both the women and men to do all the same jobs throughout Disneyland. I was one of the first women who drove a tram and directed cars. It was a monumental change for Disneyland—an important step toward equal opportunity.

I moved from the parking lot and worked on opening crews for attractions like the refurbished Matterhorn Bobsleds and Big Thunder Mountain Railroad. Being on the opening crew was a real vote of confidence in my ability, but I still didn't have a real career goal. I wanted to do something I enjoyed and make a difference in the world; a specific position wasn't in my sights. I enjoyed doing my job well, and I rarely advocated for myself; I guess I believed that my work should speak for itself.

One day, unbeknownst to me, my work did speak for itself. Big Thunder Mountain Railroad was down (a "101") in the middle of the day. I was up on the ride track (at the top of the first lift, by the bats and the waterfall) on the intercom system waiting for my location's turn to reset the ride system. The cast member in the main control tower was having difficulties with the start-up procedure. I talked the tower person through each of the procedures and confirmed that they were ready for the next step. A supervisor happened to be on the intercom system and overheard me. I was recommended for a lead training position, and that provided a path for me to become an attraction lead and trainer on several attractions throughout Disneyland. These jobs then opened the doors

for me to be in the summer management internship program and other special projects.

In 1982, in my late twenties, I was on loan to WED, still as a Disneyland employee. It was a one-year assignment to support the production and installation of the New Fantasyland project as a project coordinator. This role was the project go-to position, working with all the disciplines through the design, production, and installation phases. It was on me to communicate and distribute all necessary design and production information to every team member from creative, facility design, engineering, production, and project management.

I started at the WED offices learning my role, and it was an exciting time—so many young, eager, and talented Imagineers who were working with many of the original Imagineers (and who ultimately would be responsible for establishing the theme parks around the world, but none of us knew that then). We did know that Disney was about to grow from two theme parks to four; we were about nine months from the opening of EPCOT Center in Florida, about a year from the opening of Tokyo Disneyland in Japan, and about fourteen months before New Fantasyland was scheduled to open at Disneyland.

From my first day at WED, I had the daily support of the other project coordinator on the Fantasyland project helping me navigate the process. But after a couple of weeks, like a baby bird, I was pushed out of the nest and had to learn to fly. I jumped into the fire, knowing little about the design and production for new attractions, but I was able to watch and absorb as so many others worked around me to deliver both EPCOT and Tokyo Disneyland.

I quickly learned to appreciate the complexity of each project and the talent of the team members. The details for any of the disciplines could impact the decisions being made for the overall project. It was such a puzzle to put all the pieces together in a way that would be true

to the storytelling, satisfy the architectural and facility design needs and the ride and show engineering requirements, plus be on budget and on schedule. But that was my job—to grease the wheels and facilitate communication. I was also supposed to anticipate and correct for disasters, but *that* I had to learn on the job.

We were about to wrap up Mr. Toad's Wild Ride when we found out that the show sets—the flats and props that people ride past (without which there's not really a ride!)—were going to be two weeks late. This meant a cascade of problems and delays for Mr. Toad and another facility and would be a huge setback for the project. I was mad at the person who had withheld that crucial information until it was too late and mad at myself for causing the delay. My project manager tried to assure me that it would be okay and things would work out in the end—and in fact, we made adjustments to the new reality, caught up, and opened the attraction on time.

I realized then that I should always be looking ahead several weeks so I could influence an issue before it became troublesome. I decided not to be a pessimist or an optimist but a realist—vowing to never lose sleep over a problem, but to focus on solutions, stay positive, and move forward. I also realized that I had to work and communicate with all the team members, encouraging them to tell me the truth. I couldn't help them if they didn't tell me what was wrong (or going to go wrong). I had to make myself an ally, not an antagonist, so the team as a whole could make decisions based on facts.

At the end of the successful opening of both EPCOT in October 1982 and Tokyo Disneyland in April 1983, the company downsized WED. This was an emotional time. Of forty coordinators, only four of us were left. I watched the loss of so many talented Imagineers, many of whom had become my friends. Because I was still technically a Disneyland employee, I knew I would be able to return to my role at

the park, but in July 1983, out of the blue, I was asked to formally join WED as a coordinator with the newly established design support team called Show Quality Standards (SQS). The company believed that with four Disney theme parks around the globe, it would now be important to have a small WED design staff at each park to handle day-to-day design requirements. Naturally, I was assigned to Disneyland.

Three months later there was another round of downsizing, and I did some soul-searching. I had been at WED a year, had spent ten years as a Disneyland cast member, and had a degree in home economics with no experience in that field. I wondered what to do, but luckily, I remained as Disneyland's SQS coordinator. I believe my recent experience working at Disneyland and WED gave me the foundation of experience and knowledge to keep my new role.

I was the SQS coordinator for several years until a project on the new Star Tours attraction at Disneyland presented itself. On my last Friday at Disneyland with the SQS team, I was so looking forward to working on this new project. However, when I arrived up at the Glendale office on Monday morning, I was informed that I was now assigned as a project coordinator for the new Disney-MGM Studios Theme Park (now Disney's Hollywood Studios) being designed for Walt Disney World in Florida. Flexibility was a very valuable asset to have, then and throughout my career. And it was kind of exciting to be assigned to a brand-new park.

My experience with the team for the Disney-MGM Studios project is one of my favorites. I was a project coordinator responsible for three different attractions, but what is really most memorable is the team. Everyone believed that we were in this effort together, and that working as one team, we could be successful. We made lifelong friendships and fabulous memories, which is what can happen when there is a positive and collaborative team. I learned so much from so many different

designers and engineers. I remember how open the dialogue was between all members of the team; there was no hierarchy of roles. We all worked together, truly, on getting that project completed.

I knew from being a coordinator that on any project, everybody touches everything, and it was my task to make the whole puzzle fit together with the least amount of pain and suffering. That came down to communication. My job was as much about information flow as the actual information. But I wanted—and I wanted everybody on the team—to understand all the pieces that were part of each attraction.

My strategy was to always ask questions, even if I knew the answer, so that everybody in the room could hear the information. One of my favorite sayings was that I was an art director in training, or an architect in training, or whatever I needed to be in training so I could ask for details. This afforded me an insight into the design process and problem-solving. And although my main responsibility as a project coordinator was to focus on the production of the park, I really enjoyed looking in on the creative process. I developed an understanding of the potential impacts of the design details, and then had the satisfaction of working with the team to find the best creative and project solutions. Along the way, I learned design concepts like the emotion of color and texture, creating a space with focus, and keeping things simple but complex.

After Disney-MGM Studios opened, and thanks to the support of the project's overall art director, I moved from my role as coordinator in the production division to design administrator in the creative division. Shortly after joining the creative division, I was promoted to creative show producer, working with Jim Henson and his team on the development of the Jim Henson's Muppet*Vision 3D attraction for Florida.

My experience with Jim and his team was extraordinary. Jim Henson was a very creative, positive, and supportive soul. He was always open to a creative story suggestion. I never recall Jim Henson having a negative response; instead, he would say, "Hmm, that's an interesting idea, but I would like to go in this direction." I found this so inspirational, because he always gave the person credit for the idea—it was only that the direction that was different, and not that the idea was lacking.

In the middle of the installation of Muppet*Vision 3D in Florida, the world lost a true treasure when Jim Henson died. This was a huge emotional blow to our Disney team and the Jim Henson Company. The contract was halted and sent back into negotiation, and the Muppet*Vision 3D attraction team understood that there was a real possibility that the attraction might never open. But in the end there was an agreement to continue with the opening of the attraction. It was such a pleasure to work closely with the Henson design team and puppeteers to make one of Jim Henson's last creative stories come to life. The Muppets had such a simple way of having fun and building and keeping friendships—and this was true for Jim Henson and his design team.

Next it was my turn to experience what most Imagineers experience. I was assigned to the development of a second park for Disneyland Paris that was put on hold. Although this project was ultimately never built, I learned a very valuable lesson watching Bob Weis, then the executive creative show producer, and his interactions with the corporate business team. I remember a situation where the creative team came to Bob with a very emotional and passionate response to a proposal to reduce the scope of a specific show element. I watched Bob take this emotional input, go into a meeting with the corporate leaders, and translate it into a very appealing business

option. I learned how important it is to manage the desired outcome with the appropriate audience. One must be open to understanding that the perception of an issue is different among different individuals. We must recognize those differences and present the issue in a way each audience will understand and value.

As I continued working on projects in Florida (Blizzard Beach Water Park and the EPCOT Land Pavilion renewal), I gained not only experience but the wisdom to anticipate issues, using a combination of people skills and tried-and-true methods to keep creating Disney magic.

My most difficult project came in the late 1990s when I worked on several attractions for Disney California Adventure Park (DCA). I was the creative show producer for several attractions in the Golden State area that never made it into the park. I was excited about the Bountiful Valley Farm, the Golden Vine Winery, and the Pacific Wharf, and disheartened when the budget didn't support them. Alas, what we feared was borne out by guests. DCA struggled after opening, and I changed divisions to join the media production division, which was a sort of offshoot of WDI. Hollywood, Hollywood, Hollywood. I was now a producer in training and had to ask a whole new set of questions so I could produce and deliver visual media for Disneyland Paris's Walt Disney Studios Park. I traveled to France for the first time and tried to be a conduit between WDI and the theme park.

Then I returned to WDI to become the show producer for the Expedition Everest project for Disney's Animal Kingdom in Florida. I consider this my top design project. The Expedition Everest team had an opportunity and commitment to work together from the very beginning. The very talented ride engineers, show writers, and show designers melded the story arc with the motion of the ride track and the environment and found ways to immerse each guest in the experience.

They integrated every detail of the environment, the story, and the roller coaster to create a unique, intense, and seamless experience for guests.

I went back to Glendale, working on projects that were never green-lighted to proceed. Toward the end of my career, I specialized in what we called enhancements, like bringing Captain Jack Sparrow to the Pirates of the Caribbean, new magic to the Haunted Mansion and Jungle Cruise, a new Audio-Animatronics presidential figure to The Hall of Presidents, and new technology and stories to Star Tours—The Adventures Continue for Anaheim, Orlando, and Tokyo.

I came to Disney with a small amount of art design background and no real understanding of engineering, or facility design, or production. I found that if I was confused about any subject, I only had to ask questions. Across the organization, Imagineers were always willing to take the time to explain their processes and their design requirements. I was always willing to listen, observe, and learn new things, and I never stopped learning. Over the years, I found the fun part, for me, was working with everyone to produce the best guest experience.

Simple tasks become complex when creating immersive environments. Here's a seemingly simple example: the size and location of a speaker for an Audio-Animatronics figure. (No, they don't actually talk with their mouths!) Your audio engineer would like the biggest speaker possible, as close to the Audio-Animatronics figure as possible. Your creative designer may not like to see a large speaker box sitting in the middle of the scene. The design challenge—and my job—was to get the team to work together and find the best solution for each.

I mediated thousands of decisions in my career. I'm a Libra, and I always strove for balance. In 2009, we were working on The Hall of Presidents. The Abraham Lincoln figure would now dramatically stand and deliver a resounding speech in the middle of the show,

in the center of the stage. The challenge was where to place a six-foot-wide speaker. The audio engineers wanted it directly behind the President Lincoln figure, which would require the speaker to be raised and lowered for Abe's big moment. But we were on a tight budget and couldn't afford the mechanism for the lift, so we put the speaker somewhere unobtrusive, where it could remain unseen by the audience.

Then came the executive review of the revised show. They loved it—except they couldn't clearly hear President Lincoln. With two weeks until opening, we scrambled together as a team and quickly made a new dialogue speaker, which could be raised and lowered. This was an extreme, yet typical, case of balancing quality, budget, and the challenges of a difficult installation.

Today we talk a lot about equal opportunity and the role of women in the workforce. As I lived and experienced my career, gender rights were not an identified or openly visible issue, but they clearly affected many.

I was raised in a military family with a strong mother as a role model. She was always an active partner with my father, raising and managing our family of eleven. She was not afraid to help maintain things around the house or try creative crafts, such as painting or ceramics, and she was physically active in bowling leagues. She also always maintained her own opinion and perspective.

Following my mom as a role model, I always believed that I could do whatever I needed or wanted to. I was always willing to learn. I was always willing to be hands-on and do whatever was required to get a task or job completed.

I was also clear on who I was, and I was not afraid to meet an unwelcome advance straight on, telling him to knock it off and to never do it again. I am sure I smacked a few young men in my career.

Personally, I don't think my gender affected my career growth (after all, I got to drive the tram!). But I did witness the denial of promotions to several women who were doing the same jobs as men. The men got the titles and the raises, and many of the women left the company in frustration.

Too many times, I was patted on the head and talked down to, even when I had decades of experience and a high-ranking title. Was it because I was a woman? I believe so. But I do know that when that happened, I just quietly navigated around the obstacle, got the job done, and avoided the negativity.

One incident stands out from all the others. Each month the project team was asked to give an update of the financial and production status to our executive manager. I was scheduled for a morning update, but moments before I was to deliver my report, the executive manager said I should wait until the afternoon session. The participants in the afternoon session were all men and were reporting on infrastructure and hotel projects, not theme park updates. It turned out to be a "good old boy" fest with conversations that had absolutely nothing to do with the topic at hand. I was completely shut out, unheard, and dismissed.

I sat there and smiled, understanding that this executive manager was not helping me. I decided that I had the power—and now the reason—to directly call anyone I needed to for information, to get questions answered, or to determine direction. I then would talk directly with the president of the company, get his approval, and only then inform my manager.

I never intended to have an actual career with Disney. It took me twenty years working at Disneyland and WDI before I realized that I had developed into a very well-rounded individual with people and design skills I learned on the job—and that I had a career in theme park design.

There are so many things I learned: patience in working with different personalities and design strengths; keeping a positive outlook and focusing everyone on the end goal; and supporting the business needs, along with the design goal to create the best immersive story experience. I learned about design and engineering, electricity, Audio-Animatronics figures, architecture, sound and lighting, and special effects. And through it, I never forgot that at the end of the process would be a smiling, happy guest.

Besides all the memorable moments with all the talented, creative, and crazy Imagineers I interacted with daily, I got to meet and work with Jim Henson and his design team—and met all of the Muppets and watched them perform. I was one of the Disney representatives at Jim Henson's Celebration of Life in New York, and it was a very special touching and loving experience.

Working with Robert Mondavi and his team on the Golden Vine Winery in DCA, I, a wine dummy, learned to appreciate fine wines. (Unfortunately, this is an expensive way to learn to drink and enjoy wine.) Robert Mondavi was an interesting person to interact with. He found himself late in his career using his passion for good food and wine to make wine an everyday beverage that was accessible to everyone. I believe that he succeeded, and he definitely changed the California wine industry.

I helped install the Captain Jack Sparrow Audio-Animatronics figure in Pirates, and I have a publicity photograph of me talking with Johnny Depp near the newly installed figure. Johnny definitely took the time to study his characters. He knew the Pirates of the Caribbean attraction inside and out: he would suggest hiding places for Jack Sparrow by scene and character. Johnny would make comments like "Captain Jack Sparrow would hide here in plain sight!"

I got to meet then newly elected president Barack Obama when we recorded his speech for The Hall of Presidents attraction. It was a very memorable experience and included a personal tour of the White House by a Secret Service agent who told us that we were the most entertaining group that he had ever escorted around the White House.

But I think traveling to London for the recording session of Star Tours with the London Symphony Orchestra (LSO) at Abbey Road Studios was the cherry on top of my career. I remember feeling honored by being in the same sound studio as the Beatles and listening to the extraordinary musicians of the LSO playing music from the *Star Wars* movies. As I watched and listened, I realized that, like each instrument in the orchestra, every design detail in an attraction makes an impact on the emotion and strength of the storytelling.

I am thankful for my Disney career—I have spent my whole life learning and having fun. I once tested INFP in the Myers-Briggs personality test—introverted, intuitive, feeling, and perceiving. I'm not analytical—something either feels right, or it doesn't. I probably would have asked questions and sought understanding in any field, but I just happened to start that summer job at Disneyland, and it turns out, I never left.

Katie Olson
Principal Color Concept Designer

A Brush with Disney

One telephone call, and just like in the movies, the entire course of my life changed. It is kind of a wonderful thing to report that my thirty-eight-year career with Walt Disney Imagineering began because of an unexpected phone call from, okay, my dad. My father, Johnny Polk, was the captain of security at Walt Disney Productions, the movie studio that Walt Disney built in Burbank, California. When the phone rang that day in 1974, I was not even contemplating working for Disney, even though both my brother and father were working at the Studio. I was going to be a cop.

After leaving high school, I had applied for the Los Angeles Police Department Junior Academy program and was awaiting admittance. I was bound and determined to start a career in law enforcement. The LAPD had told me that I should take whatever I wished in college, as they would teach me everything I needed to be a police officer at the academy. So I started college and chose to major in art.

I had always been interested in drawing, an interest my dad fostered when I was a little kid by bringing me paper, pencils, and model animation sheets from the animation department at the Studio. Just the stuff he brought home was an incentive . . . this was the same paper, the same pencils, that the artists used to draw all those characters in the cartoons. He always encouraged me to draw, to excel at school, and to someday win a Disney scholarship with my "good brain," as he put it. Being a competitive little kid, I did all of the above . . . I drew, I got A's, and I won a Disney scholarship.

One year into my college career, my dad called me at the beginning of summer vacation. He said that there was an opening in the Model Shop at WED for a summer job. He had heard about this opening from a daughter of one of the writers at the Studio. She was already working at the Studio as a script girl, but the job at WED paid less than she made at the time—a whopping fifty cents less an hour. She couldn't afford the pay cut, and called my dad and told him that I should apply for it, reporting that it was a perfect job for a college student. Dad said that if I wanted to try for the job, I should quickly put together a portfolio, and he could get me an interview. He knew everyone at Disney, it seemed, including the personnel folks in charge of hiring summer help. Nepotism was an accepted part of the Disney culture back then (hallelujah!), and everyone seemed to be related to someone somewhere! I scrambled, I interviewed, and I got the job.

I remember walking through WED Enterprises during my interview and falling instantly in love with the surroundings, the people, and the incredible array of extremely cool stuff that was just sitting around in the Model and Sculpture Shops. I have to admit, one of the things that also caught my teenage eye was that there were also in evidence very good-looking men, nearly everywhere I turned my head. (One of

those very good-looking men would, many very complicated years later, become my husband.)

When I actually started work in the Model Shop, my love affair with Disney continued and grew. When the cops called a few months later to tell me I'd been accepted into the junior academy, I told them I'd taken a different career path, and that was that. I was hooked.

At WED, I did whatever I was asked to do. Believe me, painting a kabillion little model people day after day or fake trees day after day was not that exciting—except when you raised your head and looked at what was happening around you.

The hub of WED was the Model Shop. All design was conceived, gestated, born, and nurtured in that room. The art directors were constantly around, working on models, chatting with the staff, and leading any of the design efforts currently afoot. So many of the folks at WED then had been contemporaries of Walt Disney. They had come from the Studio when Walt decided to build Disneyland and had organized WED Enterprises to support that effort, and they had stayed on in the theme park business. You'd be sitting in your cubicle, and all of a sudden, the likes of Harper Goff, Herbie Ryman, John Hench, or Collin Campbell would stroll by. Being the most junior of juniors, I was usually only granted an absent smile, but it was part of the learning process to hear them engage with our production designers, give direction, or suddenly pick up an X-Acto knife and start cutting up some illustration board to work out an idea.

All the folks in the Model Shop were encouraged to take a shot at doing anything: painting, building models; whatever came up, you were allowed to give it a try. The amazingly progressive attitude was that if you weren't good at one thing, you probably were going to succeed—and excel—at something else.

I had an aptitude for painting (certainly not model building), and that became my specialty. I was taught how to mix color precisely, as John Hench (the Emperor of Color) was extremely particular about that aspect of the design process. If John handed you a swatch and asked you to mix the color and paint something with it, and if he picked up said swatch and saw you had missed an exact match, you were toast. No sloppy, "That'll be good enough, who's going to notice?" attitude was tolerated. Your work was expected to be perfect. Period. I have literally, during the course of my career, mixed hundreds and hundreds of colors to match hundreds and hundreds of swatches.

So I watched, listened, mixed, painted, and learned. I was allowed to stay on part-time after that first summer, and I continued going to college and worked as many hours at WED as I could. Then I got laid off.

This was pre-EPCOT, which was still in the pushing-pieces-of-plexiglass-shapes-around-a-map-and-calling-them-pavilions phase. There was literally nothing to do. I was being taught how to fur and feather a tiki bird for Walt Disney's Enchanted Tiki Room at Disneyland that nobody needed when my boss summoned me to his office and announced that the following day would be my last. I cried and went back to college full-time.

I was hired back into the Model Shop in 1979. EPCOT had taken off, and the company needed trained painters. I managed to finish college and work full-time—how, I shudder to remember. But the work was fun—painting scale models of all the attractions at EPCOT. I was given more and more responsibility until I finally made the grade as lead painter on the Spaceship Earth show model. A sign of the times (1980): when I was introduced to the art director as the lead painter on his project, he asked if I was there to keep all the guys company while on the job since they were all going to be working such long hours. I set him straight and got to work.

Soon after, word came down from on high that the painters in the Model Shop had been tasked with painting the color boards for the facilities at EPCOT. "Color board" is a term used by Disney to describe the documentation that takes color from pure design to construction in a format that can be used by both designers and paint contractors to first understand and then deliver the finished product—and do it right. An architectural elevation of the facility is printed, dry-mounted on board, and then painted with colors that have been hand-mixed and exactly matched to swatches that have been chosen by the designated art director.

For the Magic Kingdom in Walt Disney World in 1971, these documents were created by silk-screening, with full-blown illustrative details such as drop shadows, glistening windows, and beautiful flower boxes. When we were asked to duplicate this look by hand, no silk-screening involved, we had several very experienced illustrators among our team who could deliver what was required. Me? I was challenged.

I was given the United Kingdom Pavilion in World Showcase to render, and I was told to take color direction from the architect. That architect was, in fact, color-blind. He said he had to trust me to illustrate what he wanted, as he couldn't see the color for himself.

I didn't know that this would be the first major step in what would become my career path: architectural illustration, color design, and field delivery for facilities, attractions, and a lot of everything else—which is pretty much everything else—that gets a color in a Disney theme park.

I was young, inexperienced, and fumbling to perform something completely outside my bailiwick. While I could mix color like a champ by that point, exactly what color is a drop shadow on a facade that is yet to be built? Marty Sklar happened to walk by my cubicle one day when I was about to cry in frustration and asked me how things were going. I

expressed my hate for the colors of drop shadows; thirty minutes later, Herbie Ryman, Collin Campbell, and Eddie Martinez came by in rapid succession to visit me and ask if they could help.

Marty had gone back to his office and called three of our most illustrious illustrators and told them to go and rescue me. Eddie solved my problem by grabbing my desk lamp, holding it down hard over my swatch of the required color for a wall, and picking up a piece of cardboard to cast a shadow over the color swatch from my lamp. He pointed at the color the lamp created on the swatch, and said, "Now mix and paint THAT color!" Problem solved!

The point of this little story is not how to paint a drop shadow; the point is that our boss, Marty Sklar, took time to care for his people. He sent the best we had to help even the most junior of his artists. I never forgot that kindness—especially because at that time, Marty scared the daylights out of me. I hadn't worked with Marty at all. I worked for John Hench.

John ruled Color Design and everything to do with that particular discipline at Disney. If you think about color as a specific design element, this one aspect of design spills over every tangible visual cue to the guest. If the color doesn't reinforce the time and place that a theme park is trying to present to the guest, then you have lost your audience without their even realizing it.

Everyone has an opinion on color. We all decorate our own homes, bodies, and personal settings. What a very politically dangerous way to make a living—trying to design something correct and pleasing that is so intrinsically personal to every viewer!

John was a visionary, and a hard taskmaster, and he demanded that you trust his love for color as respectfully as he did. John taught me so very much. "Color is the first thing that needs to be present to make our product work," he always told me. Hench stories abound;

he was an incredible talent and mentor and had a huge presence in so many professional lives beyond mine. He was the absolute foundation for so much of the product that we were tasked with nurturing and growing.

EPCOT was rolling along, and then something called Tokyo Disneyland (TDL) came out of left field and hit the proverbial fan. WDI suddenly went global, and life for so many of us changed forever again, beginning with that easterly wind.

TDL was the first Disney theme park outside of the United States. It could have been on Mars for all we knew about the Japanese culture, environment, or potential audience. We had no idea that what we would build in Japan would become one of the most adored places on the planet for our new guests. We were told at the get-go that WDI was seriously uninterested in taking on this project, as the company was so wrapped up in producing EPCOT, which was funded by Disney. TDL was funded by the Oriental Land Company. So a lucky group of us—fewer than a hundred—were sent to build a theme park in a very foreign land, and told not to call home. And this was *before E.T.*, and we were as stranded as that little guy was . . . no phone home. We were told that *we sent you there because we know you can do it, so just go do it, dammit.*

I was sent to support a Japanese-born art director who had been educated in the United States. I had been painting color boards for the project and was intimately familiar with the overall design, so I was not entirely flummoxed by the position in which I found myself almost overnight.

I was to assist with all things color, approving color submissions, working with the contractors in interpreting our documents, and, in the end, making sure the right color was put on everything that was built. I was all of twenty-five when I landed in Tokyo. Of course, the

Japanese construction contractors looked askance at me every time I opened my mouth . . . at least at first.

Talk about a maturing, life-changing experience. To be a young, foreign newbie dealing with something as important and ubiquitous to our product as color with a business culture that had never taken this discipline very seriously before was, let's just say, a challenge for both sides. And of course, Japanese contractors were not at all accustomed to women having responsibility on a job site (or most anywhere else).

All I knew to do was to stick to my guns and try to get it right. The contractors argued, disagreed, fussed, treated me like a dumb bunny, and challenged me every time they could on what I asked them to do. Their paint products were not the same as what we used in the States, so they, in all honesty, couldn't match some of our color choices in their available materials.

Regarding the color matches for the castle, I was looking for perfection, of course. I finally had to look one contractor's representative in the eye and say that I never wanted to hear his opinion on the colors again, as his opinion did not matter, at all. The only opinion that mattered was mine. Period. So keep your mouth shut, please, and go remix the color AGAIN!

If you have a chance to live abroad for a period of time, on your own, with no prior language training or even the ability to read the written word in the land where you have landed, do it. You will never look back on any other endeavor in your life the same way once you have had to survive on your own in a country where the language uses the same word for "foreigner" and "outsider" (*gaijin*).

The year was 1982. No smartphones, no Google Translate, no GPS. World War II was not so very far in the past. Some older Japanese would go out of their way to either bump into or glare at me

or my colleagues, or we would be refused service or even entry to some business establishments.

I learned firsthand how it feels to be treated with racial and sexual prejudice. Once it happens to you, and you understand how unmerited it is, you realize so much about what so many do to others for absolutely no reason except the shape of their eyes, their sexual equipment, or the color of their skin. I abhorred how I was treated, and I learned that racism is a stupid, knee-jerk reaction. It sensitized me to how I treat others, and affected how I have lived the rest of my life. At the same time, I became strangely more patient, knowing that how people treat me can often be due to cultural, not personal attitudes.

But for the most part, living abroad was a hoot and an absolutely grand experience. Trying to navigate a supermarket where you could not decipher what was laundry detergent or dish soap or shampoo because you could not read a simple label was a journey up and down aisles looking like the proverbial fish flapping out of water. Initial visits to any establishment became so fraught that I begged an interpreter or support person to go with me until I got the basics. There were very few Western products, so finding a can of Campbell's soup or Smucker's jelly was like hitting the mother lode.

Restaurants—unless you were deep in the tourist part of Tokyo—had absolutely no English menus, signs, or any way to order food except to throw yourself on someone's mercy. You had to ask for help, or gesture, smile, and look like a complete idiot while pointing at things and holding up fingers for how many you wanted to buy. One soon loses one's dignity when one has to belly up to the "show window"—the ingenious Japanese invention of perfectly rendered plastic models of food and drinks in a window fronting restaurants. All you had to do, once entering a restaurant and understanding that there was no hope in hell that there was any menu available except in Japanese, was to

get up, gesture toward the show window with a silly and embarrassed smile, and literally lead your server outside. You pointed at a model of an entree, or a beer, or a sake, pointed at yourself, held up the appropriate number of fingers, and hopefully, got fed.

Once we all became more language savvy, we learned to scope out the "show window" before entering so we knew what was available and knew enough Japanese to order appropriately. And if all else failed, we had learned to say, "SHOW WINDOW, PLEASE!"

I won't even begin to relate the intricacies of communicating in taxis, where the drivers all wore jackets and ties, sat on what appeared to us to be beaded pads that could only be used to induce extreme pain, and spoke not a single word of English. Except for the one who was driving me and my boyfriend home one fateful night. We were being inappropriate in the back seat when my boyfriend made a few verbal suggestions that I declined to partake in. When we pulled up in front of our apartment building, our driver accepted his fare and then graciously wished us a pleasant good evening in perfect English! BIG lesson learned: never assume when living in a foreign country that the person you are dealing with doesn't understand you!

If we hadn't had such gracious interpreters and support staff, who would kindly write us notes in Japanese for all our favorite destinations to hand to taxi drivers, we would have become like little beetles . . . burrowed in and never leaving our apartments. We were taken to work and back by bus. The adventures that occurred on those buses were legendary, and I will not divulge details.

Tokyo Disneyland was supposed to be a "lift" from Walt Disney World's Magic Kingdom. Take the plans and models out of the drawers and build it—easy, right? My fondest memory of TDL color design happened when I was assigned to do the color boards for Tomorrowland. I took one look at the Florida colors and just had to

do something about the overabundance of magenta. John Hench was in his "pink phase" when Walt Disney World was born, and lordy, was that color dated. I went to John and said tactfully (I think, given it was his design) that the magenta needed updating. He looked through my documentation, told me I was right, and then started tinkering. By the time he finished "tinkering," he'd changed every color in the land! So much for lifting.

Toward the end of TDL installation, I wound up in Dick Kline's office, where I was told I was now in charge of approving the finish carpentry throughout the park. Everyone who would ordinarily have done this important task was busy working at EPCOT, so I was elected. When I told Dick with horror in my voice that I knew nothing about this discipline, he said, "Well, you're in charge of what goes on top of it, right? You can't prime and paint until the substrate is finished properly, right? So go make sure what you are having painted is okay with you for you to start, right?" Yeah, boss, I got this.

Talk about reverting to our training back in the Model Shop—you may be good at something that you haven't ever tried! So I found myself on scaffolding inspecting joints, caulking, spackling, siding alignment, and even crawling on roofs looking at flashing details, and just winging it. Turned out, of course, I could do it.

Suffice it to say our little band of merry Imagineers somehow built an incredible park where there used to be only seawater. When it was completed, it was immensely gratifying on Opening Day to watch our very first guests in our very first foreign theme park literally run out from under the canopy of World Bazaar, regardless of the rain, and make a beeline straight for the castle.

It was soon after TDL's opening that I began a relationship with my future husband, John Olson. John started at Disney in 1974 and is probably one of the most gifted men I have ever met, in so many

ways. (No snickering.) John was discovered by Disney because of his modeling skills and was and still is one of the most talented model railroaders in the history of the hobby. He built gorgeous models, photographed them, wrote hundreds of articles, and was published widely—and one of his biggest fan bases was in Japan. John translated his ability to create 3-D environments from small-scale to full-scale, and he became the head of our character facade discipline after many years of directing fabrication of rockwork in several of our theme parks. John and I were married in 1988, and soon after moved to France for the Euro Disney project. What a way to honeymoon. Get married, move to France, explore Europe, learn French, eat and drink your way around several countries, and build one of the most beautiful theme parks on Earth.

It was through John that I met Bob Jolley, who was John's partner in the field on many projects. Bob was in charge of character paint (also known as theme paint) for WDI. Character paint finishes are used in our theme parks to make the new look old and the manufactured real, using techniques originating within the film industry. These finishes enhance the design intent established by the sculpting of architectural and rockwork forms, and contribute a wealth of detail such as aging, weathering, and wood graining. Bob was a master field art director, and once we met, we hit it off. He and I discussed in detail how our color boards were implemented in the field, and luckily he took a chance and invested in me. Bob taught me the importance of illustrating themed paint finishes accurately, and how the new style of color boards could be used to demonstrate design intent, especially to field painters whose first language was not English. I began taking my work to a higher level, both in the design process and in the field, thanks to Bob. The Big Thunder Mountain load/unload building for Tokyo Disneyland was our first collaboration, and we took off from there to the Norway Pavilion

at EPCOT and beyond. John and I loved him dearly, and owe so much to him and his involvement in our lives.

I was involved in every overseas Disney theme park, from TDL to Euro Disney to Tokyo DisneySea to Hong Kong Disneyland to Shanghai Disneyland, with domestic projects such as Disney's Hollywood Studios, Disney's Animal Kingdom, and Disney California Adventure among a kabillion other assignments. I have designed and directed color for facades, attractions, props, light fixtures, area development, and every other little detail you see when you enter our theme parks. Every single thing you see in a Disney park has been touched by so many talented people. I am honored to have worked with such passionate, dedicated, gifted colleagues.

I retired with the lead color design for Shanghai Disneyland project as my last assignment. Just before that, I worked on the Ratatouille project in Disneyland Paris, designing color for the facades and the entire attraction, and completely redesigned the color of the exterior of the "it's a small world" attraction. Remember, I started in the Model Shop painting little plastic people and making fake trees. If I can climb a ladder, so can you.

The gift of being able to travel the world, live intimately with other cultures, work with fantastic colleagues, and even get to do it with your life partner at your side, is one that I will always cherish. How very lucky we are to have had careers that gave back so very much. I would like to pay that gift forward by outlining a few of my lessons learned that I hope will be of value to future budding Imagineers.

It's a cliché, but that makes it true: there is no letter "I" in the word team. **You are part of a team.** Unless you are the designated art director, you are there to make the art director happy and confident that the product you are helping to deliver is the best it can be, but here's the important part: do it within reason. **Disney is *not* a religion.** It is

a business in which every party has a vested interest. The contractor needs to be financially successful and finish on schedule and on budget, with a beautiful product that everyone can be proud of producing. But they need to make a buck.

Do not let your ego interfere with good business practices. I have seen art directors noodle with every tiny little detail, details that no guest will ever see or notice. They are so worried that one of their colleagues will say, "Who bought off that piece of shit?!" that they will not give on any level of compromise. Remember your audience, not yourself.

We Imagineers tend to perform for each other, more than for the guests. We at WDI are such consummate critics that there is a danger that you will go overboard on trying to make it perfect so that there is absolutely no room for criticism. **You have no right to kill your contractor.** Every detail does not need to be perfect.

Remember that **there is a hierarchy to good design**. Where do you want the guest to look, to get in line for an attraction, to buy a souvenir? Pay great attention to where the guest needs to pay attention. If they are looking at the lovely detail around the menu board, they are not looking at the menu. Hierarchy is key.

Always remember that this is a place where people walk around dressed as mice, ducks, and dogs. Do not take it so seriously that you jeopardize your health, your family, or your personal life by thinking you are the only one that can do what you do. The splash always fills in again after the fish jumps. It is not the Pentagon. It is a theme park, albeit the very best in the world. Be proud, but be sane.

Be confident. Learn to answer questions directly, without dithering or needing to check first with a higher authority. So many of our young field personnel are paralyzed at the prospect of taking responsibility for making a decision when asked by a contractor for direction. You were

put there to direct. So direct clearly, and do not change your mind in midcourse. It is a very basic skill set . . . learning to say yes or no.

There are a few billion people out there who do not speak English, and they won't learn or understand you any better if you shout at them in English. Make sure you are understood, whether you use the services of an interpreter or draw sketches in the sand if that is what you need to do to be clear! Communication is absolutely key to a successful project. You are not in Kansas anymore, so plan accordingly.

Have fun. You are working on something that will make millions of people happy, creating memories for them that will last a lifetime. You are very lucky: you could be doing something that you hate.

It's hard work. Try being in boots, safety vest, and hard hat, a hundred feet up on a scaffold, in hundred-degree weather, with 100 percent humidity, and fifty people yelling at you—daily, for months. Of course, you also might be one hundred feet up on a scaffold in thirty-degree weather, with the paint literally freezing. At the end of each day, you're exhausted, sweaty, and covered in paint. You've yelled and compromised and held your ground and made some mistakes and done some good work. It takes a lot to build a theme park. Plan accordingly.

In closing, I wish to thank my fantastic teammates at WDI for thirty-eight incredible years of making the magic. We had a ball, didn't we? And it certainly shows in the gorgeous, fun, and absolutely unique product we were able to help create. Be proud.

Now let's go fishing.

Julie Svendsen
Concept Show Designer

Finding My Way to Disney's Lands

My dad's dad, Fredrik Svendsen, was a Norwegian sea captain. His son, my dad, Julius, was born in 1919 in Kristiansand, Norway. Soon after Julius's birth, Fredrik and his wife, Mary, immigrated to the United States and began living in New York. And when Fredrik was not at the helm of four-masted windjammers, he loved to paint pictures.

At a very young age, my dad displayed formidable artistic talent. With the encouragement and the blessings of his parents, he followed his passion for drawing and painting, graduating from Pratt Institute in New York in 1939 with a BFA. He made his way west and was quickly hired by Walt Disney Productions and began working in their animation department. My mom, Carol, had a turbulent childhood; she was raised by her older sister after their parents passed away. But Carol toughed it out and grew up to be bright, determined, and headstrong. At seventeen, she was hired to be a tour guide at Walt

Disney Productions. In 1949, Julius and Carol were introduced to each other on the Studio lot by a Disney colleague, and they soon fell in love and got married. I was born in 1950. I lucked out.

When I was a kid, I spent a lot of time drawing pictures. My dad's job (by then he was a full-time animator) was also drawing a lot of pictures. The Disney characters—Mickey Mouse, Minnie Mouse, Goofy, Donald Duck—were ubiquitous visitors at our house in their many forms (comics, toys, books), but mostly in the form of animated cartoons. On every one of my and my siblings' birthdays, we were treated to seeing the latest animated short or feature my dad had worked on. He would bring home reels of 16 mm film and then carefully thread the celluloid through the complicated pathway of uncooperative projector spools while we all impatiently waited to see those wonderful images show up on the roll-down screen. When the projector motor finally started and the opening credits showed up, my brothers and sister and I and all our friends invited from around the neighborhood were rewarded and delighted.

After I graduated from high school, my mom and dad suggested that it might be a good idea for me to go to college, or maybe get a job. I did both. For a couple of years, I worked as a clerk in a small office. I also enrolled at Valley State College (now California State University, Northridge), and I took random classes. My grades proved that those classes were not at all interesting to me. Knowing that WED Enterprises was very busy designing and building Walt Disney World in Florida and probably staffing up, my parents arranged for me to be interviewed for a job—any job—at WED.

In the summer of 1970, I was interviewed and hired at WED to be a full-time accounting clerk. I was nineteen years old, and I had no idea how lucky I was. Being a clerk involved doing lots of perfunctory tasks—mostly filing, running errands, and paper-pushing. I was also trained to be an operator on the WED switchboard, so I'd be sent downstairs to spell one of the main operators and answer phones. Those tasks may have been humdrum, but they afforded me the opportunity to be in the middle of the place where all the concepts, design, artistry, architecture, engineering, and manufacturing for the Disney theme parks happened.

Within the walls of that building on Flower Street were the most stimulating, exotic, and highly skilled people—and I got to be among them forty hours a week! I soon realized that I loved being there, working among all those talented people who were creating and building fantastic attractions and experiences for people around the world.

Part of my job as an accounting clerk involved being sent to work at different locations on the WED property. For several months I clerked in the purchasing department, which was located on the second floor of the MAPO building. (It was named that, among other reasons, because it was built from the profits of the *Mary Poppins* movie.) I saw the inner workings of the place where all the components for the various theme park attractions were built, manufactured, and assembled. There was a machine shop, a plastics shop, and an Audio-Animatronics figures shop—all top secret and accessible only to Disney employees. The entire first floor of MAPO was a cacophony of clanging, whirring, and drilling while the sets and the Audio-Animatronics figures and the ride vehicles were being built for Walt Disney World.

After a couple of years as an accounting clerk, I got promoted to cashier for WED and MAPO. The job of cashiering entailed cashing checks for the employees, selling tickets to Disneyland and Walt Disney World, collecting expense reports from employees' business trips, and distributing weekly paychecks to the various department heads. Every Thursday morning I set out from my cashier's office and delivered batches of paychecks. My weekly excursions gave me the profound privilege and pleasure of meeting and getting to know many of the Imagineers.

The most interesting areas to distribute paychecks were the offices and studios and shops of the various artists working on idea sketches, graphics, model building, and sculpting. I saw up close what they were doing and how they worked, and those artists and artisans were never too busy to stop and chat for a couple of minutes. Of course, as a child, I had grown up seeing some of the animation work that my dad was doing. But the huge variety of things being created and built at WED was amazing: paintings, graphics, art for murals, scale models of buildings, and entire tiny and exquisitely detailed themed lands. The sculptors were working on maquettes and full-sized figures. There was an area exclusively dedicated to "fur and feathering" to assemble the attractions' birds and animals.

I was still drawing and sketching for myself after work and on weekends. But working at WED, I became aware of some of the career opportunities available if I chose to become a professional artist. The energy and the creativity and the fascinating treasure trove of smart, funny, and crazy people working around me were intoxicating. These people inspired me. I started to think seriously about doing what it

took to become one of them. My artistic engine had been ignited.

A few other things happened to me at WED between the ages of nineteen and twenty-three, and while they weren't very inspiring, they were things that incentivized me to get going and make some changes. As a young and naive woman in that busy workplace, during the seventies—long before companies instituted workplace protections—I experienced uncomfortable situations and received my share of suggestive comments and actions from a few of my male colleagues.

These experiences fueled my resolve to make something (else) of myself. Plus, I realized that I was the one responsible for myself—and that I had to believe in myself. I had been told many times over the years that in order to succeed, I had to have someone believe in me. But it finally dawned on me that I was the one who had to believe in and be responsible for myself. This realization was an epiphany, and it has informed me and my actions, consciously or unconsciously, ever since.

With encouragement from my family (especially from my mom), I quit my job and went back to school to get an art education, aiming to become a professional illustrator/designer.

In the fall of 1974, I became a full-time student at California State University, Northridge (CSUN), majoring in 2-D art. I spent two years there taking classes—drawing, color, design, printmaking, and graphics among them. (And to my astonishment, I made the CSUN dean's list.) I used my work from those classes for the portfolio I submitted to ArtCenter College of Design (ACCD), which had, and still has, a reputation for being one of the top, and one of the toughest, art schools

in the country. Just to underscore how tough ACCD is, I had asked several show designers and conceptual artists at WED about their art training. One of those artists said to me, "If you can get through ArtCenter, you're guaranteed to be, at the very least, a competent illustrator." So, with his words in mind, I was elated and terrified when my portfolio was approved and I was accepted.

The instructors at ACCD are professional artists, designers, illustrators, and graphic designers. The classes and the homework assignments for the classes were grueling. During my first semester, I spent an all-nighter working on a homework assignment—a charcoal sketch for a class the next day. That morning, my bleary-eyed classmates and I dragged ourselves in and pinned our work onto the classroom walls. The instructor proceeded to move down the line of sketches, critiquing each one. At one particular piece, he stopped, gave it a closer look, and, as we watched in horror, cruelly dragged his finger across the drawing and then held up his blackened finger to make the point that all charcoal drawings needed to be sprayed with fixative upon completion. So while some of the time spent at ACCD was enjoyable because I was doing what I loved to be doing, in each of my eight semesters, there was a boatload of serious and time-consuming work.

To pay my way through ArtCenter, I accepted my mom's generous financial assistance, and I pitched in by working during the summers. One of those summers I was a waitress; another summer, I was a cashier at a golf and tennis center; and another summer I was hired at WED as, again, a clerk. Then, in the summer of 1979, a year before graduating from ACCD, I presented my portfolio to the WED Graphics Department and got hired as an intern—my first paying job as an illustrator! My assignment that summer was to design and illustrate a poster for the Crystal Palace Restaurant at Disneyland. (What?! A poster for Disneyland? Did I hear you right?) I was floored. It took

me most of that summer, but I designed, sketched, and painted the Crystal Palace poster artwork while receiving various suggestions and art direction from my colleagues in graphics. Then the time came for my artwork to be seen and, hopefully, approved by John Hench, who oversaw all design, show, character, and color for the Disney theme parks.

I barely slept the night before John was scheduled to critique my poster. With butterflies in my stomach, I watched the hands of the clock slowly move until the appointed time that John was scheduled to arrive at my work space, and when he did, all the chitchat in the room stopped. He looked over and evaluated my work, made a few minor art direction comments, thanked me, and approved the poster. Wow. He was all business but could not have been more pleasant and professional. He was courteous, and he cared only about the concept and the craftsmanship of my work. My poster was to be printed and displayed at the parks—and I was over the moon.

A few more words about John Hench: during my career at WED/WDI, I had the honor, good fortune, and pleasure to work on many projects with John. He had joined Disney in 1939 as a sketch artist and, over the years at the Studio, had worked on many of the early animated features. In 1954, he began working on the nascent Disneyland for WED. His range of experience working in all aspects of the arts—storytelling, filmmaking, animation, painting, sculpture, graphics, theater, and, very importantly, color—before and during his work for Disney was what made his expertise and his eye so invaluable. We, as WDI show designers, all needed to hear what John's opinions were about everything the guest would see and experience at the parks. But interestingly, John, echoing the words of Walt Disney, felt and often expressed that the parks' guests were the best art directors and that we were working to please our guests. He felt so strongly about

this that it was customary for him to go to Disneyland and Walt Disney World and wander around the park impersonating a paying customer so that he could overhear what the real guests had to say while they were waiting in line, or while they were having a meal. John took notes and passed them along to the appropriate people at WED.

After that wonderful summer internship, I completed my senior year at ArtCenter and graduated, earning a BFA in illustration. After graduation, I applied for work in the creative development department at WED Enterprises. I was interviewed and had my portfolio reviewed by Maggie Elliott and Rolly Crump. With luck on my side again (and a sample of the poster I had done the previous summer as a graphics intern), I started working full-time as an artist in the WED Model Shop in the summer of 1980.

So I scored a job at my favorite company as an illustrator/designer. Awesome! But while all those college art classes and all that work was tough going, no college class or college art instructor had said a word about the ins and outs of joining a workforce of artists and artisans in a big company that builds theme parks. (These days, I've heard that some schools now offer "theme park design" as a major.) But here I was back to work at WED, my familiar stomping ground. And except for some of the people there whom I still knew from my days as a clerk/cashier, the landscape of my new WED job was a steep cliff of a learning curve. I hoped that I had at least achieved competence, as my colleague had foretold that I would. Six years of CSUN and ArtCenter experience, along with my summer internship in graphics, had given me maybe not a running start, but a leg up, and from that first day at work, I gave it my all.

I started out by contributing to several project teams. One of the teams was working on "New Fantasyland," the long-overdue makeover of the original Fantasyland at Disneyland, which had opened with the park in 1955. I sketched and painted illustrations that would later become murals in a few of the updated dark rides. I also joined a team of color board artists who were painting architectural elevations for use as an exterior color reference for the newly emerging pavilions at EPCOT. Our job was to match exactly the colors chosen by John Hench and the various architects so that the on-site painters had a guide to follow. Mixing and matching colors was on-the-job training for me, something I wasn't taught in any class at art school, and I have Joyce Carlson—the WED wizard of color matching—to thank for imparting this skill to me and several others.

In October of 1982, EPCOT opened. And right around the time of the opening of this huge project, there were noises in the hallways and workstations about impending layoffs. Luckily, at about the time I started wondering if I too might be a casualty of the layoffs, Rolly Crump started his own small company called Mariposa, and he offered me a position there as an illustrator/designer. He told me he was impressed with my versatility. I accepted his offer gladly and became part of a team that, for a couple of years, created themed entertainment and experiences for various venues. At Mariposa, our projects ranged from designing show elements for a historic fort in Oman to designing shows for restaurants featuring the Warner Bros. cast of characters. I also began doing some freelance work for Jean-Michel Cousteau, the son of explorer Jacques Cousteau, who, at that time, was at work planning a Cousteau Center, which

would house an aquarium, his now-famous boat *Calypso*, and other themed guest experiences.

In 1986, there was news that WED, now known as Walt Disney Imagineering (WDI), was staffing up again in anticipation of several projects that had been approved for design and construction by the new leaders of The Walt Disney Company, Michael Eisner and Frank Wells. Once again, I applied and was hired. One of the first projects I was assigned to was Disney's first major water park, Typhoon Lagoon. I was so very lucky to be a designer and illustrator on this park, helping to shape the concept and storytelling from the beginning, and then to be a part of the wonderful team of designers, architects, and engineers who collaborated to realize this wild, whimsical, and gorgeous Florida water park.

Typhoon Lagoon turned out to be such a crowd-pleaser and so successful that work soon began on a second water park. We all started brainstorming ideas. One day, a WDI mechanical engineer assigned to our team came in with an idea inspired by watching the Winter Olympics the night before. That glimmer became Blizzard Beach, a (snow)ball to work on.

At around this time, I also began working on the Wonders of Life Pavilion for EPCOT. The Wonders of Life was a late entry to EPCOT because it had taken several rounds of development to arrive at a concept that was finally approved. I once again had the distinct pleasure of working with my colleague John Hench.

My next assignment took me to work on Frontierland for our first European park, Euro Disneyland (now Disneyland Paris). Jeff Burke was the show producer, and I was assigned the job of painting portraits and landscapes for the Phantom Manor attraction, a unique

Disneyland Paris version of the Haunted Mansions at Disneyland and Walt Disney World. My paintings included the new characters and situations in the "stretch room" and portraits of the bride of Phantom Manor.

As things were winding down for me on Disneyland Paris, I got busy on the show aspects of the brand-new Disney Stores for New York, San Francisco, Orlando, and Las Vegas. I became immersed in layouts and color roughs of the characters, ranging from the historic (Mickey Mouse, Goofy, the Three Little Pigs, Bambi, Pinocchio) to the, at the time, new (Belle, the Beast, Ariel, Simba). As I created ideas for murals and sculptures, I might have been channeling my dad a little bit, remembering all those characters around the house when I was a kid, emerging from Dad's pencil or my own. I learned that to draw a character correctly, you do have to know their personalities. I would inhabit each one as I drew them, "acting with a pencil," like my dad had done.

Soon word got around, and I became the go-to person for any work involving a character presence. The Disney Cruise Line project was becoming a reality, and the Disney characters would have a huge presence aboard those ships, so I contributed there. Most fun: the large sculpture for the *Disney Magic* of Goofy suspended in midair, painting the finishing touches on the hull.

Also taking shape at this time was Disney California Adventure (DCA). I contributed concepts and show designs to a few attractions at DCA. My favorite project in that park was working on show elements for the store called Off the Page, which featured my concept of an array of Disney characters that seemed to be coming off the animation paper pages—again, a bit of an homage to my dad.

I also had the amazing luck to meet a new hire. A very talented Egyptian man named Hani El-Masri arrived at WDI in 1990, and we

became colleagues and very close friends. We discovered that we both loved painting all sorts of things in watercolor and, especially, en plein air landscapes. We both used watercolors for our Imagineering work, and we attended painting workshops whenever we could. We started traveling together to different places around California on the weekends to paint. We loved doing this so much that we proposed the idea of organizing painting workshops at WDI to show designers how to expand and enrich their work. The idea was approved, and a program of monthly day trips to paint landscapes was initiated. That program was even expanded to include weeklong trips to workshops in Montana.

In May of 2001, I was laid off as part of another wave of departures. (The first two times I had left WDI, it was on my own terms.) I dusted myself off and scrambled to find work, availing myself of every referral, believing that my background and my skills would be needed somewhere, by somebody. I also considered a career change and enrolled at Valley College to take classes to become a nurse. On or around the third session of chemistry class (while discovering that chemistry was *not* my best subject), I got lucky again. Disney Publishing called, and I illustrated children's books for them for a few years. In addition, I worked for a company designing and building a Singapore theme park for DreamWorks SKG, and Hani and I created a comic book for Ocean Futures, a company headed up by Jean-Michel Cousteau.

In 2005, I applied to a company called The Children's Place, which had just purchased the Disney Stores from Disney. I worked there full-time for three years designing toys based on the Disney and Pixar characters. The 3-D work was interesting, but in 2008 Disney bought back their stores, and I, along with many others, got laid off. As luck again would have it, Imagineering

was able to use my freelance help while they were designing and building Shanghai Disneyland.

Now, as I'm writing this, I spend most of my time and get most of my enjoyment from painting watercolor landscapes for myself. My seafaring grandfather enjoyed painting scenes of rural life. My dad enjoyed painting scenes of various places in and around Los Angeles. I am enjoying painting landscapes just about wherever I go—in my neighborhood, at the beach, in someone's backyard, or sitting at a park bench. Painting keeps me going like it did for my father and my grandfather. And I hope I'll be lucky enough to spend many more days hunched over a watercolor, watching paint dry.

Paula Dinkel
Principal Show Lighting Designer

Lighting Is Magic

People often ask me how I got into lighting for theme parks, and the honest answer is that I responded to an ad in *Theatre Crafts* magazine when I desperately needed a career course correction. I was working too many hours at USC teaching lighting classes, designing shows, and running three theaters on campus, all while trying to be a single parent of a son. I might have gone on that way except that the "Building a Better Mouse" ad campaign really caught my eye and I saw that WED Enterprises was looking for set designers, special effects designers, and, amazingly, show lighting designers. I'm honored to have spent nearly thirty years at Imagineering and I've had a wonderful career. I love all things Disney and I have been pixie dusted for life. I came to theme parks from the theater, but it might never have happened.

My path was by way of music and dance. I studied ballet, tap, and jazz starting at age seven, developing self-discipline, persistence,

and stage presence. Then came music, and I learned to play the flute. Marching band soon took over my life for several years, and I learned teamwork, leadership, and showmanship. I also edited the school's literary journal, wrote for the student newspaper, and wrote poems. Later on all of those skills would come in handy.

I didn't have a clear goal for life after high school, so I started community college at Allan Hancock College in Santa Maria, California, with a vague notion of a career in journalism. On the first day of classes, I saw a posting for auditions for a musical in the theater department. I thought it would be fun, and I was cast as a dancer in the musical *Half a Sixpence*. Students who were onstage also had to work backstage, and soon I was happily painting sets, running props, and working in the scene shop. Music and dance went by the wayside. I loved the theater culture: the scripts, the characters, and their stories, as well as the people who created the magic. I loved the feeling of a shared vision and a shared mission, and even more, I loved the people and our shared experience. Finding the theater felt like finding a home; I felt like it all came together for me. It was the first year or so of the Pacific Conservatory of the Performing Arts, the professional theater company at Hancock, and today it's still going strong.

The first time I ran the dimmer board for a play, I found my passion. It was magic! I know that might need some explanation. The play was *The Subject Was Roses*, a drama, and there was a very emotional moment where the lead actor was brooding in the dim light and shadows of a living room set. His stage direction was to turn slowly and reach over to turn on a working table lamp (referred to as a "practical"). A theatrical light was focused straight down above the practical, and that supplemental lighting was going to be controlled by me. My job was to synchronize that cover light with the actor's movement. Plus, it had to come on simultaneously but not blind the audience, so the

lighting designer directed me to fade it up quickly to about 20 percent of full intensity, and then continue with an imperceptible fade up the rest of the way to the desired level. Computerized lighting consoles were just a dream then, so the cue had to be run by hand.

I could almost feel the tension of the audience as they watched the actor, frozen in shadow and indecision, finally reach for the lamp. The cue was called by the stage manager. I timed it perfectly, and both the audience and I breathed a sigh of relief, knowing that the character was coming out of emotional darkness and would be okay, and I knew I had executed the cue to perfection. The actor and the play had touched the heart of the audience, and so had I. I was to feel that rush again and again when an actor finds their spotlight, when my lighting design helps to tell a story, and of course at that breathless final "fade to black" when we hear the applause. I still feel the thrill of engaging an audience, whether it's in a theater or on a thrill ride. I love doing my part of the storytelling.

I was at Hancock for three semesters, earning my way by working at a restaurant and modeling for life drawing classes. I spent the summer of 1969 working shows performed in repertory at PCPA, followed by the next two summers working professionally as the prop master for Sacramento's Broadway at Music Circus.

I transferred to California State University, Fullerton to earn my BA in theater. My son was a year old when I graduated. I taught theater part-time at California State University, San Bernardino, for two years before going back to college for my master of fine arts degree. I was also a single parent by then. I worked three part-time jobs, did my thesis show, and wrote the thesis, earning the first MFA degree in Theatre Arts from California State University, Fullerton, in 1979.

I thought that was hard, but my first job out of school was even harder: assistant tech director and lighting instructor at the University

of Southern California (USC). I loved teaching and designing, and I loved the students, but commuting from Los Angeles's Eagle Rock neighborhood to downtown LA, raising a five-year-old, running three theaters, and managing a staff of stage electricians was taking its toll.

That's when I saw the ad for WED. I sought out Dan Flannery, who was teaching at USC, because I knew he had some experience with Disney. He was kind and generous with his advice and friendship, which is still going all these years later. My application was rejected, but five months later I got a call to interview. A second interview followed a week later with Rolly Crump, and a week later I was an Imagineer.

I got my first dose of pixie dust in orientation on June 23, 1980, and I was in very good company. Pat Gallegos was there in class on my first day, and I soon met show lighting designers Joe Falzetta, John Shipley, Michael Valentino, Bill Groener, Ed Zeigler, Larry Pageott, Patty Glasow, Bill Sly, and several more who have all gone on to distinguished careers in theme parks, architecture, events, and entertainment. They are a talented group of people and beloved colleagues who basically invented the design discipline of show lighting for theme parks.

As I walked the halls of WED, there seemed to be magic around every corner and pixie dust everywhere I looked. I felt at home again. After learning my way around WED, my first assignment was at Disneyland. I had lived, worked, and attended college next door to Anaheim, so I certainly knew Disneyland. I had watched the *Disneyland* TV show in the early fifties, and I saw all the Disney exhibits at the 1964–65 World's Fair in New York. I first visited Disneyland in 1966 when my family moved to Lompoc on the Central Coast of California.

I attended Disneyland Grad Nite in the spring of 1967 and got to ride the newly opened Pirates of the Caribbean with my high school sweetheart. The park was a wonderland that night! I was curious about what was going on with that spooky mansion nearby and imagined what could be behind those lit windows on Main Street.

Many of my college classmates worked at Disneyland in shows, parades, food service, and merchandising, but I had never even thought about the fact that the castle, all the buildings, the attractions, the gardens, the walkways, and the overall environment had been designed by someone. I quickly learned that WED comprised artists, architects, engineers, animators, sculptors, and dozens of other disciplines I'd never encountered before, all working to create the magic of Disneyland.

Rolly had hired me to join a newly formed team of Imagineers who would be based at Disneyland to help keep it looking good while the rest of the company was mostly dedicated to building EPCOT and Tokyo Disneyland. The first team was very small, consisting of Kim Irvine for show design, Kirk Winterroth as show coordinator, and me.

When I first started at WED in Glendale, I was living in Eagle Rock. Since I was spending so much time at Disneyland, I eventually decided to move to Anaheim. I found an apartment around the corner from the elementary school and then signed up my son for an after-school program at the YMCA across the street.

Having my life and my work in the same neighborhood shrank my hour-plus commute to ten minutes or less, and I was able to spend more time with my seven-year-old son. I had health care, a pension plan, and a job I loved in a magical place. I got a smile on my face every day when I drove through the gates. Life was good.

In the 1980s, Disneyland was closed on Mondays and Tuesdays, when much of the preventive maintenance and repairs were done.

Imagineers had total access to the attractions on those two days so we could walk through them and look behind the scenes. It was a privilege to study them all. I was especially looking at the lighting, of course, making notes of the fixtures used; how they achieved color through filters, gels, and colored lights; the kinds of lamps used; their mounts; and where the lights were hung. I had a lot to learn about black light, fluorescent, metal halide, mercury vapor light sources, and all things low voltage—things I'd never seen in the theater.

Having been trained only on theatrical fixtures, I also had a lot to learn about equipment like servo motors, and controls like programmable logic cards (PLC), which did then what we do now with computers. There were also MAPO flicker units that controlled lights like the guttering candles in the huge chandeliers in the Haunted Mansion entry and the lanterns over the Pirates of the Caribbean load dock. The proprietary equipment was made by the manufacturing division of WED, called MAPO.

I was also dazzled and fascinated by the special effects, especially in the Haunted Mansion. I am often asked about the ballroom scene and the dancers, but my lips are forever sealed about how the effects are done. Experienced designers or magicians might have figured out some of the illusions, but I'm not saying a word.

Walk-throughs of the park with art directors and designers were part of the Imagineering team's training. Rolly would usually lead them, telling us stories along the way. In the beginning, I wasn't really clear on who was who on the tours, but to my very young self, they appeared to be a bunch of congenial middle-aged men with lots of Disney experience. It wasn't long before my coworkers filled me in on the fascinating backgrounds and important contributions of Rolly, Wathel Rogers, Mark Miller, Larry Pageott,

Jack Taylor, Bud Martin, and Yale Gracey, just to name a few of the most memorable Imagineers who would join in on tours. It was a thrill to walk the park with men who had walked it with Walt, and a delight to know that it was even more magical at night. Tony Baxter, Eric Jacobson, and others also sometimes joined us on the tours.

As needed, additional designers were assigned to work with us for specific rehabs, and others rotated in and out of short-term field assignments. I was always happy when Leota Toombs Thomas was working with us, because she had great stories to tell. The resident team grew along with our responsibilities. Tom LaDuke, a designer from special effects, joined the team along with Kathy Rogers in coordination and Katie Polk Olson in color and paint.

The year after EPCOT opened, Rolly arranged a trip to Walt Disney World for the entire team, plus many of the original designers and some management people. I will never forget my first glimpse of EPCOT from the Monorail at night, coming around a corner to see the beautifully lit Spaceship Earth in the distance. I fell in love with Walt Disney World then.

One of our jobs was to ride the attractions with the guests. The idea was that designers would have a chance to mingle with them and experience the park from their perspective, and then use that knowledge to improve the design. This was always a favorite task for me, especially the roller coasters. We also took show notes of things that needed fixing and passed them on to maintenance.

Eventually these checklists were formalized and distributed so the ride operators could do them, too. For instance, at the Haunted Mansion, is the key light on the Birthday Girl Audio-Animatronics figure working correctly? Are the ghosts lit and in sync with the vehicles at unload? This was important because the ride operators

rotated among attractions and might not know each scene intimately. Ultimately, the checklists helped ensure the consistency and quality of the shows. Along with operations, we also developed the criteria lists to standardize as much as possible the decision to close an attraction due to a mechanical breakdown (code-named "101").

My first years were a huge learning experience and an invaluable base for the rest of my career. I worked with the electricians and sound techs from the maintenance division and also with the engineering department on the annual attraction rehabs, and provided design guidance as needed in the day-to-day upkeep of the lighting. They were happy to teach me about the attractions, and I was a very willing student. They taught me how to make fireflies for the Blue Bayou in Pirates and then how to install them just right so they would dance and flicker, and how to make the twinkle lights in the trees. I learned about dichroic color filters—specialized coatings on glass used with lights in Small World and in Pirates. I learned how to focus a key light on an Audio-Animatronics figure, creating "free animation" by throwing a shadow in another part of the scene. I learned how flame effects were created. They showed me how a painted backdrop was lit with blue fluorescents and black electrical tape and introduced me to the Broggie Light, a tiny light made at MAPO that lit the moon behind the shack on the Blue Bayou, and countless other things. It was all fascinating, and (still) top secret stuff.

Our projects went from small to huge, from rehabs to show upgrades. We added lights in windows on Main Street, spruced up the treasure scene in Pirates, designed and implemented the Christmas overlay for Country Bear Jamboree, added fiber-optic stars to the down ramp into the Haunted Mansion's graveyard scene, and refurbished some of that ride's older original effects, too. We were involved in

the complete makeover of the Emporium and the Main Street jewelry and clock shop. New projects, too, like the Bengal Barbecue and the Harbour Galley.

I used my Silver Pass to visit Disneyland often with my son. He wanted a job selling popcorn there, and he was also pretty good at figuring out how special effects were done. Sometimes he would go with me when I had to make a quick run over there to see something at night. In those days, we rode scooters around the park during closed hours, and we could also drive our cars into some areas. On one such night, my son was in the car with me and I let him get out while we looked at the newly installed landscape lighting. Bored, he sat down on the pavement, leaned up against the metal railing—and got his head stuck! The maintenance guys figured out how to get him loose, and everybody was a good sport about it.

Part of our team mandate was to develop a better working relationship between the Imagineers and the parks team. My whole first year was mostly a PR campaign and I got to know the maintenance people pretty well. We had mutual respect going and they were always helpful while we were getting input ready for the planned work programs. The area supervisors were really great and did all they could to support our work. Eventually people were willing to vent some frustrations about their jobs and identify some disconnects between WED and the park. They had a lot to say, and one complaint in particular led to a major change.

Every time there was a new attraction or a major rehab that changed out equipment, the designers from WED would be there for the installation and programming and then go off to the next assignment. There was no formal system in place at the time for feedback and follow-up, and there was lots of grumbling about the

WED designers in their ivory tower. They would wait for WED to leave and then go "fix" the attraction. It was nothing that changed the story or the design; it had to do with equipment and systems.

They swapped out equipment and rewired and tailored it for how they could best maintain it, standardizing when they could. We had lots of talks about finding a better way and came up with a proposal that would provide input from the people who had to maintain whatever WED designed. The proposal was implemented, and Disneyland started assigning a maintenance representative to work in Glendale with the project team during the design phase of the major projects. Disneyland operations also sent a representative, and eventually, a joint master-planning team between WED and Disneyland was formed. Of all the good things that we did in those early years, I think that this one thing had the most impact and the most long-lasting benefits.

Walk-throughs at night with the team were especially exciting, and even more so on a night when the park was closed. It was easy to tell that Rolly loved the way the park looked at night and really understood that lighting was key. He would talk about how the Haunted Mansion facade was lit, for example, and I would go searching through the bushes to find the fixtures to learn how it was done. I learned a lot about what a mercury vapor light source does to foliage versus what a metal halide lamp does, and what happens when you put a UV filter into a mercury vapor fixture. (Hint: it's a very distinctive color on a certain spooky large house.) I learned how to spec a narrow-beam sports light fixture powerful enough to light the top of our tallest "mountain." It was a special thrill to have the opportunity to climb to the top of the Matterhorn to

get a bird's-eye view of the park and take some photos of the night lighting.

Especially at night, when things were more relaxed, I learned how things came to be in the beginning of Disneyland from the wonderful designers who had been there! Now I really wish I had kept a journal to record the firsthand accounts; if Rolly was talking, he usually started with "There's a cute story about that." I especially loved the tales where Walt Disney himself played a part.

They described how the Main Street shops and restaurants were built, a lot of them by Studio carpenters, stage electricians, scenic painters, and other movie craftspeople. They said it was really a team effort, drawing lots of talent from the Disney Studios as well as WED. It was thrilling to learn that Rolly was the designer of the Tower of the Four Winds for the 1964–65 World's Fair that I had seen at age fourteen.

Being a show lighting designer, of course I was very interested in how different the park looked at night. I was most enthralled at "magic hour," that time when the sky still has a soft glow and the facade lights and twinkle lights in the trees turn on in anticipation of darkness. It's a great time to take photos when the fading daylight still provides enough ambient glow to illuminate the facades, the points of light from the rim lights outlining the rooflines provide sparkle, and the lit windows provide a warm glow. Every photographer hopes the sky produces one of its legendary West Coast splashes of sunset color for a backdrop to the beautiful scenery.

On days when work got a little tough, I tried to make it to Main Street for magic hour so I could get a refresher dose of pixie dust. I would take off my name tag and just mingle with the guests, waiting to hear exclamations of "The lights!" The whole street would light up, and it never failed that the guests would gasp, ooh, and aah. It still

makes me smile to remember it. On one such occasion, I noticed the themed gas streetlights were not burning. I remembered them from visiting Disneyland in my youth, and in particular from Grad Nite '67. After questioning a few people, I learned that they had been turned off during the 1972 gas crisis about ten years earlier, and just not turned on again. That started my campaign to investigate the current condition of the gas lines, find out if it was feasible and safe to turn the gaslights on again, and then to make it happen—which turned out to be successful. Good thing, too.

All of Southern California was hit with a total power blackout a short time later (December 1982). The emergency generators kicked in for Tomorrowland and the east side of Disneyland. The entire west side—Frontierland and Adventureland—went dark and silent, rides and all. On Main Street, the gas streetlamps were the only source of illumination besides flashlights. I heard from cast members later on that they were so grateful to have that light to evacuate the park.

I didn't get to see that until several hours later, however, since my blackout adventure began in my office, which was behind the Pirates attraction. Both Tom LaDuke and I were working late at our offices when the power went out. We could hear on the radio what was happening in the park. We had flashlights, and we wanted to help. Since Pirates was the nearest attraction, we ran over there to find guests stranded in boats in total darkness in the Blue Bayou. We let the guests know that we were there and made sure that everybody was okay. Next, we let security and operations know where we were. Tom waded in waist-deep water to push the boats to the evacuation point (one of the little scenic houseboats), and I helped the guests step out to the waiting hand of the operations person to walk them out of the building. The guests were amazingly calm, nobody freaking out at all. In fact, it seemed like they were considering it an adventure. I could

hear them loudly singing in the dark, "Yo ho! Yo ho! A pirate's life for me!"

Two years later, in 1984, I got to spend a lot more time with our guests. The cast members went on strike and salaried employees had to run things for a bit over three weeks. I was assigned as a ride operator on Big Thunder Mountain Railroad and trained on all the positions. It was so much fun to interact with the guests, to line them up to load, to dispatch, and to unload them, smiling and laughing. The only thing I didn't like was resetting the attraction when it went down, because I had to walk the track for the whole ride, which is a strenuous hike! Being in the park with guests provided us with invaluable insights, and running attractions provided us with the firsthand experience of what the operations cast members dealt with every day.

·✦·✦·✦·

I have to include at least some of my experiences with sexism in the workplace. The gender mix was overwhelmingly male—not that a few women hadn't made it to positions of authority and responsibility, but there were very few. Some disciplines had no women at all, like special effects, electrical engineering, and sound design. Over time, women would gradually advance into management and creative leadership, but Imagineering was still out of balance.

When I started in the show lighting department, all the lead positions were held by men, most my own age or even younger. It was a fairly large group in the EPCOT years, and women were all assistants, associate designers, secretaries, or clerks. All the lighting designers came from the same theatrical background, almost all of us had master's degrees, and several came from teaching at the university level. Almost none of us had any experience with architectural lighting,

as the crossover between that and theater was practically unknown at the time. You were either an electrical engineer who did lighting layouts for buildings, or you were a theatrical/entertainment lighting designer. Our management held the prevailing opinion that they could teach architectural lighting design to theater folks, but they couldn't easily teach an electrical engineer about story and theater. We all agreed with that.

Life had already taught me several lessons on handling sexism, and some of them were harsh. I'd had to deal with plenty of male aggression, intimidation, and harassment while growing up, and I had learned how to handle it. I grew up in the fifties and sixties when women were not expected to be competing with men but complimenting them. Messaging to young girls was, "Don't appear to be smarter than the boys. Don't show them up. Do the things he likes to do." There were things girls weren't supposed to do just because they were girls. My response to that usually was, "Oh yeah? Watch me." Fortunately, I had the love and support of my parents and family who cheered me on whatever I wanted to do.

I learned a valuable lesson in high school when I was told that I couldn't advance from majorette to drum major in my high school marching band because only boys could be drum majors. I strongly objected and said that if I auditioned and was the best, they had to choose me. I was a timid, quiet person, and I still don't know where I got the guts to say that to teachers—but it worked, and I won the position of drum major. That year the band marched in the San Juan Capistrano parade celebrating the annual return of the swallows, and we won the Sweepstakes Trophy, the first trophy of many. I once had the ambition to be the drum major in college at Ohio State, but their informational brochure stated that only males would be eligible.

I had excellent female role models at the beginning of my theater life. Both my first and my last lighting professors were women. Two very famous female lighting designers worked in the Broadway theaters, and I saw them as role models, too. Jean Rosenthal's *The Magic of Light*, published in 1972, became an inspiration for me.

In college theater, both boys and girls were expected to work backstage, and I had no problem with asking to work in the scene shop instead of the costume shop. I prided myself on being strong enough to carry a sheet of three-quarter-inch plywood all by myself. I could hang lights, climb to the top of a rolling A-frame ladder, use a crescent wrench, and run the table saw. Despite all that, men sometimes did insulting things like grab a hammer out of my hand while I was pounding a nail to do it for me or tell me I shouldn't be loading heavy counterweights into the arbors or pulling the fly system ropes. That was condescending enough, but the personal put-downs were the hardest thing to take. When I didn't look very typically feminine because I was in work jeans, T-shirts, boots, etc., one guy in particular would call me butch. Sometimes a guy would go into bully mode and then say something like, "Oh, now you're going to cry." I would just glare at him, calmly tell him to fuck off, and laugh. I learned to deflect the harassment with humor and my language really went into the gutter. The funny thing is that my true nature is introverted and shy, and acting like a tough theater babe made me feel powerful and in control.

I had met many challenges to my gender, both on the stage and behind the scenes in theater and theme park design. But I had never worked in the all-male, hyper-macho world of construction, where my "Oh yeah? Watch me!" attitude would come in handy.

The New Fantasyland project at Disneyland, scheduled to open in the summer of 1983, was my first experience on a construction site. I

started working on it with Michael Valentino, the lead lighting designer, around 1981. There were only a few women on-site, and most of them were from WDI or Operations. I don't recall a single woman working for a contractor.

Disney had issued strict rules for the construction contractors about the behavior of their workers. Pretty basic: the men had to keep their shirts on, they couldn't talk to or mix with the guests, they couldn't whistle at women, etc. That didn't stop the construction workers from staring at me and other women walking through the site. Sometimes when the work stopped, I'd hear whispered comments, and they'd even drop a hammer now and again just to get my attention. You'd think they were starved for female attention and hadn't just left their wives or girlfriends at home that morning!

In Florida, the men on construction crews harassed me all the time, but in such subtle ways that I felt that I would just have to put up with it. I complained about it in a department meeting once, and the response was blank stares and silence. It was such a blatant negative reaction that it was a quick lesson in "Just shut up," so I did. I learned that women who complained didn't get very far. You risked killing your own career, and not hurting the person you complained about.

When I expressed my frustration about the construction workers to one of the contractor's supervisors, he explained it this way: "When a man walks onto a construction site, it's assumed that he is okay until he fucks up and proves otherwise. When a woman walks onto a construction site, it's assumed she is a fuckup until she proves otherwise." Sometimes the men in WDI upper management weren't any smarter about women.

By contrast, the men I worked with in both Disneyland maintenance and Walt Disney World maintenance were always respectful, helpful, and friendly. If they were occasionally a bit patronizing and overly

protective, I appreciated their good intentions and just gently pushed back. The area supervisors in Disneyland maintenance were especially supportive of our team's work, and really looked out for both Kim Irvine and me in the beginning and then throughout my ten years there.

In the late eighties, I ran smack into the misogyny of the lighting industry when WDI agreed to send a few of us to an entertainment lighting trade show. It seemed a wise and reasonable thing to mingle with other people in the lighting business, and we were excited to have the opportunity. Just walking the floor showed us, though, that it was a very male-dominated field, judging by the scantily clad young women greeting the customers in the exhibitors' booths, some in outfits that were shockingly sexual. There was even a pretty Miss Flexible Connector performing on a six-foot-high platform, doing amazing contortions in a skintight outfit, with several rows deep of men watching, eyes glazed. It gave the other women and me a clear preview of what kind of bias we would encounter.

Manufacturers' reps were eager to sell to Disney, of course. When we entered the booth to look at some lighting equipment, the rep always went directly to the men in our group, shaking their hands and completely ignoring me. This constantly happened in the early days; I'm happy to report that things have changed dramatically over the years, but it still lingers a bit.

A typical Disney project takes two to five years to reach completion, and an entire theme park can stretch out to five to seven years. Once a team is in place, designers are generally tied up for the duration. This tends to limit the opportunities for upward mobility for both men and women, but especially women, mainly because there are fewer of

us to start with. After EPCOT and Tokyo Disneyland opened, layoffs began, and it was brutal. From 1982 to 1984, the company went from approximately four thousand people to four hundred or so. I remember an all-hands meeting where Marty Sklar stood up to give us an inspiring pep talk. He held both arms up as though bestowing a papal blessing and said, "You are the four hundred!" It was over.

When I had traveled up to WDI for what was to be my layoff appointment, I was escorted to a conference room. The assembled executives asked me to stay instead because so many people from Disneyland had called to say how much they needed me. Surprised, I told them I had just interviewed at Universal. They offered me an additional fifty dollars a week to stay and I said, "Yes!" I would have stayed anyway.

The thirty-plus lighting designer group was whittled down to three—John Shipley, Joe Falzetta, and me—and it stayed that way for several years. I happily continued my work at Disneyland for the next six years.

When Imagineering started hiring again a few years later for new projects, John Shipley and Joe Falzetta were the principal lighting designers for the Euro Disneyland (EDL) project, of course. Lighting designers Michael Valentino, Ed Zeigler, and others were rehired, and David Taylor was recruited from teaching at Pepperdine University. Andrea Randall was our manager at the time and was actively hiring more women, too.

Once again, all the lead positions in the department and on the major projects were held by men, and there seemed to be no possibility for advancement. I was pretty sure that the pay of the men I had started with years before had surged way ahead of mine. I needed to find a way to compete for more responsibility and higher pay. Staying on the Disneyland team would be comfortable but wouldn't offer the

opportunities I wanted. I was a senior lighting designer by then, but I was aiming for principal.

Andrea rotated me out of the Disneyland team in the fall of 1989, and I was assigned to be a part-time assistant on EDL, plus a project and a few little rehabs in Florida. I moved back to the Glendale area again and bought a house. As often happens when a park is nearing its opening, I and many others were sent to Paris in December 1991 to help finish the installation and programming of an attraction, and to help where needed. Returning home, I was assigned to work on two projects in a row that were canceled: Tomorrowland 2055 with Pam Rank, then Disney's America with Brian Gale. My big break came with Disney-MGM Studios Europe (DMSE). I was the lead lighting designer for an entire land, with Brian Gale as the principal and lead lighting designer. That project was also canceled after two years of work. It re-emerged several years later as Walt Disney Studios Paris. In between those three lost projects, I designed lighting for Mickey's Toontown Fair at the WDW Magic Kingdom, and for Innoventions and the Imagineering Labs at EPCOT with the creative team that would later go on to develop DisneyQuest. I learned from these experiences that I really wanted to lead a major project team someday. Andrea supported me in my goal.

I requested a meeting with my division director and asked him what I needed to do to become a principal designer. His answer shocked me: "Paula, you will never be a principal."

"Why not?" I asked. He said that I would have to be like Abbey, who had been hired in as a principal from her very successful career in concert tour lighting design. Anybody who knows Abbey and also knows me knows that I could never have the charisma she has.

Being told again that I couldn't do something, I relied on my attitude of *"Watch me!"* I set out to find a way to be a better me so that I could

become a good principal designer. I read lots of self-help books like *Smart Moves for People in Charge, The One-Minute Manager,* and the classic *How to Win Friends and Influence People.* I even read *The Art of the Deal* and learned a thing or two. I read books on construction and I took every class I could on workflow, management, relationships, time management, and anything else that came along. I worked on "managing the perception," and I intended to be ready when an opportunity arose.

I started working with the WDI design team on the Disney Stores, which provided the opportunity to design the lighting for the Disney Store at Caesars Palace in Las Vegas, the concept design for the Disney Store on Fifth Avenue in New York City, and other smaller Disney Regional Entertainment projects. At about this time, David Taylor was taking on the leadership role of the show lighting design team for the new Animal Kingdom project in Florida. He asked me to come on board as an assistant. That brought me to a real crossroads: to be an assistant for another four or five years on a big project or keep leading the small projects and develop a small team. I knew I could learn a lot by working with David, and it would be a great experience. In the end, the choice was easy: I turned down David's offer in favor of developing my leadership skills by managing smaller teams. Soon I had two assistants working on Club Disney with me, and the team grew when we took on the DisneyQuest projects.

After a total of sixteen years at Disney, in the summer of 1996, I was at last promoted to principal show lighting designer. The creative design team that we were working with was beginning to develop the Walt Disney Studios Paris park, and I really wanted that project. Things being what they were, I was not the only lighting designer who wanted the project, and I had to work up the courage to go to management and present my case.

I got the assignment, and I had permission to bring on the lighting designers I wanted. Having got my chance at last, I passed the opportunity along to two other very talented lighting designers. I chose Laura Yates to lead one of the lands, and Tracy Eck to lead the other. Laura had been working with me for several years, and she deserved the opportunity. Tracy had been an assistant lighting designer on the Disneyland Paris project and had stayed on as the resident lighting designer. She had the experience and the talent that we needed, so she joined us and relocated to California with her kids during the design phase.

The rest of the show lighting team consisted of a mix of men and women. I was the first woman to rise through the ranks to be promoted to principal, and the first and still the only woman to be the principal lead on a whole new theme park, Walt Disney Studios Paris.

Tracy was promoted to principal lighting designer and was awarded Lighting Designer of the Year by *Lighting Dimensions* magazine in 2002. As I write this, she is the art director for Disneyland Paris, and Laura is a principal lighting designer at WDI.

Pam Rank was the second woman on a similar path to be promoted to principal lighting designer and has now retired, too. In the "small world" category, Pam and I both were teaching at USC at the same time; she was the assistant tech director running the scene shop, while I was the assistant tech director in lighting.

Walt Disney Studios Paris opened in 2002; it's now 2020, and you'd think things would have changed more than they have. Tokyo DisneySea opened in 2001, Hong Kong Disneyland opened in 2005, and Shanghai Disneyland opened in 2016. All three show lighting teams were led by men. In fact, all of Shanghai's lead show lighting designers were men as well, until Lisa Katz joined later as a senior

lighting designer to take over Mickey Avenue during construction. It's just a matter of time, but how long, who knows?

<hr>

It's commonly said that change is the only constant. I often said that working for Imagineering was like changing jobs without changing companies. John Horny, one of Imagineering's concept artists, drew cartoons across his weekly time sheet, and copies were shared around. One of his favorite recurring themes was "Change is just around the corner." He would draw a guy who looked a lot like him, peeking around a corner, with a baseball bat at the ready, and a cartoon or commentary about what intrigue was going on at the time. His work made us laugh and helped us get through some tough times.

Change came in the form of management shuffles, new project assignments, project cancellations, and company reorganizations. Show lighting was moved from show production to the architecture and engineering division, and back again. People left, and new people arrived. One of the biggest disruptions was relocation to Florida, Paris, Hong Kong, Shanghai, or Tokyo, and even harder, the repatriation home at the end of an assignment. Things would have inevitably changed while we were out on assignment; some people who were hired in while we were gone might treat us as interlopers and rivals when we returned. Readjusting to the culture at WDI and to the United States again was also sometimes disconcerting. I had learned how to adapt through my childhood experiences of frequent moves as an Air Force brat. You learn how to let go and how to adapt quickly to a new environment and new people, all very useful life skills.

My relocations to Paris and Shanghai were exciting adventures that I cherish. I made the most of any free time by exploring Shanghai, traveling as much as I could, and developing lifelong friendships. Single people tended to live in Puxi along West Nanjing Road, where there were lots of restaurants. I invited three other single Imagineers out to dinner so I wouldn't have to eat alone and jokingly called it the Puxi Supper Club. As more people joined us, we set up a dinner out once a month. We didn't have the time to do it anymore once we got to the installation and programming phase of the project, but it was really fun.

Changes also came with rounds of layoffs following the opening of the really big projects. Several Imagineers went on to start new companies like WET Enterprises, Technifex, and many others that now provide fantastic designs for other theme park companies, architectural and public works projects, and live entertainment, including Disney. A group of those companies, plus others in the theme park design world, came together to form the Themed Entertainment Association, now known as the TEA, to promote and support the growing industry.

All of that change was inevitable due to shifts in the culture, technology, and the needs of the company. In the eighties, computers were becoming a viable tool in the workplace, women were rapping on the glass ceiling, and competition in the theme park world was increasing. Very talented people embraced the changes, left Disney, and learned new things. They often brought their knowledge and experience back to Imagineering when opportunities arose to be rehired.

In the slow years between 1984 and 1989, my work went on at Disneyland. I was designing small shop makeovers, scene upgrades in attractions, teaching lighting design, working with design teams on major rehabs of attractions, and lighting new food and merchandise venues. I knew that I needed to learn more about architectural lighting,

so I joined the Illuminating Engineering Society (IES) and signed up for the beginning lighting class.

The local chapter in Orange County met once a month, and I began meeting electrical and illumination engineers, and lighting reps. They were very interested in Disney, and I was interested in steering them toward a greater understanding of lighting as a design element. When they asked me to do a presentation about Disneyland, I saw it as an opportunity to work on my speaking skills. I was given permission by WED to do it, as long as all slides were taken from the guests' point of view. Tony Baxter was recruited to do the presentation with me, and it was well received. Other chapters heard about it and invited me to speak in San Diego; Las Vegas; Washington, D.C.; and New York City. This led to speaking at IES conferences and at the LDI (Lighting Design International, now Live Design International) trade show. I never considered myself a particularly good speaker, but I had a fascinating topic to present and a beautiful slideshow.

LDI published a monthly magazine, *Lighting Dimensions*, and was always hoping to get a story about a Disney project. They came to me about Club Disney, and I pitched it to my manager and WDI communications. We had a long phone conference with the writer, communications, HR, and me about it, and it was approved. It was published as the cover story. There was quite a stir when my lighting coworkers saw it, proclaiming that I was going to be fired—as if I would do it without permission!

There was the same reaction to a story about the Disney Store on Fifth Avenue. I was pleased for the team to be in the spotlight because I knew that it was one of the ways of building a positive reputation and gaining recognition.

When DisneyQuest opened at Walt Disney World in 1998, we were honored with another cover story in *Lighting Dimensions*. Then I was

surprised to be named Lighting Designer of 1997 for Themed Projects at the annual LDI trade show. WDI management was alarmed by the LDI award and I had to explain that I hadn't submitted any drawings or artwork and that I had no idea it was in the works.

My lighting team held together and grew when we made the transition to the Walt Disney Studios Paris project. I had ideas of how a team should be managed, the main one being that we would manage by consensus, and we would standardize. I believed my role was to take care of my team members and provide guidance. We discussed issues and worked them out with agreed-upon actions. I believed that people should not have to sacrifice their family life or their children for their job, so I insisted on reasonable working hours, and that people use their vacation time. My child was grown by then, but Laura and Tracy had young children, as did some of the assistants. We adjusted the work to accommodate absences and it all worked well.

I believed that I could serve the project best by not trying to carry overall project team management while designing an entire land. It was a departure from the norm, but as manager of the team, I was expected to prepare budgets, prepare labor forecasts, estimate equipment costs, fill out reports, attend project managers' team meetings, and provide some level of personnel management. Additionally, I pitched a plan that we should owner-furnish all the theatrical lighting. This would typically have gone to the general contractors, but the onstage theming for Walt Disney Studios included visible theatrical lighting equipment. From experience, I believed we would get a more cost-effective result and a much better creative outcome by managing it ourselves. I proposed that the general contractors install the electrical systems, facility lighting, circuiting, dimmer systems, and fire-safety systems. Then I proposed that the project should directly hire theatrical production companies to provide the theatrical fixtures,

lamps, and accessories, plus the installation and focus crews and the programmers.

They agreed, so the team and I took on the added responsibilities of vendor searches in Europe, working with contracts to pull together the spec books for bids. At the time the Paris project was starting up, DisneyQuest Chicago was being installed, and I was traveling weekly between Glendale and Chicago.

I decided to hire an administrative assistant who could help me stay organized and informed, giving up a spot for an assistant lighting designer. Once again, our manager, Bob Radabaugh, supported my plan, and it turned out to be absolutely worth it. Laura, Tracy, and I divided up the park between us. I took Disney Studio 1 and Rock 'n' Roller Coaster Avec Aerosmith as my two attractions. All three of us had a full-time assistant lighting designer, plus designers we brought in to help meet deadlines. We kept the same arrangement when we moved to Paris for the installation, and on to opening in spring 2002. As usual, we brought over several more people from show lighting to help get the park open. I was very happy with the team, and management said they were happy with every team member and me, too.

After I came home from Paris in the summer of 2002, I was diagnosed with kidney cancer and had radical surgery in the fall. Although it was a very large tumor, the cancer had not spread, but it scared me to death, and I began an intense review of my life, my work, my heart, and my future.

I had a mother who was getting older, a young grandchild, and a son halfway across the country, and I was missing cousins' weekends, summers at the lake, and all the kinds of things that could enhance my life. What I wanted most was time: more flexible time, more time with family, more time to travel, more time to read, and more time to

be me. I wasn't convinced that I would even have much time, or that I would have a retirement before cancer came again to claim me.

While I was debating my future, I designed and installed the lighting for Soarin' at EPCOT, and the complete redo of Space Mountain at Disneyland. I started a project for Disneyland Paris, but I handed it over to Tracy because I had made a decision.

I reached my twenty-fifth anniversary in June 2005, and a few months later I volunteered to retire. I was able to take advantage of layoff benefits since there was another round in progress; I probably saved someone else's job. Management let me choose my departure date and when to announce it to my fellow lighting designers and Imagineers. I told them three months in advance so I would have time to hand over my projects, finish and post documentation, and slowly cull twenty-five years of my office files. When I was done on January 6, 2006, I had boxes of mementos, a big collection of name tags and hard hats, and boxes of project swag. I also had tons of photos, years of great memories, and lifelong friends.

I sold my house and moved from California, splitting my time between my lake house in Wisconsin and my winter place in Arizona. Leaving Imagineering was one of the hardest things I've ever done. If I wasn't Disney, then who was I? I was determined to find out. I could visit the parks and enjoy being a guest. But then?

I did take on some consulting design work after my formal retirement from Disney, including going back to work for WDI in 2012 and relocating to China for the construction of Shanghai Disneyland, repatriating three and a half years later. A few months after that, I went to Dubai for over three months to help Pat Gallegos with the final lighting focus and programming of the Motiongate theme park. Small world again: Pat and I were in the same WED orientation class in 1980. The DreamWorks Building at Motiongate received the

Illuminating Engineering Society Award of Excellence in 2019. These days, in semiretirement, I direct my energies toward mentoring the next generation by being active in the Electronic Theatre Controls, Inc.–sponsored Fred Foster Student Mentorship Program and taking on small projects—and lighting a play now and again.

My friends and family got used to me taking off so often that now they ask, "Are you really retired yet? Are you done now?" I guess I won't be done until no one hires me. After all, I never stopped being a lighting designer, because that's who I am, in my heart and soul. My friends and family say I failed retirement, and I respond with a joke that goes like this: Lighting designers don't really retire, they just fade out.

Elisabete (Eli) Minceff Erlandson
Principal Concept Architect

One Smart Woman, and Three Idiots

Thoughts of the past flooded my mind as I drove from my small apartment in Hollywood to my interview at WED Enterprises. It had been ten years since I had immigrated to the USA. I did not know English back then—and now I was driving toward a goal I had set for myself as a child.

I grew up in Brazil. As a child, I equated the name Walt Disney with a lovely homemade doll handcrafted by my Chinese Russian neighbor. The doll had a red dress with black polka dots. I was told her name was Minnie Mouse. I received her as a gift before Disneyland existed. In 1960, family friends flew from São Paulo to Los Angeles and brought back color slides of the new Disney park. These slides made me love that homemade Minnie even more and inaugurated a lifelong interest in everything that carried the name Walt Disney.

When I was nearly twelve, a new immigrant to America, I told my parents that my goal was to work for Walt Disney someday. At twenty-two, I was taking a big step toward that goal, but the path had taken some unexpected twists and turns.

I was born and raised in Brazil to Bulgarian parents who had met while studying at the University of Vienna. The two young newlyweds (my dad was an electrical engineering student going for his PhD, and my mom was studying medicine) fled Europe while they were still students. Their parents told them not to return to their country, which had transformed from a constitutional monarchy to a communist regime. They advised their kids to try to survive outside Bulgaria. My parents' goal was to live in the USA, but new immigrants were not being accepted. So my folks and many of their friends from university went to Brazil, where the country was welcoming young professionals with open arms.

Eighteen years later, my parents immigrated to the USA with their two young Brazilian-born daughters. English was not one of the languages we already knew (we spoke German, Russian, Portuguese, and Bulgarian). But we learned English fast. There was no option.

In the USA, I was determined to study art. My spare time in childhood was spent mostly in artistic endeavors such as drawing, painting, sculpture, and inventing new environments for animals and people in my imaginary world. Unfortunately, my parents did not approve of my plan. It was acceptable in child's play, but not as a profession. In their old-fashioned European way, they truly believed that a career in art would only bring pain and heartaches, especially for a woman. Out of respect for them, I did not rebel or disagree.

The years continued with me producing my private art; I expanded my endeavors to poetry and short stories. In school I excelled in math, sciences, literature, languages, and the history of art and architecture.

Set on finding a solution to my dilemma of "art is forbidden as a profession," I chose to study architecture. Intertwining the sciences with design and art, I considered it a solution to my problem. My parents approved, and I never regretted it.

On my graduation day from the University of Southern California with a bachelor of science in architecture, my father handed me my graduation present: an envelope. Inside was an application to WED Enterprises. What was WED? In 1975, it was a little-known place secretly located in an industrial area of Glendale. It was so secret that the location did not even have a sign on the building. My father had spent a good portion of a year speaking with various people to discover the existence of WED, and he obtained this application for me. I was deeply touched.

As I walked through the front doors of WED Enterprises for my interview with Bill Martin, I told myself to stop thinking of the past and concentrate on what I was about to do. I mentally reinforced myself by noting in my head: I speak seven languages (I had added not only English but also French and some Italian); I have an architectural degree; I can do all kinds of art, and I am willing to learn a lot more. Four decades later, I still remember what I was wearing and the black portfolio I carried with pages showing my architectural design studio work as well as some of my personal art. I also vividly remember Bill Martin's handshake and the warmth of his character shining through his large bespectacled blue eyes. He made me feel at ease, as if we had known each other for a while.

The interview was long, and it became even longer when Bill invited a diverse group of Imagineers to meet me. Among them were Claude Coats, Marc Davis, X Atencio, John Zovich, George Windrom, and Dave Jacobs. I wish I could remember all who were there. The office was full of men standing and asking me questions while looking at my

work. We barely had any elbow room, let alone space to turn. Many handshakes later, coupled with a "We will call you with our decision," I left the office feeling that it had gone well, maybe. Weeks passed without hearing from WED. I decided to look for another job; my rent was soon due again. A few weeks after accepting a new job at a construction company, I received *the* call! Fortunately, I had forewarned my new employer. I was waiting to hear from Disney, and if they hired me, I would go there.

My first assigned location at WED was the architectural drafting room, a sea of drafting tables with many men and one woman. She and I forged a friendship that lasted for years. Her name was Zaira Tugan. She was twice my age, also an immigrant, very hard-working, and unrelenting in a "man's field." She was an engineer by training, not an architect.

I was the youngest person there and definitely the most inexperienced and very eager to learn. Eventually they jokingly called me the "token woman" in architecture. I didn't care. I thought of myself as a professional, and that battle was not one I wanted or felt I needed to fight.

The first memorable stumbling block on my path to being an architect did not happen at WED. In my second year of architectural school, I had a professor who refused to give me an A, even when it was well deserved. I asked him why he did not accept my hard work when it was as good as the other students who had received A's.

His answer was cold and simple: "I do not believe women belong in architecture." I was not ready for that response, and my stunned face, without a response, probably amused him; but I was not going to give him the pleasure of showing him any tears. I was only nineteen and had

never met anyone who blatantly wanted to smash someone's dream. This was long before the time women were given legal protections against such behavior. Young, innocent, and heartbroken, I was able to hold my tears until I got home.

My father asked what was wrong. I told him. He leaned against the wall, became seriously pensive, and then blurted out, "So? You just met your first idiot! Don't let that stop you!" I looked at him and laughed through my tears. This was an unexpected statement coming from a highly educated and very cultured, soft-spoken man. I had never heard him speak like that before. With that in mind, I continued on my chosen path, even though the "idiot" refused to give me my well-deserved A. I certainly never took a class with that idiot again!

The second memorable obstacle was in my first year at WED; it came from a man whose professional contributions to the company were far beyond my own. He was a man I looked up to, recognizing my own lack of experience at the start of my career. While working at my desk, he would approach from behind, lean over, and whisper in my ear. I could feel his breath while he spoke. His suggestions were shocking, still would be today. It became such an uncomfortable situation that the pleasure of coming to work disappeared—and I even considered leaving the company.

Today women can go to the personnel department and file a complaint. That was not the case then. He was considered a leader, and I was the new, naive young woman, inexperienced in her profession. I told no one. I did not want to leave, and I could hear my gentle father in my head, saying, "You just met your second idiot. Solve it!" The thought of leaving WED and all the amazingly talented individuals, the incredibly energetic environment, and the renaissance occurring there was not the solution.

I requested a transfer to the show set design department. The reason given: for personal and professional growth. What an unexpectedly great move that was. George Windrom was the manager, and he warmly accepted me into his small team (Jack Schilder, Brock Thoman, Randy Carter, Walt Green, John Kasperowicz, Joe Lucky, and Ed Barron). We worked hard, we played and joked often, and our friendships lasted decades. Those were some of the happiest years of my professional life. Lesson learned: have the courage to divert ugly situations to an alternate path.

※ ※ ※

While working, I learned quickly that I needed to be careful about whom to trust with questions and concerns. Some used these as excuses to diminish my value; others appreciated my eagerness to learn and were happy to contribute to my education. The talented people around me in architecture and show set design gladly shared their own expertise by showing me what they were doing and how they were doing it. My thematic design learning curve became exponential. Among the men in architecture, those who openly shared their craft were David Ott, Ron Bowman, Stan Yukowicz, George Terpatzi, Mac MacElravey, Joe Navarro, Glenn Durflinger, and others.

Another architect, Jacques Valin, was also among them. His fiery gaze with large, bloodshot blue eyes behind thick lenses, and his deep, dark introspection on any subject defined him as "darkly different." He was an architect with a passion for painting townscapes. I loved chatting with him. His viewpoints reflected his French cultural background, plus we chatted in French. I understood his extreme frustration about being an architect when he wanted to be a painter full-time and saw how it reflected in his sarcasm and demeanor. He made me wonder:

Will I be the same at his age? Bitter about not having painted enough? I hoped not. I also hoped I would be able to abandon my new fear of being an artist when surrounded by the best full-time artists I had ever seen and known. My answer came years later.

In the meantime, I was soaking in the knowledge and experience around me. I was like a thirsty bottomless well of learning. Others outside architecture who also helped me were Harper Goff, Herbie Ryman, John Hench, X Atencio, Marc Davis, Claude Coats, Jack Martin Smith, and other highly accomplished individuals. They made me feel a part of the WDI family and impressed me with their humble demeanor when sharing things with me.

My path also crossed with near-contemporaries like Wing Chao. Wing and I often shared the large layout tables in the drafting room, working on separate projects but sharing what we were doing and exchanging general ideas. We developed an easy friendship based on mutual respect and appreciation, which served us well in our separate careers at Disney.

WDI was a "hallway culture" where people often stopped to chat with one another. Many project ideas were born that way, many problems were solved, and ideas were shared openly and flowed freely. In the digital age, information is shared in seconds. Back then, walking the hallways, observing someone at work, and talking to them gave us a chance to share more than just project-related information. It gave us a bond, a network, and an informal, low-stakes place to take problems and find solutions.

As a show set designer, I had the incredible good fortune of being assigned to Harper Goff, who was in the process of designing the

World Showcase for EPCOT. I was concurrently assigned to Jack Martin Smith, who was designing the Universe of Energy Pavilion for Future World. Both men were accomplished professionals, though very different. I felt privileged to work with them.

Harper Goff's big idea was to create pavilions for different countries around a large lagoon. He was in the process of having a large model built and needed designs for the different countries to be showcased around the lagoon. As a first assignment, Harper gave me free rein to design the (unrealized) Israel Pavilion. He taught me how to hand-draw 3-D aerial views as we went along. In those early years, Harper assigned many of these countries to me, and my concepts were constructed into that first model.

The World Showcase model was a work of art, built by a small and very talented crew of dimensional designers. It was also painted to perfection. When the model was completed, there was a photo shoot. Harper asked me to stand beside him while he scrutinized the model. He complimented the team. The air was filled with satisfaction. We knew we all had done our best, and it looked great.

After the first couple of photos were shot, he turned to me and asked me quietly if I noticed anything was missing. I said, "No, it looks beautiful." Then he said loudly, "Stop shooting! Bring me some salt." Salt? Really! Was this a superstition, a WED ritual we were about to witness?

With saltshaker in hand, Harper leaned over the model, creating perfect miniature white wakes on the lake surface behind each tiny boat. It was so realistic that the boats looked like they were sailing forward on the green-blue lagoon! Another lesson learned. I noted to myself that every detail counts, no matter how small.

At the same time, I was working on the Energy Pavilion with Jack Martin Smith. I dove into the research on the future of energy and on

the most recent development of photovoltaic cells. I designed an entry statement for the pavilion: a huge sun-tracking parabolic dish. It had a diagonal, extendable arm to track the various angles of the sun daily and traveled horizontally on a large circular rail to follow the sun's position in every season. It was designed to provide power to parts of the pavilion, including the show—a new idea in the 1970s—and it was also an impressive sculptural statement.

Solar power—and panels that tracked the sun—soon would become a bright idea internationally, though not on the immense scale of my parabolic dish that tracked the sun. My design, which had seemed so forward-thinking and new, never made it to EPCOT. In Future World, we had a difficult problem to solve: the ideas of the future would quickly look like the present once they were finally built.

As part of the EPCOT team, I was surprised to be invited to attend "blue sky" work sessions on Spaceship Earth and listen to Ray Bradbury, Marty Sklar, Gordon Cooper (the astronaut), John De Cuir Jr., and others in numerous story sessions developing show ideas. Why me? Someone had seen, propped in my cubicle, the storyboards with the research I had done for various World Showcase pavilions—and liked my penmanship under the images. What luck!

I sat listening to the masters of storytelling and adventures and dutifully wrote the index cards that would define the story points and ideas for the Spaceship Earth attraction, while Claudio Mazzoli and Jono Liem were creating beautiful, large artwork visualizing the stories. What a great way to learn the creative process. What an environment. The conference room where these sessions took place was a slice of perfect magic and a symbol of the renaissance occurring within those old warehouse walls, unbeknownst to the world outside.

I was already wallowing in happiness when, out of the blue, I was given a chance to design a solution for the core of EPCOT. I presented an idea, keeping in mind our mandate to think beyond the present, and made a model of it. Even today, the technology to build it has not arrived. I had learned in that Spaceship Earth conference room it is acceptable to dream and design buildings that go beyond the known. Big lesson learned: accepting small assignments and doing your very best, even when it does not make sense for your professional goals, can lead to much larger, unexpected things.

In the 1970s, it was customary to take exams to attain an architectural license after getting a degree and working three years in the field. I applied and found out that my work at WED would not be accepted, because the company was not owned or run by an architect. Disney wrote to the board, to no avail. I had to decide whether to stay at WED and give up the dream (and benefits) of becoming a licensed architect, or go somewhere else to get my work credits.

I left WED with the intent of returning within three years, architectural license in hand. I had not imagined one thing: having great fun working in a small architectural firm, designing and building themed restaurants throughout North America. I was well appreciated by the owner, Gene Miles (a Texan), who eventually asked me if I would consider becoming his business partner. During my job interview, he loved my portfolio and my presentation of it, but then he bluntly said with his Texas drawl that he could not hire any women. I responded, "I am not any woman!" and got the job. I did become a licensed architect and spent eight years working as his "right-hand man" from initial client contracts through construction. But then I received calls from

Eric Westin and Joel Trinast asking me to return to WED and help out the team designing the new Disneyland that would be in Paris, France. Tori McCullough, an old friend from the early days, pitched in on the phone calls to entice me back. They succeeded. It was time to return to the place I loved.

✧✦✧

Eric Westin was unique, open, and knowledgeable. He understood many professions and what was needed to pull them together into a team. He also had the gift of persuasion. He managed to achieve what I told him would be impossible: he convinced my husband, Ed Erlandson, to leave his own hard-earned small but successful architectural firm and join the Disney team.

At the end of 1987, we were heading to France with our young son. The relocation process started, and we jokingly were called the "guinea pigs" for two reasons. It would be the first time a husband and wife team would work together on the same project, in parallel positions—and the company had not yet devised an international relocation policy to help us settle in France.

Along with Carolyn Bouazouni, a WDI mechanical engineer, and her small family, we were relocated a full year ahead of any reinforcements to work with all the consultants and the construction management firm that was paired with Disney to make this project happen. We made a daily Herculean effort in our work, our marriage survived, and Ed and our son, Michael, became very proficient in the French language. In that first year, we also overcame a slew of difficulties settling into the country without much help from the company. We were both working full-time and overtime while we had our little son, who needed to be placed in a school,

to be driven there daily, and to have trustworthy after-school care before we got home. I was told by a project leader to deal with this quietly and not let many know I had a son, since that would hinder my professional credibility. If I had not known French, the arrangements for my son and our lives in France would have been impossible. The hardships we went through that first year helped the company devise the new overseas relocation policy for all the relocatees who would come later.

Marty Sklar kept in close touch with those of us in the vanguard. The project benefited greatly when he paired up with Mickey Steinberg, who became our staunch ally in France. He understood that quality could not be ignored in favor of cost and schedule. It was a delicate balance.

If I had not had the experience outside Disney on working drawings, on contracts, and in construction, I would have had a hard time surviving. Had we not had Mickey Steinberg redefining the structure of the project and everyone's roles in it, we would have failed.

During my years at WED/WDI, I worked on World Showcase and other projects at EPCOT, Disneyland Paris, Tokyo Disneyland, Walt Disney Studios Paris, Magic Kingdom, Disney-MGM Studios (now Disney's Hollywood Studios) in Florida, Disney's Animal Kingdom, Hong Kong Disneyland, Shanghai Disneyland, and on expansions to parks already open and running. My husband and I were very fortunate that when we were both employees at WDI, we were always busy and never had to endure the pain of the lull between projects as did some of our colleagues.

Ed and I were often working on different parks—I might have a project in Florida as he would have one in Tokyo, and then vice versa—but we had an agreement: we would not relocate separately. Instead, we took many business trips to our separate project locations. In the three decades we were at WDI, we can declare that half of those years were spent on international relocations or on business trips.

But this life can be very tough on the nuclear family. Trying to do our best on all fronts, we survived as a family, and we are proud of the man our son, Michael, has become. We know he endured more difficulties than he would have if we had always remained close to the home office and grandparents, aunts, uncles, and cousins. My life as a working mother and spouse would have been simpler, too, with the help of family. However, the extended families, and some friends, had a wonderful time coming to vacations at almost all the locations we were sent to. Through thick and thin, everything in life balances itself out, one way or another.

During a most gratifying and productive time being concept and project architect on the African village for Disney's Animal Kingdom, the entire park project was put on hold indefinitely. That was a blow for all the land's teams, but it held a double blow for me.

My superior at that time was intent on building a staff that only created digital working drawings. He had no use for architectural designers. He believed architects did not need to be creative. When he called me into his office, I thought he was going to put me on a computer-aided design (CAD) training program while the project was on hold.

After a brief hello, he told me I was too creative. If it was a compliment, it did not sound like one. (Too creative? After all, I worked in a creative company.) I stayed silent, wondering where this was going. He proceeded: since the Animal Kingdom Park was on hold, I would have more time to be a wife and mother, which, he added, I should have been doing in the first place.

I told him I looked forward to getting some CAD classes, and he said okay. Confused, I left his office. What had just happened? Should I request a leave of absence for CAD classes while the project was on hold? Would Disney keep me on full-time pay while I got training?

Within the hour, I realized that, besides his inappropriate comments about my life as a wife and mother, the man did not have the guts to tell me to my face that he was laying me off. That reality hit me again later that day when I received a call from the human resources department informing me what the next steps would be. I had an explosion of feelings inside—shock, surprise, anger, disgust, grief. To calm myself, I remembered my father's advice to me decades ago, and this went through my mind: *So, I just met the third idiot in my life.* I was again determined to make it work for me, not against me.

Soon after he laid me off, this guy was laid off. Later I also found out through a friend and colleague that one of the Africa team members wrote an unexpected letter to the company and resigned. Apparently, he said he did not want to continue working in a company where a competent professional would be terminated as I had been. I am grateful for his courage and professional integrity. I had no idea this happened until years later!

I am also grateful to Marty Sklar and Peggy Van Pelt, who asked me to consider transferring to the creative division and staying. Even though I was extremely tempted by their offer, I decided to leave because

I would most probably not be working on architectural projects, where I knew I belonged. There was no concept architecture in the creative division at that time.

⋆ ✦ ⋆

The very day I stepped out the door at WDI, Universal Studios Hollywood called and offered me a job. Many past WDI employees were on the Islands of Adventure project in Florida, some in high positions, and they knew me. After almost a whole year with them, I quit and became a consultant. Universal and Disney became my clients. I signed confidentiality agreements with both firms; this was unusual but easy. Just keep your mouth shut and do your work. Both companies knew and trusted my professional integrity.

More than a year into my own business, WDI managed to pull me into design work for a second park in Paris, using all my time. This was opportune: Universal's work had dwindled in California as their project had moved to Florida. I was offered an office and architectural design responsibilities on three-quarters of the Walt Disney Studios Paris park. Eventually, I rejoined WDI as an employee, this time as a concept architect in the creative division. Apparently, since I had left, the company had created a concept architecture position within the creative division. Five other individuals who had been in architecture and landscape design were also transferred: Joe Kilanowsky, Coulter Winn, Becky Bishop, John Sorensen, and John Shields. I noted that the six of us were not only creative but also very experienced, could carry projects from early concepts all the way through the end of construction, and had done so multiple times before.

⋆ ✦ ⋆

In a creative organization like WDI, there are many great minds, talents, and experts in various fields. My career has been in projects all over the world, not in departmental management.

When in projects, at the initial concept stages someone may have a great idea, but it will remain only an idea until it is realized by the combined efforts of a team. A team that recognizes and respects all the talents and expertise of its individuals is a team that is fun to work with. That team will most definitely achieve a successful conclusion to a project and feel proud of it.

In reality, not every team is ideally composed. Sometimes egos and personal agendas get in the way. In those cases, the collective "we" makes for a miserable experience even though we still manage to produce our best to the end.

I have experienced both types of teams and can attest to the great joy of the selfless team, and the misery of working in a team where egos and agendas were interfering with the actual work. I persevered no matter the odds against me. The ego problem will continue to happen because it is inherent in human nature (and stronger in some humans than in others). Nevertheless, I have noticed through the years that some of the biggest egos—those who felt they deserved much acclaim and made life difficult and miserable for the rest of us—are also those who did not stay at WDI. The biggest egos of all leave the company, disgusted by the "we" mentality of an Imagineering team, believing they are the only ones talented enough or intelligent enough to understand the real issues. They ultimately feel under-appreciated and misunderstood; they cannot stand residing in the "we" mentality.

Everyone hired at WDI is talented and, in time, also becomes quite experienced. A healthy respect for others is cultivated when we awaken to the fact that we are surrounded by other high-caliber

professionals who are as proficient in their fields as we are in our own. It was a wonderful journey for me, with all its ups and downs; I know I contributed a lot, and I learned a lot. It is incredibly fun to know that each project will offer different learning experiences. No two projects are the same, except that all demand excellence, flexibility, and accountability. Of the three requirements, flexibility is the crucial one; without it, you can't last. As a designer, I can say "I" did this or "I" did that, but underlying such a claim is the knowledge that designs are like ideas. Designs do not survive unless they are realized by the combined efforts of a flexible team, and designs are enhanced by the contributions of that same team. Ultimately, it is the team's achievement.

The Walt Disney Studios in Paris (DSP) was a difficult project in that it was minimally staffed and had a small budget and a tight schedule, making it tough to achieve the quality we always strived for. The company's attention and funding were centered on the grand project for Japan: Tokyo DisneySea (TDS).

WDI's creative leader, Marty Sklar, was on a site walk-through with a few members of the team when we finally finished DSP, before Opening Day. He asked me, "Which building in this park, of all of the ones you designed, do you like the best?" I had difficulty answering him, since I had designed so many, and each had presented diverse and difficult challenges to overcome. I wondered if it was a trick question. I glanced over to Tom Fitzgerald and Paul Osterhout, who were the executive creative leads of the project. Why was I being asked such a question on a project that posed so many limitations to design? Our potential had not been tapped to its fullest, our creativity limited.

I gave a vague answer and was uncomfortable. Ever sensitive to people's reactions, Marty told us that he liked best the art deco restaurant. He looked me straight in the eyes and said I did a very good job, and we knew he was not talking about one building or a single restaurant. It was good to hear this from a man who never gave out empty compliments.

⁘✦✦✦⁘

What a wonderful, exhilarating run I had from 1975 to 2016. Through the years, I noted that the company became more inclusive. When I first applied in 1975, they responded to the new "inclusion laws" to include women and minorities in positions always held by men. With light brown hair and blue eyes, I was amused that I was legally ranked a "minority," being from Brazil and also a woman. I can't help thinking that having grown up on a different continent with a very diverse group of individuals from around the world had made me a prime candidate for the many work relocations I was sent on. When working on overseas projects, I was very conscious of the fact that we were not only representing The Walt Disney Company with its goals and ideals, but also the country, as Americans in a foreign environment. We were ambassadors.

As a kid, I naturally assumed everyone's household was a multi-lingual United Nations. In Brazil, our home was always filled with friends who came from everywhere and anywhere, and among them were intellectuals, engineers, scientists, entrepreneurs, artists, and musicians. My parents welcomed everyone for casual weekly gatherings. The house was filled with smoke from their cigarettes and loud with American big band jazz music and heated discussions about events around the world. Besides Europeans and displaced

Jews from everywhere, my parents also befriended local Brazilians, Chinese Russians, Indians, and Japanese. The Chinese Russians were third-generation Russians from Shanghai, and some were from Hong Kong. The Shanghai folks ended up in Brazil when the Communists won the civil war and expelled all foreigners.

It was fun to have friends who were blond with green eyes and spoke Mandarin as their mother tongue. In any one gathering, there could be eight languages concurrently spoken—and that tradition continued for us in the United States.

The world is still learning that people of different backgrounds, color, and ethnicity add value. I was very open and accepting of every individual based on their value as human beings, not based on race or on cultural background. It made a difference in how I dealt with work.

Through the years, I traveled to Canada, France, Hong Kong, England, Spain, Italy, Japan, and China to review the work done by consultants. I also traveled to Africa, England, Spain, Germany, the Netherlands, Norway, and within the USA, researching different projects. I always respected the people I met, no matter where I was.

Late in my career, I came to the realization that I should have spoken openly about my achievements, especially on the projects I worked on overseas. Because of my upbringing, I had an aversion to "tooting my own horn" and did not appreciate those who did it for themselves. I did not realize that by working on overseas projects, I would not be recognized for work well done in the same manner as the staff members who remained at home and who were more visible (and verbose) about their achievements. It was naive of me.

I came to the full and very clear realization about this in 2014 when I received the Walt Disney Imagineering Environmental Design and Engineering Quality Award. It was "presented in recognition of team achievement of extraordinary quality in its deliverables." I was being recognized for excelling in my job responsibilities as lead concept and project architect on a job being produced in the home office: the Disneyland Paris Ratatouille project. I estimated the work to be done and orchestrated a team of architectural concept designers and technical detailers who produced the required architectural drawings to be sent to Paris for construction, defining the character of all the buildings and the collective environment these created.

I was pleased to receive the prize, but wondered why for this particular project? This accomplishment was nothing more than doing my job as I always did, and even simpler than some overseas projects from decades earlier. That is when I came to the realization that the team at home were not aware, had not even a clue, of what I had accomplished on Disney projects overseas.

The message here is do not hesitate to "toot your own horn"; do it tastefully and with a sense of humor, which goes a long way.

Culture Clash

I was raised in an old-world European family, and our disagreements were presented in soft-spoken tones, all views were discussed, voices were never raised, and agreements were reached. I assumed everyone would be like that.

I learned late in my career the value of adopting one particular American cultural attribute: the uniquely American way of openly speaking about what is on your mind—even when it is contrary to

the project leaders' views and contrary to your perceived acceptable behaviors as an individual.

As an immigrant, I had it ingrained in me to consider any pushback a disrespectful display toward, and lack of confidence in, the leadership. I was too diplomatic, not American enough, and I earned the reputation of being "nice." It is not necessarily a bad thing, but I did not like it. I later noted that my "nice" demeanor was also a disservice to those who would have benefited from hearing "a piece of my mind" to improve their understanding of the issues. When I returned to the company as a licensed architect with a lot of outside experience, I was more comfortable with the power of speaking up, and speaking to those who might have influence. I fought for better schedules and bigger budgets, and I fought to bring on people I knew would do a good job on an assignment, adding value to the project. I found my voice and greater success.

Overall Impressions

Clutching that Minnie doll back in Brazil when I was a little girl, I could never have imagined the evolution and scope of my unforgettably fulfilling life's journey. Even though long hours and too much work-related travel did take a toll on our personal life as a family, our son benefited from being a child of Disney employees. He was included in our travels and the fun events organized by the company for the employees and their families. Thanks to relocation to France, our nuclear family of three speaks French with one another when we feel like it, and also with our extended families in France and Belgium. Thanks to all the work done overseas, we have friends in countries throughout the world.

When our son was growing up, we asked him, "What do you want to be when you grow up?" He did not hesitate one second: "Not an architect, you guys work too hard!" It's true, we did—but it was an E ticket ride, and he understood that. As a sidenote, he is not an architect, but like his parents, he works hard at what he does.

Would I do this again? Most definitely I would!

Would I do it differently? Yes—only a fool would not apply lessons learned, both professionally and personally.

What am I most grateful for? At the very top of the long list are Ed, my husband; and our son, Michael. My husband always has encouraged me to do my very best fearlessly (which also helped me get rid of my fear of being an artist). And Michael made an effort to understand his parents' crazy journeys and never complained when it was not easy on him.

I am grateful that I took advantage of the generous perks the Walt Disney Company provided. I took refresher courses in some languages, and art classes at the ArtCenter College of Design in Pasadena, California, paid for by Disney. Another plus was working on projects that required extensive research. While working on "blue sky" designs for the unrealized Space Pavilion at EPCOT, our small team had a private tour of of the Jet Propulsion Laboratory (JPL), also in Pasadena, to learn more about space travel. It was during the development of the Mars Perseverance rover, and we learned a lot. We were also given an unexpected privilege: the team's signatures ended up on the computer files that went to Mars, along with other records about humanity. I can say that thanks to Disney and JPL, my signature is on Mars!

Then there is the research required to build environments that are true to the locales they portray. Thanks to Joe Rohde's creative vision and serious interest in creating authentic environments, Animal Kingdom's

design teams traveled to Asia and Africa to learn and see. He knew that this type of in-person research would create the best designs for the park, and that was an unforgettable experience.

I retired in 2014 from WDI, but continued working on WDI projects until 2016 as a consultant. I would have worked longer, but my mother was diagnosed with aggressive terminal cancer. I chose to spend more time with her. She was a smart, strong-willed, fearless woman of few words. Before she passed on, she verbalized to me that she regretted not letting me study art. She said she loved my art. I knew she did; we knew how to read each other without words. My answer to her was to remind her I have had a fabulous career as an architect, and now I was switching careers to be a full-time artist.

I never was bitter or regretful about what I was doing. It is worthwhile to note that it helped my morale to have my husband's full support on anything I ever wanted to do. I made the choices. At this point, I could not help but think of my old friend, the architect Jacques Valin, who finally did become a full-time artist, fulfilling his lifelong dream. Jacques told me his wife is the one who helped him make the transition, and he was forever grateful to her.

I wrote this foremost for Michael, his wife, and our grandchildren, with a grateful heart recognizing them as a crucial part of our life. I also wrote this to record a period in time when women were not considered equal, especially in professions considered "a man's field." Having persevered and been successful when the odds were difficult has made it all worthwhile, and I hope it opens more doors for those who follow similar footsteps.

I thank all the men and women who helped me along this great journey; a list of these individuals would be longer than this entire book.

Finally, one of my favorite quotes which guides me on life's journey:

The beginning of wisdom is: Acquire wisdom;
and with all your acquiring, get understanding.
Proverbs 4:7

Women of Walt Disney Imagineering

MAGGIE — Part of the Magic
KAREN — Part of the Magic
BECKY — Part of the Magic
TORI — Part of the Magic
PEGGIE — Part of the Magic
PAULA — Part of the Magic
PAM — Part of the Magic
ELI — Part of the Magic
KATIE — Part of the Magic
JULIE — Part of the Magic
LYNNE — Part of the Magic
KATHY — Part of the Magic

Maggie Irvine Elliott
Senior Vice President, Creative Development Administration

My first workspace, a four-by-eight sheet of plywood in the Model Shop with Leota Toombs (left), circa 1968.

The start of a wonderful career: painting Disney character cutouts under the art direction of X Atencio, mid-1970s.

My favorite pencil sketch of me by my godfather, Herb Ryman, 1954.

Sketch by John Horny of Marty Sklar and me in front of the overall EPCOT Center model, late 1970s.

I love painting models! This is Figaro, for Pinocchio at the Magic Kingdom WDW.

One of many after-hours talks with Marty Sklar reviewing World Showcase model progress, late 1970s.

A WDI chili cook-off, with senior staff as judges. The chili and the afternoon were hot! Marty Sklar and I sharing a laugh and a beer.

My mother and my nine siblings at the Disney Legends award ceremony honoring my father, Dick Irvine, 1990.

Elisabete (Eli) Minceff Erlandson

Principal Concept Architect

1975–76 at WED, drawing freehand elevations with a thin felt-tip pen for a presentation to OLC in Tokyo.

Ratatouille, Paris: Freehand elevation (black felt-tip and colored pencils) drawn at a meeting with Pixar to explain ideas for the restaurant (2011).

WDW, Magic Kingdom FL, 2009: partial view of a rendering for Aurora's Cottage as an idea for a queue entry design (colored pencils and markers).

1993 sketches for the Animal Kingdom safari queue on what was for years my favorite paper for design sketches: thin yellow trace paper.

My son Michael and I, 1983. In a few years he would be attending a local French school while we worked on Disneyland Paris.

2002–2003: in my office at the HKDL construction site, reviewing countless shop drawings with my infamous red pen.

A big plus of being relocated is travel during short holidays. My husband, Ed, and I went to Myanmar (Burma) with fellow Imagineers (behind us in another horse-drawn cart).

Honing my freehand drawing skills at a WDI after-hours life study workshop, 2008: pastel sketch of a 20-minute pose.

After inspecting the pre-manufactured GFRC (glass fiber reinforced concrete) installations on the Shanghai DL Castle, 2016.

Honored to receive the Annual WDI ED&E Quality Award for Ratatouille at Disney Studios Paris!

Peggie Fariss

Executive, Creative Development

It's official! My first Disneyland ID, 2/26/66. Never dreamed it would be the start of a fifty-year career!

Scaffolding on Cinderella Castle, hard hat in hand. I'm the only woman on this WDW Orientation Tour, summer 1971.

Celebrating the successful press conference announcing Phase One of Walt Disney World. I'm on the left, bottom row. Ocoee, FL, April 1969.

A magical moment for me with Disney Legends Ollie Johnston (left) and Frank Thomas (right) signing their art at the Disney Gallery, Disneyland, circa 1988.

My beautiful 50-Year Service Award and three of the four talented sculptors who made it. (Left to right: Scott Goddard, Steve Cotroneo, Erma Yazzie. Not pictured: Frank Newman.)

Signing documents for the official opening of "World of Disney," Disneyland Paris, summer 2012.

A precious souvenir of my Imagineering team from my farewell party, outside Paris, July 2015.

Paula Dinkel

Principal Show Lighting Designer

Spring 1982: My first construction project, New Fantasyland at Disneyland. An exciting challenge and a far cry from my theater training.

For *Disneyland: Inside Story*, photographer Jerry Schneider needed "guests" for a photo shoot in Mr. Toad's Wild Ride. My son and I volunteered.

The first Club Disney, a regional entertainment center for children, opened in 1997 in Thousand Oaks, CA.

Lighting for the street party that never stops. Hollywood Boulevard, Disney Studio 1, Disney Studios Paris.

Ride vehicle ready to launch at Rock 'n' Roller Coaster Avec Aerosmith, Disney Studios Paris, spring 2002.

DisneyQuest, a location-based entertainment center, opened at WDW in 1996. This is the Chicago facade in 1998.

Karen Connolly Armitage

Concept Designer

The Disneyland Dream Suite rendering was commissioned in the style of Dorothea Redmond, with whom I worked early in my career.

I was proud of all the hats I wore at Imagineering; it was like being an actor in a repertory company. Outside work, showing my horse Charlie kept me agile, flexible, and resilient.

The work was challenging and intriguing and—yes—fun!

Designing for World Showcase interiors and exteriors expanded my skills. I worked on both the German and French pavilions.

Early work at WDW with Dick Kline, from whom I learned so much, prepared me for drafting the Cowboy Cookout restaurant at Disneyland Paris.

Creating a colorful, playful visual style for Animal Kingdom.

I did some concept work early on for Disney California Adventure. This is "Hollywoodland"!

Early bird's-eye for Main Street, HKDL. Grateful I had skill sets that could fulfill all these needs!

Katie Olson

Principal Color Concept Designer

TDL, 1982: a memo decreed that all WED personnel were to a wear a tie in the offices. They forgot (or didn't care!) that there were a handful of women on the installation team. So I started wearing a tie to work when I wasn't in a hard hat on the site!

Animal Kingdom, early 1998: posing with "my" Florida panther at the Tree of Life.

The WDI Christmas party 12/12/2002 was also WDI's fiftieth anniversary. Patty and Roy Disney were always very sweet to me; they had known my father well at the Studio.

My husband, John, and I in southern Japan, 2000.

We loved cherry blossom time (Ohanami) in Japan! Here I am with my friend and interpreter Juli Naruse.

Working with paint teams in California and France, we hauled out the original EDL castle model to redesign the color scheme in 2011.

Just days after that staged WDI Model Shop photo, here I am at HKDL Grizzly Gulch working on color samples for the rockwork in the geyser area. And loving it!

Becky Bishop

Area Development Executive

This juniper was exactly what I wanted for a California seascape in Paris. Unfortunately, it was a government-owned tree.

When it was dug up and shipped, the tree was far bigger than any of us imagined!

Here she sits—three crane attempts later, a one a.m. installation that grabbed the attention that morning of lookie-loos.

Me with my faithful partner in crime, Richard Lunnamann, landscape construction manager.

Grateful for a farewell dinner in my honor with my OLC counterpart Ohata-san.

All three acres of Tokyo Disneyland's Splash Mountain—my pride and joy!

Pam Rank

Principal Show Lighting Designer

My husband, Jeff, and I on the HKDL Sleeping Beauty Castle parapet during construction.

Feeling proud of my contributions to the HKDL castle, approaching opening day.

Fairy-tale lighting progresses through softly changing color schemes.

Heat and humidity not stopping me from climbing scaffolding at HKDL Small World!

Three lighting ladies working the scenery inside Small World. From left: Stellar Chow, WDI-HK lighting design associate; me; Carey Chan, electrical supervisor.

My cubicle was behind New Orleans Square at Disneyland in the early 1990s.

TDS Mermaid Lagoon night lighting was designed as if emerging from the sea, dripping with water and sparkling in the moonlight. One night while programming, I witnessed a lunar eclipse.

The Sleepy Whale at TDS Mermaid Lagoon swallowed many ships' lanterns to help me light the shop inside him!

Lynne Macer Rhodes

Producer

Lynne Macer — Research & Planning

DEBUTS

We have some new faces at WED and MAPO, and we've devoted this page to introducing those who joined us in February. To all our new employees, "Welcome!"

My debut in the March 17, 1977, "WED-WAY" Newsletter. I was hired in January 1977.

My three-week immersion in Japanese culture in the mid-80s began with the traditional gift exchange.

Mixing business with pleasure at WDI always made business a pleasure: early in my career with Pat Scanlon, Barry Braverman, and Marty Sklar.

Eric Westin and me: My path took an unexpected turn when Eric forwarded my name to WED's HR Department in January 1977.

Brainstorming sessions ignite the creative process: Andrea Favilli, Joe Rohde, me, and Kevin Brown, sometime in the 1980s.

Disney California Adventure Opening Team, on-site in early 2001.

2/28/01

Walt Disney Imagineering

Lynne —
Congratulations on your important role at the center of the DCA Creative Team! Your support of Barry and the creative team made a big difference in enabling the talent to "do their thing"! Many THnx!

Marty Sklar

Marty Sklar's notes in red felt-tip pen were infamous.

Me with Tom Fitzgerald at a Ryman Foundation fundraiser to provide classical art instruction for gifted young people.

Kathy Rogers

Executive Show Producer

I had fun being one of the first female Disneyland parking lot tram drivers in the early 1970s.

One of my fondest memories: our WDI Team at the Muppet Offices in New York, working with Jim Henson and design team on the WDW Muppet*Vision 3D attraction, 1989.

Reviewing the status of the Hollywood Studios Great Movie Ride show installation with Imagineers Robin Reardon (left) and Eric Jacobson (right), 1988.

I enjoyed collaborating with so many talented Imagineers on the Animal Kingdom's Expedition Everest attraction in 2005.

You never knew who might lend you an "ear" when cruising around the WDI campus!

Discussing installation progress in the wee hours at the WDW Haunted Mansion with lighting designer Mark Dunlap (left) and show programmer Eric Swapp (right), 2007.

Working with artists made wearing safety equipment fun during the show installation of Tokyo Disneyland's Star Tours: The Adventures Continue in 2012.

Watching the crew prepare a harvest scene for the Golden Vine Winery's film at Disney California Adventure, fall 2000.

What a highlight: at the White House in 2009 to record Obama's speech for the WDW Hall of Presidents with Imagineers Pam Fisher and Eric Jacobson.

Julie Svendsen

Concept Show Designer

My dad, Julius, celebrates *Winnie the Pooh and the Blustery Day* winning the Oscar in 1968.

My grandpa, Fredrik, navigates creating paintings of ships he had navigated on the high seas, early 1940s.

Herb Ryman and I swap stories during a WED lunch gathering at a nearby park, 1972.

One of many drawing classes, late 70s.

John Hench and I, approx. 1994

Self-portrait, 2002.

Rough concept sketch for Off the Page, the Disney character animation store for Disney California Adventure, 1999.

Final approved logo for Typhoon Lagoon, 1986.

Mural for Geppetto's workshop for the Pinocchio ride for New Fantasyland, early 1980s.

The Scrooge McDuck dynasty.

Storyboard sketch for Monsters, Inc. attraction for Disney California Adventure, 2003.

Tori McCullough

Executive, Interior Design

The first picture taken of me at WED in 1976.

On the Disneyland Paris construction site in front of le Château de la Belle au Bois Dormant, 1991.

Elephant ride with WDI's David Brickey in Thailand during our design research trip for Animal Kingdom, 1993.

I'm sitting among the full-size artwork for le Château de la Belle au Bois Dormant, in Aubusson, France, 1991.

With my dad, X Atencio, at his retirement party in 1984.

Our family at the service awards dinner, 2016: my 40th year, my husband Mike's 35th. Daughter Kelsey (also a Disney cast member!) was our guest.

The Shanghai Disneyland Hotel Lobby, 2016, and the team responsible for the stained glass: from left, Wong Kai, me, Weide Chen, and May Chen.

Women at Work

Becky Bishop's original design for the landscape treatment of what would become Expedition Everest.

The Expedition Everest Team. Kathy Rogers was the Creative Show Producer.

Julie Svendsen's early marketing sketch for Blizzard Beach. Typhoon Lagoon was a hit, so the team reunited on a second water park.

Imagineers building Blizzard Beach included Kathy Rogers as creative show producer.

Getting a little dough-nutty at a morning meeting at Disneyland's Aladdin's Oasis, early 1990s. Pam Rank (right) joined by Jimmy Pickering (left) and Michelle Malakoff.

Working Around the (Disney) World

Imagineers who would oversee the HKDL Castle gathered at the site in 2003. From left, Lori Coltrin, Howard Brown, Ed Erlandson, and Eli Erlandson. Eli was the architect.

WDI coworkers and friends, from left, Manni Wong, Paula Dinkel, Daphne Howat, and Eli Erlandson, visiting a historic Chinese water town near Shanghai.

Tori McCullough (third from left) with her husband, Mike, and Imagineer Bob Jolley and his wife, Colleen, on a 1986 research trip for the Norway Pavilion at World Showcase.

Victory dance at the opening of Disney Studios Paris. Paula Dinkel (left) with Imagineering show lighting designers Tracy Eck and Laura Yates. Tracy is now the WDI art director for DLP and Laura is a principal show lighting designer.

Katie Olsen in all her glory, mixing paint backstage at HKDL.

Kathy Rogers (left) worked on the final installation for Disney Studios Paris and snuck in a visit to Notre-Dame with former Imagineering colleague Anne Osterhout.

Where We Were Then...

From 1977–1982, Peggie Fariss presented EPCOT Center to prospective sponsor company executives.

Maggie Elliott flanked by her Imagineering boss Mickey Steinberg (left) and his boss, Disney chairman Michael Eisner (right).

Katie Olsen in the WDI model shop, mid-1970s.

Tori McCullough receives her ten-year award from John Hench, who mentored so many in this book.

and Where We Are Now

Karen Connolly Armitage in Paso Robles with her horse Tag, September 2021. She designs projects around the central California coast and is still an equestrienne.

Lynne Macer Rhodes (back row, far left) in 2010 with staff and advisers of A Better LA. She is currently a board member and advocates for social justice in South LA.

Katie Olsen splits her time between Bishop, CA, and the Florida Keys and does a LOT of fishing in both locales.

Besides providing the initial impetus for this book, Eli Erlandson travels the world to paint en plein air (here, in Jalama Beach, CA).

And ONE Time We Were Together!

For a few days in May 2018, we assembled at a rented house in Yosemite to bang out ideas for this book. Back row, left to right: Maggie Elliott (red hair), Tori McCullough, Karen Connolly Armitage, Becky Bishop, Lynne Macer Rhodes, and Katie Olsen.

Front row, left to right: Julie Svendsen (white hair), Peggie Fariss; Paula Dinkel, Kathy Rogers, Eli Erlandson, and Pam Rank. Photo by editor Mel Malmberg, who had the presence of mind to document twelve still-busy women all in one place at one time.

Tori Atencio McCullough
Executive, Interior Design

Designing Woman, Managing Mom

Many of my friends would have said that my brothers and sister and I were the luckiest kids in our school. Our dad, X Atencio, worked for Disney as an animator, and in the early sixties, there were very few people who worked for The Walt Disney Company. It was a unique situation, especially out in the west San Fernando Valley, where most of my friends' dads were in the aerospace industry. For our birthday parties, Dad would bring home large round film cans that held those precious Disney animated movies, along with the projector on which to show them. What a treat it was to sit in our living room with friends and watch these films. Little did we know then that our children would be able to pop these Disney classics into the VCR at any time and enjoy them in the comfort of their family rooms.

We also got to go to Disneyland anytime we wanted. Anaheim was a long way from Woodland Hills, so we didn't get to go as often as we

wished, but we have many wonderful memories of parking backstage behind Main Street, Sunday morning breakfasts in Frontierland, and going on rides, sometimes through the exits if the lines were too long. Those were the good old days, for sure. To show what a warped sense of Disney reality I had, when a friend invited me to go to Disneyland with her for her birthday, and we parked in the parking lot, I was thrilled. I had never been on the tram before. Given this upbringing, it isn't too surprising that when I graduated from high school and was looking for a summer job, I ended up at WED.

Believe it or not, the only employer I have on my résumé is Walt Disney Imagineering. Actually, my siblings tease me about the fact that I never had to write a résumé. But I did fill out two applications (which I found recently)—one for my first summer job at WDI in 1972 and one in 1976 when I applied for full-time employment as an interior designer. I retired in 2016 after forty years. We all look back at that period of our lives and ask ourselves where the time went. But in fact, when I am faced with writing that "résumé," I can easily account for those four decades. They were packed with projects in four different countries, adventures in faraway lands, and lifelong friends I made along the way.

The path that each Imagineer takes to land that job varies almost as widely as the number of Imagineers. It is ironic, then, that four of us in this book got our foot in the door because of our dads' employment with and connections at Disney. Nepotism was alive and well back in the seventies. I never felt uncomfortable that my dad "got me" that summer job, because I quickly learned that getting that foot in the door was only step one. Keeping both feet in the door was much more difficult.

Back in 1972, WED Enterprises was a relatively small place, and the employees often found summer jobs for their kids throughout the company from the mail room to the Model Shop. I never got to work in the Model Shop or the mail room, but over the course of four summers, I did work in accounting and the research library, and filled in for executive secretaries when they went on vacation. My best assignment during those summers was filling in as John Hench's secretary—as they were called then—when his secretary, Edie Flynn, was on vacation. That was the beginning of a very long relationship with John that I cherish to this day.

When I wasn't working at WED during the summer, I was attending Loyola Marymount University (LMU), where I was pursuing a degree in studio arts. After taking an interior design class as part of the curriculum, I was hooked; however, LMU didn't offer more classes in that discipline. One of my professors suggested that I look into UCLA Extension's nascent interior design certificate program. Concurrent with getting my BA from LMU, I took interior design classes at UCLA, just up the 405 freeway (then a paradise—now a parking lot).

In my senior year, it was time to look for employment. By now, I loved both WED and interior design, so I took my little portfolio and applied for and landed a job in the then-tiny interiors department. In 1976, my hiring brought our department up to a grand total of three employees.

In those days, the interiors department was primarily responsible for the selection of the colors and materials, and the specification of the furniture for the shops, restaurants, and theaters in the parks. Occasionally we would get to work on hotel projects, and my first project of note was the Tangaroa Terrace at the Polynesian Resort, working with architect George Rester. In true full-circle fashion, my last

projects for WDI were also hotels, both for Shanghai Disneyland (the Toy Story Hotel and the Shanghai Disneyland Hotel).

✦✦✦

Once EPCOT was announced, a hiring frenzy began in earnest, and our little department of three grew to a department of eight, mostly young, recent graduates who were excited about being part of this new and ambitious project. Working on EPCOT Center was like being in a master's class. We were lucky to work with some of the best of Hollywood's art directors, like Harry Webster, Harper Goff, and Jack Martin Smith, and the finest architects who understood how to translate the vision of the art directors into reality. We learned so much from these mentors about themed design.

I think the best way to describe this kind of design is that it's like being a set designer in the movies, except these sets have millions of people walking through them every year. In addition to creating the environment, we had to be concerned with durability—finding materials that could hold up to all those feet. I worked on several of the World Showcase pavilions and designed restaurants and shops for the Germany, France, and Mexico pavilions.

By this time, the interiors department had a bit more responsibility in the design process. While we received the interior architecture from the architects, we did develop the design of all the casework in the shops, along with all the material specifications and furnishings. I was very fortunate to work with Dorothea Redmond, another great illustrator and production designer who worked on many well-known films such as *Gone with the Wind* and seven Hitchcock productions. Her watercolor sketches were extraordinary placemaking. They expressed the concept so perfectly and with such detail that you could believe you

were standing in the room. She did a rendering of the Weinkeller shop in the Germany Pavilion with a beautiful dusty rose ceiling. John Hench would not rest until that exact color chip was found and specified for the ceiling color. She was such a wonderful mentor, and we could only hope to aspire to her greatness.

As interior designers, we were responsible for specifying the color and materials, and those all had to ultimately be approved by one man, John Hench. John was the company's color specialist, among other things, and every color board was stamped with APPROVED BY JOHN HENCH, which he initialed.

Many Imagineers can tell stories of the presentations that did not go so well, or of when a color or two had to be tweaked. I recall once not making the change, thinking that John would never remember that he told me to make the revision. What a mistake that was. I soon learned that John forgot nothing, and eventually you *would* change that color chip. As painful as that lesson was, I learned so much about color from John. Years later, as John neared his nineties and finally spent less time at WDI, he said, "After all these years of endless critiques and mentoring, if you can't pick a color without *me*, I haven't done my job very well!" It was kind of like graduation day when John finally let us fly on our own.

Once we made it through design, EPCOT had to actually be built. Again, a young team was assembled to head to Florida, working with contractors to oversee the construction and installation of materials and props. I was down there for close to six months. The Imagineers took over several loops of the Fort Wilderness campground to call home. There were a lot of lessons to be learned from veteran construction people like Jim Nagy and Milt Gerstman from Tishman. We were lucky to be part of this, and we relished the experience. We worked long, hard hours, but we had never been part of a project of this magnitude

and complexity, and we had no idea how difficult it was going to be to open it on October 1, 1982, as promised.

For instance, while working on the France Pavilion, I was told to install the carpet when there weren't even windows in the building. Proper construction sequencing was tossed to the wind. We had to get done anything we could get done in any way possible. This became the norm on Disney projects and would not be the last time I was asked to work this way.

Following the opening of EPCOT (we *did* make the opening date!), the ranks of WED went from a couple of thousand employees to fewer than five hundred. Remember what I said about how the hard part of working at Imagineering was not getting in, it was staying in? This was my first test, and thankfully I passed.

In the following few years after EPCOT's opening in 1982 and the start of design for Euro Disney, several pavilions were added to EPCOT. I worked on Horizons; the China Pavilion; the new restaurant for the France Pavilion, Bistro de Paris; and the Norway Pavilion. These "EPCOT Years," as we fondly refer to them now, were formative, both professionally and personally. It was while working on this project that I learned the very foundation of Disney design. It is also when I met my husband, Mike McCullough, a fellow Imagineer from research and development, and it was during this period that colleagues became friends; and those friendships endure to this day.

In the early days of WED, there was little reason for most Imagineers to travel beyond Orlando, Florida. But beginning with the design of EPCOT, project teams began to travel abroad to do research for the design of the World Showcase pavilions, or to go on buying

trips for props. We would research everything from architecture and design to food and culture, and our experiences influenced our designs at every turn.

I was the lead interior designer on the Norway Pavilion in the mid-1980s, working hand in hand with a WED architectural wizard, Ron Bowman. By this time, the interior designers were given more responsibility for the architectural interiors. The Norway Pavilion was being sponsored by a consortium of Norwegian companies, and they wanted their products showcased in the pavilion. I worked closely with their representative and their interior designer, who was part of their team. Toward the end of the design phase, as the project was going to be built, my husband and I, and Bob Jolley (our themed finish art director) and his wife, got the trip of a lifetime to Norway.

Bob was going to be looking at the buildings throughout the country to better understand the colors and the aging of the wood and stone so he could replicate it for EPCOT. I was going to meet with the companies who wanted to have their products in the pavilion, and more importantly, I was buying all the props that would be found in the attraction, shops, and restaurant. At that time, we traveled with traveler's checks. In order to take the needed amount of money to Norway, they opened a Norwegian checking account in my name so I could write checks for the props.

We traveled around the country for ten days with access to some places that even native Norwegians don't get to see. For example, one of our first stops just outside Oslo was a private fishing lake surrounded by ten small cabins. We were hosted by a resident who offered us homemade Norwegian moonshine (perhaps their idea of afternoon tea?). We stopped here to see the Norwegian pinewood that was being milled into paneling. (It ultimately served as the walls of the bakery at our pavilion.)

We traveled by plane from Oslo to Bergen to Stavanger and were met at each place by a local representative who wanted to show us the best of their region. As we went, these locals took me to places where I could buy accessories and antiques. The most impressive piece was an antique hutch over one hundred years old that featured the iconic Norwegian flower painting (rosemaling). The only reason the hutch was allowed to leave Norway was that it was going into their pavilion. I had to sign a letter agreeing that if it was taken out of the pavilion, it would be returned.

Years later, in 1994, I was part of a project team for Disney's Animal Kingdom and went on a two-week trip to Southeast Asia with seven of my fellow designers and managers, and Joe Rohde, Animal Kingdom's creative leader and visionary, as our guide. We visited Bali, Thailand, and Nepal. These research trips were often referred to as "boondoggles" (work or activity that is wasteful or pointless but gives the appearance of adding value) by those who didn't go. Sure, an all-expense-paid two-week trip to Asia sounds like it was a wasteful perk. Those of us who were fortunate enough to go on these trips understood the value of being immersed in a culture, experiencing it firsthand rather than reading travel articles and looking at research books. Many details can be missed when looking at a 2-D picture. What's that really made of? What's around the corner? What's up high, just out of the frame? But when you are in a place, using all your senses, and having it surround you, it is much easier to replicate it.

In fact, Imagineers do a fantastic job of re-creating and interpreting these foreign places for guests. I laugh because many times when people visit places that were replicated in our parks, they say, "Wow, Morocco looks just like the World Showcase!" Or, when they are visiting a small European town, "This looks just like Fantasyland!" I have to admit, I have found myself saying it!

My Interior Design Saga

Another thing you learn about Imagineers with long tenures: they almost never stay in the same department during the course of their career. I once asked John Hench why people stayed at WDI for so many years, and his answer was simple: "We don't make widgets, Tori." His point was that every time you began a new project, it was like starting a new job. You began work with a new project team, many of whom you hadn't worked with before. Every project, in turn, had its own challenges, be they financial, physical, or cultural. We were challenged every day.

But I was one of the few who did stay in the same department, interiors, for forty years. What changed was my role and the responsibility I had. As the years and projects clicked by, I gained more and more experience and learned from many seasoned project managers how to get a project designed and built.

By the time we began design on Euro Disneyland, as it was known then, I was assigned as the lead interior designer for the project. This was a new role created for this new park. I was responsible for hiring interior designers, assigning them to the different land project teams, and maintaining some consistency between all the lands. Concurrently, I also had personal design responsibility for three restaurants in Fantasyland, the gem being the high-end table service restaurant Auberge de Cendrillon.

We worked with all the land art directors and architects to conceive the look of each space, and then we worked closely with outside design consultants. Then the drawings were sent to Paris to the Bureau d'Etudes (a governmental agency whose architects and designers finalized the design, coordinated with engineering, and ensured all French codes were met). Mike and I were among the

first wave of WDI employees to move to Paris to oversee this effort. Besides ascertaining that our designs were being executed correctly, I started supplementing our small expatriate staff with local hires who could help us during construction. After the hiring process was complete, I had to manage all these people. Oh, and I had a baby during design and construction, too.

As we neared the end of construction, I was stretched pretty thin between the management and the design oversight in the field. My colleagues and dear friends, David Brickey and Lynne Itamura, who were my Fantasyland interiors team, gave me a piece of advice: trying to do management and design at the same time was not a good idea. It was too much to take on. It was good advice that I took to heart and used to effectively shape the future of my career.

In the ensuing years, as I combined management opportunities with project work, I found that I really liked management (and if the truth be known, I think I was better at directing the design than actually doing it). With every project, I learned more about all the other disciplines we interior designers interfaced with. When you sit in enough project team meetings and design reviews, and you spend enough time negotiating with architects over placements of doors and windows, and engineers about the locations of columns and the sizes of ducts that will impact your ceiling heights, you learn a little bit about their business. And after all, it was our business—the business of building a theme park.

It was around 1994 when environmental design and engineering (our division within WDI) got involved with the design of Disney's Animal Kingdom Park. Once again, I took the reins as the lead interior designer, but following my friends' advice, I did not take on any design responsibility. I focused on the programming of the space—actually finding out, from the park operators, what each space would be used

for. I worked closely with operations, the food and beverage team, and the merchandising team to ensure their needs were met. Since every land had a different team of designers, those of us with oversight over everything ensured everyone would be designing to the same parameters. We also made sure our final designs were telling the stories we wanted to tell.

It was around this same time that the manager of the interiors department was let go. The director of architecture and interiors at the time asked me to step in and help out as the "acting" manager, and pick up duties back in Glendale, assigning staff to projects and hiring and reviewing employees. This was a long time ago, and if it wasn't for old yearly reviews of my own that I have reread, I wouldn't have remembered this precise sequence of events. And I was an overachiever type A personality who was happy to get the chance to take on more responsibility. This went on for almost two years until I guess I proved to them that I could do this job, and they officially promoted me to manager of interiors in 1995.

In reading my coauthors' stories of fighting for recognition or career advancement, I have to admit that at no time along my career path did I feel held back because of being a woman. But—and this is a big BUT—I was also a woman in a field, interior design, that was predominantly female. There were many times that I would sit in management meetings and, halfway through the meeting, realize that I was the only woman in the room. It was certainly true that there was a dearth of women in leadership roles at WDI, especially during the first three decades of my career.

Truthfully, I liked having the responsibility of searching out good talent, hiring them, and then nurturing them to make them great designers. I also had this idealistic view of my role: that I could make a difference. My frustration with previous management made me want

to do things differently and better. But I realized very quickly that managers weren't autonomous. Working for a behemoth company like Disney, decisions and policies were dictated by "Upper Management," which was far above my pay grade. One thing I knew for sure: by getting the right talent in our department, the interiors department could take on even more design responsibility. That vision was not idealistic but completely realistic, and we did indeed grow in both size and abilities. By this time, the interiors department could and did take the design of shops and restaurants from concept design all the way through working drawings, and specify all the materials and furnishings. Soup to nuts, A to Z, we could deliver the whole package.

By 1996, the Animal Kingdom design was essentially complete, and we began work on Disney California Adventure (DCA). It was the second park in Anaheim, being built on the real estate that was then the parking lot (the one I had been so thrilled to ride through on the tram!). I was asked to be the lead interior designer overseeing the design of this new park, so once again I was balancing management responsibility with being the lead interior designer. But then there were a few added levels of difficulty in the management of the interiors department. The Oriental Land Company had decided to proceed with the design and construction of the second park in Tokyo, Tokyo DisneySea (TDS), and from across the Atlantic Ocean, we were designing the second park for the Disneyland Paris resort. I had to substantially increase the size of the interiors department to handle all this work. At the height of the design and production phases, our little department had grown to over seventy-five people, with more than two-thirds of them assigned to the Tokyo project.

DCA was a huge design challenge because it stood steps from the iconic Disneyland, and the budget for the park was on the smaller side. We all accepted our constraints and went to work to

design the shops and restaurants that would further immerse our guests in the story of each land. Like at Animal Kingdom, I worked closely with the merchandise and food and beverage teams to meet their needs, while working to make sure story design requirements were met. Through my position, from brainstorming sessions to buildings, I helped influence the final outcome, although I did not personally design anything for DCA.

WDI interiors got involved in the design of the Hotel MiraCosta, which stands at the entry of TDS, very late in the game. It was the first time that we had put a hotel inside the park, and it sat above the shops and restaurants in Mediterranean Harbor. An outside consultant had been hired to do the design of the hotel, and it was being managed by the hotel division of Imagineering that focused solely on the Disney resorts. Wing Chao, our executive vice president of resorts and master planning, reviewed the design and was very unhappy. He called our in-house interiors team in. With a small group of ten people, and in a very short time (just a couple of months), we redesigned the hotel's public spaces and guest rooms, from architecture and finishes to furnishings. It meant a lot of late nights for the team and late-night calls from Wing.

The resort group at WDI had never used WDI interiors; it was felt that we did not have the hospitality design experience. And of course, we didn't. We had never developed that skill, because it was always farmed out.

But the expertise we did have—and still have to this day—cannot be found in traditional interior design firms. We were specialists in art glass, decorative lighting, carpet design, and elaborate stone floor patterns—and every one of those skills came into play with the Hotel MiraCosta. This was my second foray into the world of hotel design.

In 2001, Tokyo DisneySea and Disney California Adventure both opened. The enormous staff that had been hired to do these projects concurrently had to be reduced to reflect a smaller future project menu. This was my first time being a part of a major layoff from the management side. It is the inevitable but painful consequence of project work. And although everybody knew that layoffs were coming, delivering the news was never easy. I hated "playing god," and I tried to keep things businesslike, retaining those people with the largest breadth of talent and experience, not the ones whose personal stories I knew. But it was difficult to be strategic without knowing what was ahead for our department, or for the company; my own position could have been cut. But at the end of the process, just as in the staff reduction after EPCOT opened, my feet were still inside.

※ ✦ ✦ ※

This might be a good time to interrupt this management narrative to discuss the challenges of the working mother. When my daughter heard that I was going to be writing one of these chapters, she said she hoped I would address how I balanced having a career and motherhood, because she thinks I did it very well. (And frankly, her opinion is the only one that counts.)

I am no expert on this subject, and WDI is full of women dealing with this delicate balance. When my daughter, Kelsey, started kindergarten, a working mom with children in her school gave me some advice. She told me never to miss the Halloween parade in the schoolyard, or special performances that happened throughout the year. If I made those, she said, my daughter would not feel neglected—and I never

missed one. After-school day care was a godsend for many years until she hit that age of enlightenment, when she declared she had had enough of that. At that point, I negotiated a reduced workweek; I stayed at WDI until 3:00 p.m. so I could pick Kelsey up after school. WDI assumed correctly that I would work from home for several hours per week. After a couple of years, I realized that I was getting paid for thirty-two hours, but I was still working forty. I went back to working full days and made other arrangements for after school.

Many funny stories came from this juggling routine, but there is one that will always be a highlight and one my daughter won't ever forget. There was a meeting that took place early one evening when a few of us had to bring our kids back to the office after picking them up from day care. They were all between eight and ten years old at the time. We put them in the conference room next door to our meeting, turned on the TV, and gave them five dollars each to buy junk food from the vending machines. They thought this was the greatest, but it was not my proudest moment as a parent. It certainly illustrates the challenges and sacrifices we made along the way.

On one Bring Your Child to Work Day (a legitimate one, not one of those where you have your kid hide on the floorboard of the car as you go through the security gate), Kelsey got to go to a meeting with me, which I happened to be leading. That night at dinner she told me that I should apply to be on *The Apprentice* because I could do what they were doing. She witnessed me leading a team, assigning tasks to various members, and discussing the project schedule and strategies. I had to admit, that is exactly what those team members on that show did every week, and her only experience of the "working world" was watching that show. Fortunately, I didn't have Donald Trump yelling, "You're fired!" at me.

The Agony and the Ecstasy

The most fantastic assignment I had was Euro Disneyland (EDL), now known as Disneyland Paris. Not only was it Paris (Paris!), but there is nothing more adventurous or challenging than working on an international project and traveling to or living in a foreign country.

In late 1986, I began working on the design of EDL. In 1988, Mike, now a project manager on EDL, and I moved to Paris. Where could the "agony" possibly be in that? That is a fair question. Living in Paris was a dream come true; that is the ecstasy part. We took weekend trips all over France and nearby countries, and longer vacations to others. My daughter, conveniently born between the end of design and the beginning of construction, can claim that her first vacation, at the age of seven weeks, was to Saint-Tropez.

The agony was the challenge of working with the governmental agency called the Bureau d'Études. These architects and designers were responsible for documenting (and approving) our designs for construction, but they didn't know a thing about theme park design or themed interiors.

Both the Americans and the French artists were doing drawings by hand, but our methods were completely different. We generally drew on tracing paper with pencils. They drew on acetate sheets with ink, and when they made a mistake and had to make a change, out came the razor blades, which they would use to scrape the ink from the sheet.

In Fantasyland, Disney designers were proud that there wasn't a single straight line: walls were crooked, plaster wavy, wood beams heavily distressed. It took forever to get the bureau to put away their straight edges and draw crooked lines. We explained that if they drew everything straight, the contractor would build it straight. Eventually, some of our French colleagues caught on. Despite the

difficulties of getting the drawings and specifications complete, we met many wonderful people who were truly part of the team. We hired several of them, and twenty-five years later, Sylvie Massara and Nathalie Piette-Caron still work for Disneyland Paris in design leadership positions.

Building a theme park is an enormous endeavor, but building one in a part of the world that is unfamiliar to you makes it immeasurably more difficult. "That's not how we do it in Europe" was a common refrain. To construct Fantasyland, we worked with an Italian company, disinclined, like the Bureau d'Études, to build sagging roofs and crooked beams. I remember we thought it was the hardest thing we had ever done. When Imagineering turned the park over to the operations team in early 1992, it was far from finished. But they had to start training their army of cast members, who, like the designers and contractors before them, had never worked at a theme park. The operations team trained in the park during the day, and the contractors and Imagineers came in the late afternoon and worked through the night for what seemed like months, right up until Opening Day in April. We were on a plane home the very next day.

In 2010, after almost a decade of negotiations with the Shanghai government, the agreement for Shanghai Disneyland was signed, and the project was green-lit. Yet another new country, with a very different culture. The design of this Magic Kingdom could not be lifted from our previous parks as we had done in Tokyo and Hong Kong. The buzz phrase "ADDC: Authentically Disney, Distinctively Chinese" became the mantra used throughout the entire process.

Everybody from Disney was trying to figure out how to build and operate a theme park in mainland China. My first research trip to Shanghai was in 2010 when a group of us went to check out shopping and food and beverage trends. Again, I was very involved at the

beginning of the project. Just as in Paris two decades earlier, the Chinese Local Design Institutes, or LDIs (government-approved architecture and engineering firms), had no idea what went into designing a theme park.

One of the first big challenges for Imagineers was learning about Chinese materials. Part of the contract stipulated that a very large percentage of the materials specified had to be from China; if they weren't, we had to have a very good reason why. We quickly found out that when it came to standard interior finishes like ceramic tile, fabrics, and wall coverings, there was no market for them in China—so there was nothing to find. If we wanted to cover the floors and walls with stone, we had come to the right place. But we wanted fabrics—the kind we had always used in our other parks. Those fabrics were made in China. Done, right? Um, not so fast!

As we set off to find fabrics, a Shanghai interior designer told me, "When it comes to fabrics, just count on importing them." I was incredulous. How could that be, as it seemed that every fabric we had used in our other parks was milled in China? It turns out that there are fabrics that are made for the export market, and then there are the fabrics that stay in China. What we wanted was the former—so they had to be made in China, exported, and then imported back in. This is a very small example of the "agony" of building in China.

A couple of years into the design process, my dear friend and colleague Lynne Itamura found herself trying to oversee the design team of Mickey Avenue (the equivalent of Main Street in our other Magic Kingdoms) and the two hotels that were being designed by outside architects and interior designers. Clearly, she couldn't keep all those balls in the air, so I volunteered to oversee the two hotels, the Shanghai Disneyland Hotel and the Toy Story Hotel. I had been involved with more hotel projects at the Disneyland Resort, and I thought it

would be a great opportunity to work on hotels from the ground up. That decision pretty much changed the direction of my career and my personal life for the next four years.

I traveled to Shanghai so many times between 2011 and 2014 that I can't count them and spent innumerable nights in hotels and endless days in the offices of the design firms, just to get the drawings and specifications completed. For each hotel there was a Disney team of Chinese design managers, project managers, and construction managers with whom I worked very closely; without them, and their dedication, we could never have gotten the hotels built.

At the end of 2014, it became apparent that we needed continuing Imagineering oversight while these hotel interiors were being constructed. This was always the plan for the theme park, but it had never been discussed for the hotels. I recall the day that Craig Russell, WDI's senior vice president for project delivery, called me in and asked me what I thought we should do. The fact that I was managing the department at the time made a move to Shanghai a bit more complicated. Without hesitation I told him that it would be easier to replace me as the functional manager in Glendale than to get someone new up to speed on all the design decisions in Shanghai. I told him I would go, but could not commit to moving there; I would travel back and forth. And travel back and forth I did: in 2015, I spent 286 nights at the Kerry Hotel on the Pudong side of Shanghai.

That year was filled with highs and lows, both brought to us by our contractors. The Toy Story Hotel was a mammoth 800 rooms, and we battled the contractor over the quality of their work. I spent the majority of my time, though, on the Shanghai Disneyland Hotel (420 rooms) because of the complexity of its design. An art nouveau extravaganza filled with massive public spaces, the hotel was designed with sinewy, curvaceous lines everywhere. We were very lucky

because our contractor, Dong Shun, was really good. They took great pride in their work and hired great people . . . but it was still a learning "curve" for them.

It was almost impossible to describe in one dimension our drawings. Plus, there was a further complication: the Chinese were completely unfamiliar with this architectural period. They had no frame of reference for what we were trying to achieve. So for every detail, we showed them dozens of research photos of art nouveau that would help them understand it.

We had designed a five-story wall for the lobby—delicate, elaborate climbing vines, to be executed in plaster. When we went to check their first attempt at producing this, I nearly had a stroke. What had emerged was a big fat tree trunk that looked like a kindergartener had made it out of Play-Doh.

I knew then and there that we needed help from the Disney master craftsmen who were working on the theme park. Fortunately for us, the park was behind schedule, and there were very talented artists living in Shanghai who could make models and direct the work. This was the first example of how having some veteran Disney know-how was vital. My dear Chinese team would have had no idea where to get help, and honestly, I'm not sure they understood art nouveau well enough at the time to recognize there was a problem.

The second crisis came in the form of stained glass. The lobby had a five-meter stained glass light fixture in the ceiling that was to be constructed on-site. It was surrounded by four five-story columns capped with stained glass capitals several meters in diameter. This had been my big idea, inspired by the Palau de la Música Catalana in Barcelona. Little did I know how hard it was going to be to actually pull it off.

The Chinese contractor had to find a stained glass studio to design and make the glass panels. Then they had to engineer and build the steel framework that would hold that glass, and finally we had to figure out how to actually light the things—in a way that wouldn't cast shadows across the glass, would stay lit for as many years as possible, and would be accessible when it was time to change the light bulbs.

For this massive project, Dong Shun hired a company that made little Tiffany-style lamps, and they were completely in over their heads. So once again I called in a WDI expert to save the day. Miriam Ben-Ora has been leading our specialty glass studio for over twenty years. She is a brilliant designer as well as a technician. After one visit with her to this substandard glass vendor, she confirmed my concerns. She returned to the Glendale office, designed all the patterns, and specified the glass, which had to be imported from Europe and the United States. We ultimately found another glass studio in Shanghai, Weide, that had done many enormous glass installations, including skylights. We partnered with them, and while the task wasn't easy, they were wonderful to work with and excited about the project. When we installed the glass into the enormous steel frames and turned on the lights, I think I wasn't the only one with tears in her eyes. It was the culmination of a year of challenges and tribulations, but with the flip of one switch, everything seemed worth it.

And so you ask, where did the ecstasy come in, in Shanghai? Just as I had done in France, I got to travel around China and see places and things that I would never have dreamed of ten years earlier. I made lifelong Chinese friends, and I got to experience an emerging world power, not as a tourist but as a participant. How many Americans can say they went to work in Chinese offices, saw firsthand how their new colleagues thought, and learned about their culture by playing a part in it? I wish I could say that I learned the language, but that was just an unattainable goal for me.

I left Shanghai for the last time in January 2016, when the hotel was about 90 percent complete. Even I couldn't come up with any good excuses for why I needed to stay; my local team could take it from there. We teased our contractor, Dong Shun, that they were now the foremost authority on art nouveau in China. Wang Kai, their design coordinator who interfaced with us on a daily (sometimes hourly) basis, by the end, could tell us what was acceptable or not. He, too, had become an expert. Leaving the project and my new friends was bittersweet. I was happy that I was going home, but I was going to miss my new friends and the bond we had forged through adversity.

When I got back to Glendale, I made the decision not to return to the functional management position and left interiors permanently in the hands of Barbara Dietzel, who had taken over for me when I went to Shanghai. I knew that my plan was to retire within the year, since Mike was retiring in March and there was no reason to cause chaos with changes in management when there didn't need to be.

In September 2016, I retired. I was blessed with an enviable career, where I got to work with an amazingly talented and dedicated group of people. We did great things together. I always told my dad that he was so lucky to have worked at Disney in those golden years, working with Walt and creating Disney classics, both animated and theme park attractions. But I think my generation was lucky, too. Perhaps we worked in the "silver age"—defined by extraordinary theme park growth and our own opportunities to grow and learn. I was involved in the design and construction of six Disney theme parks and three hotels. I hope that the next Disney generation will be as lucky.

Pam Rank
Principal Show Lighting Designer

Stories from the Field

I was a show lighting designer at Imagineering for over twenty-seven years, from 1987 to 2015. My career began with *Magic Journeys* at the Magic Kingdom and culminated with Mystic Manor at Hong Kong Disneyland (HKDL). Although I did not exclusively work on attractions that began with "M," I *did* stay in one department, show lighting, for my whole career. Lighting is both my love and my area of expertise. I never had any desire to do anything else.

Our department is responsible for designing all the permanent, onstage lighting for Disney theme parks worldwide: for rides, attractions, shops, restaurants, exterior facades, and landscaping. Lighting designers contribute to every phase of design: concept, construction drawings, installation, programming, and closeout documentation. The wide breadth of tasks needed to take a project from initial sketches in a conference room to final touch-ups in the real attraction requires coordination with almost every other department at Imagineering.

My randomly assigned freshman roommate in college at Bucknell University was a blond-haired, blue-eyed beauty queen who was also a very fine actress. She dragged me over to the theater open house on the first weekend of school, and we both signed up to work backstage on the first show. I loved it, and throughout my college years, I spent most of my free time at the theater. I appeared onstage once, and that was enough to convince me that I belonged strictly behind the scenes!

For me, the theater was just a hobby. In my senior year, a new technical director arrived and took me under his wing. A theatrical technical director oversees all aspects of backstage production, with emphasis on scenery construction. He taught me some new skills, including welding, and gave me more challenging roles in our productions. Early on, we had the conversation that changed my life:

Mike: "What are you going to do when you graduate?"
Pam: "I have absolutely no idea."
Mike: "You should go into technical theater."
Pam: "You can't make a living doing theater."
Mike: "If you're good, you can!"

That encouragement did the trick. I went to grad school at the Yale School of Drama and earned my MFA degree so I could qualify for a faculty position at a university, aiming for a combined position of lighting designer/technical director. In fact, my first two jobs were as an assistant technical director, first at Tufts University in Massachusetts, and then at the University of Southern California (USC).

For me, technical direction was a good way to secure a job, but lighting design was always my first love. I loved the way lighting

allowed me to influence the mood of the production in a very ephemeral way. With my first "thumbs-up" from a director—when I used lighting to subtly shift the audience's attention from a large, boisterous group to a small, secretive one—I knew I had the potential to become a merely average technical director but a really excellent lighting designer.

A lighting designer must understand the nature of the scene to be lit, and the story behind it. She determines how to tell that story using properties of light, such as brightness, angle, color, texture, and movement. Then she decides what type and arrangement of lighting equipment will produce the ideal quality of light. I have always been energized by the challenge of combining technical proficiency with visual artistry. Like music, lighting has a mystical quality that can evoke a subconscious emotional response. I found I enjoyed composing the scene, and I took great delight in programming the timing of the lighting to interact with the movement and sound of the scene, almost like a dance partner. Most of all, I loved the sheer beauty lighting brings to every environment.

My big break came when our lighting designer at USC, the very talented Paula Dinkel, left the university to accept a job at Imagineering. I succeeded her and held the USC lighting design position for the next six years.

Landing that lighting job at USC did not automatically endow me with all the necessary experience. So I went out and designed lighting for numerous small theater companies performing in dismal ninety-nine-seat storefront spaces with black walls and low ceilings. I was often both lighting designer and master electrician. I remember testing light fixtures by plugging them in, and having about one out of three

fail, some of them explosively. If I had a stage crew, they were sometimes people fulfilling their community service sentence after a drunk driving conviction.

I did learn a lot from working with limited resources and trying to evoke emotion using equipment only one step above a flashlight. Los Angeles has an abundance of actors, directors, and screenwriters who perform for small theaters in between paying jobs in TV and film. All were enthusiastic about these live shows and their roles in them. I learned from collaborating with such diverse colleagues, and I learned simply by practicing my trade.

✦✦✦

My advice to those starting out is simple: learn your craft, pay your dues, and be persistent. I think I applied to Disneyland Entertainment twice, and to WED three times, before I was finally hired.

Once I finally landed the job, it was as a full-on lighting designer, not an assistant. As the new hire, I assumed I'd be handling lighting for parking lots and backstage offices. I was delighted to hear that electrical engineering consultants did all that boring work. WDI wanted a creative artist, not someone who calculated foot-candles of illumination. I already knew how to use light to create form and illusion and focus and emotion. I just had to learn about architectural equipment as opposed to theatrical equipment, and I had to learn about architectural standard practice and electrical codes.

My department apparently didn't know my starting date. On my first day, I was seated in the office of someone who was on vacation. Then I was given a foot-high stack of architectural drawings so I could "become familiar with what a drawing set looks like." So I stared at them. It was not a very exciting day.

Soon I was assigned to design lighting for a small rehab in the Magic Kingdom, installing the 3-D film *Magic Journeys* (1988) into an existing theater space. I was introduced at a team meeting, told to feel free to ask questions, and given the due date for the construction drawings. I was expected to figure out what to do from there.

I was off to a slow and bewildering start. It seemed like I spent weeks agonizing over the choice of a simple lighting fixture—one I was ordering out of an architectural catalog. WDI's maze of cubicles and communal worktables worked to my advantage. If I heard over the wall that someone had an approaching deadline, I'd volunteer to help assemble the paperwork so I could see how it was formatted. When I walked past someone at one of the big tables, I might get called over to learn a new trick.

I slogged through my own design one step at a time and had my drawings ready to send to Florida on the deadline. At the last minute, I learned I had to track down a manager to sign for the overnight shipping cost. I obtained the signature, musing that no one had had to sign for the hundreds of thousands of dollars of work that was specified in that $10.95 shipment. Little did I know what a lengthy review process was yet to come, courtesy of the architectural world.

I was lucky to be hired when there was an abundance of projects, big and small. I was assigned to half a dozen small projects, plus Star Tours (1989), for the theme park now known as Disney's Hollywood Studios, which was just finishing up the design phase. I completed all the designs in my first year and all the installations in the next year and a half. Since Hollywood Studios was a whole new theme park, I worked in the field with several experienced lighting designers who taught me invaluable particulars about the equipment and the process. I had a wonderful opportunity to learn a great deal in a short time span.

The best advice came from one of my fellow lighting designers. He told me to go with my gut reaction. He pointed out that even though my teammates might have tons of Disney experience, I was the one with the lighting expertise. His encouragement to trust my own instincts was especially helpful when I was just starting a new job, and it served me well over the years, even after I had gained more of that unique Disney knowledge.

One day, I was called to the lighting library and confronted by a lineup of all the other lighting designers. They told me I had to prove my mastery of one more skill to be accepted as a "real" member of the show lighting team. There was a beat, and they all pulled their hands out from behind their backs and began to juggle. I said, "No way!" "Start practicing!" they replied. To this day, I still cannot toss a roll of gaffer's tape to someone on a ladder and get it within three feet of them. But they decided to let me stay anyway.

As a theatrical lighting designer at the college level and in live theaters, my gender was not unusual for my role. In fact, some of the first generations of Broadway lighting designers were women, sometimes starting as assistants to production designers who preferred to concentrate on the scenery and not be bothered with the lighting. I was often on an all-female team of designers, and I worked with many female directors and many female electricians.

At WDI, most of the lighting designers throughout the years have started their careers in theater. Theatrical training teaches skills in

support of storytelling and entertainment value. Naturally, I was thrilled to be among theater people in the lighting department. There may have been a predominance of men, but there were always other women besides me. Perhaps I was naive, but among the lighting designers and throughout the show division, I never felt I had to prove myself as a woman during the design process.

On the construction site, however, it was another matter.

Women, minorities, short men, people who look too young—in a new situation, we all have to work a little harder to earn the respect of our coworkers.

In 1988, my first time on a construction site at Walt Disney World, I had a lot to learn. I had to ask a lot of stupid questions and admit to being inexperienced, which earned me a few eye rolls and some patronizing advice. But that was okay, because I got past that and didn't have to ask again. On the other hand, I found that the foremen were often impressed that I knew the drawings inside and out. Well, of course I did. I had drawn them myself and placed each and every light with a lot of thought. That knowledge helped redeem me, and we entered into something of a partnership. They would help me out when I blundered, and I would identify some of the finer points of the installation that they might have missed. Mostly, I would take responsibility and stick up for them when things didn't go quite so smoothly.

Along with my technical knowledge of lighting, my theater experience was always in the back of my mind. As a technical director, I had been in charge of scenery construction, and I was often viewed skeptically by a new guy assigned to my crew. What does some girl know about carpentry that he doesn't? One of these cocky types installed

a piece of wood with a big knot in it on a structure that an actor had to climb. When I told him to replace it, he argued that it was perfectly safe, and he demonstrated by climbing up very carefully, stepping only near the end of the board where it was strongest. I told him an actor shouldn't have to be that careful and that if he jumped on that knot, the piece would break. He jumped. It broke. He fell. Fortunately, only the board and his pride were injured, and I never had trouble with him again.

Similarly, the average field electrician on a Disney lighting job is familiar with standard equipment, but often has little or no experience with theatrical light fixtures. Once, as soon as a light was turned on for a test, I called out, "There's something seriously wrong with this light!" The electricians thought it looked fine. We opened it up and quickly discovered that it had arrived from the factory with one of the lenses missing. Score another one for me!

Every time you know something your team does not, you earn bonus points in respect, especially if you don't gloat and rub it in (like I just did). It's comparatively easy to get ahead of the game by learning about the equipment and testing samples. Sometimes we get a little lax about this step. No matter what your discipline, the more you educate yourself about the details instead of leaving them to someone else, the better off you are in the long run.

One way to earn respect is to treat others with respect. Don't assume, listen.

At a lighting trade show, I walked up to a color filter manufacturer's booth and was greeted by an attractive receptionist. I told her I had some technical questions about

dichroic color filters and asked her to direct me to someone who could help. She answered, "I can help you with that. What do you need to know?" And I said, "No, I'm a lighting designer for Disney, and I need someone technical." She replied, "Actually, I'm the head of the dichroics department. I really am the best person to help you." I was so embarrassed! Just because she was young and pretty, I had assumed she was hired for the trade show to be a "booth bimbo." It's bad enough for a man to make that mistake, but so much worse for another woman to underestimate someone based on her looks.

One of the best things about Imagineering is that no two projects are ever the same. Can you design it all to work on a moving stage? Can you design this for trackless vehicles that can turn in any direction? Now see if you can do it underwater! Now go do it all in another city, or another state, or another country!

With a few projects under my belt to answer those questions, I felt more confident about being able to handle my next assignments. Over the next few years, I designed the lighting for Splash Mountain (1992) at Walt Disney World and for several small projects at Tokyo Disneyland.

I was also sent to Anaheim to serve as the on-site lighting designer for Disneyland design services and show quality standards—another job Paula Dinkel had held before me. This assignment allowed me to continue at Imagineering, but in a completely different role—different people, offices, duties, budgets, and schedules. Everything demanded an immediate response, and all the logistics centered around a fully operating Disneyland Park.

When you're working on attractions in a fully operational theme park, the challenges are many. Much of the year the parks are only closed for the overnight hours, meaning you can't just walk out into the park and make adjustments and repairs while guests are enjoying the attractions. On the plus side, you can walk out and see what is working and how it is working for the guests. Occasionally I would come into my cubicle to find pieces of a light fixture on my desk with a note: "Where can we get a replacement?" I had no idea where it was from, what it might be for, or when it might possibly have been purchased in the years since 1955.

One night, I looked at the color-changing lights on Space Mountain and thought, "No lighting designer ever programmed the lighting to look like that." After checking the documentation, restoring the control settings, and returning the right colors to the right light fixtures, we looked at it again. It was gorgeous! That's why a designer is needed to be sure the original show quality is maintained and doesn't gradually degrade over time.

The projects were smaller, but I had the gratification of seeing them completed within weeks or months instead of years. Working with the same small teams over and over fostered a level of camaraderie and trust among us. It was an enjoyable and rewarding change of pace.

Rather than studying a model for inspiration, I loved being able to walk into the park to absorb the environment full of guests. One day I was in Adventureland to take pictures of existing conditions with a Polaroid camera, the kind that immediately spewed a print out the front. The paper cost about a dollar a shot and provided a very handy reference. A guest stopped me and said, "I'll give you a dollar if you take a picture of my son." I looked over at her son, who was covered head to toe in ice cream! I laughed and took several shots and gave them to her. Needless to say, there was no charge.

After three years at Disneyland, I was called back to WDI Glendale for a new assignment as the lighting design lead for Mermaid Lagoon (2001) and Lost River Delta (2001), two very different lands at Tokyo DisneySea.

The company had three whole new theme parks underway at this point: Tokyo DisneySea (TDS), Disney California Adventure (DCA), and Walt Disney Studios Paris (DSP). In the flurry of hiring, my husband, Jeff, joined Imagineering as a systems planner.

Some couples work well together, but not us. I think spouses expect something different of each other, as if their partner should know what they want, so they don't explain it the same way as they would to someone else. Fortunately, our specialties took us on different journeys. It was perfect for us to work at the same company but not in the same building and rarely on the same project. We knew many of the same people, and we could appreciate each other's stories. We would commiserate about our day at work during our commute, and by the time we arrived home, we were finished with that and could move on to other interests.

I had completed the Florida installations after numerous long business trips. For TDS, I moved to Tokyo for about eighteen months without Jeff. Even though they might have found him some kind of work to do, it would not be as a planner, and he didn't want to put his career on hold, especially since he was fairly new to the company. As for me, TDS was my best project yet, and I wanted to see it through to the

end. It was a tough decision to go without him, but we had celebrated our twentieth wedding anniversary, and we decided we could handle the separation.

I was fortunate to have the opportunity to live in another country under such supportive circumstances, and I had even studied Japanese in college. By the time I actually moved, there were many Americans who had relocated before me, and I already knew many of our Japanese counterparts from prior business trips. There was a relocation company that helped find me an apartment, set up utilities, and complete all the paperwork. I had American coworkers and friends to share stories and laugh about how we had missed that train connection. I had Japanese coworkers and neighbors to ask for advice in getting around and shopping. (I couldn't believe how many different kinds of soy sauce were on the grocery store shelves!) Everyone was very welcoming and happy to help. It's amazing to me to think of how brave people must be to relocate to a foreign country where they don't speak the language and have none of this support. What a great opportunity to experience life abroad with a huge safety net!

Over the years, the world has gotten smaller: travel is easier and communication is hardly an issue. I remember cutting drawings up into 8.5-by-11-inch sheets so they could be faxed to Florida in 1987. Now we access drawings all over the world with our smartphones. But those are just technicalities. Communication involves many cultural undertones.

A Floridian construction supervisor once remarked that people in California automatically assume he's stupid because he speaks with a Southern drawl. I already knew how smart this person was, but

it made me realize that I often had that same prejudice when I first met people with a Floridian accent.

Later in my career, I had to learn a similar lesson about people speaking English as a second language. I suppose idiomatic unaccented English makes a person seem smarter and a little less foreign. Then I learned that Japanese companies often choose an especially fluent and likable guy to represent them and earn the trust of their foreign counterparts. (I can't imagine a woman in this role.) While we might think of him fondly as a great guy in a key position, the Japanese might think of him as our handler. I still have a lot to learn about how other cultures perceive us.

Becky Bishop gave me some excellent advice about working in Japan, in addition to taking me to a fun little craft shop, showing me how to find the swap meet near the temple, and generally making me feel welcome in a strange new place. Becky advised me not to push my technical knowledge too much with our Japanese colleagues. Note that I worked almost exclusively with male Japanese engineers and technicians. She suggested that I would be challenging them if I took them on in a technical issue, but if I could find a creative reason for using a particular method, it would be easier for them to accept my direction. A creative vision was (and still is) recognized both as an Imagineer's role and a woman's role.

In Japan, I learned about the importance of giving face, another way of showing respect. The Japanese watch to see how people are regarded

by their team. Do people seek out their opinion, or listen to them when they talk? Or do they brush their comments aside? The Japanese are especially sensitive to this ranking within the group, but it applies to all of us. When a new person is introduced, if several people say, "Oh, isn't that great? She'll take care of us!" everyone is immediately predisposed to like her. Even on the first day the construction workers treated me with a deference that went beyond politeness, and that meant the Japanese engineers had given me a good report in advance. I resolved to do the same for other newly arrived American team members. We all benefit from a little help from our friends.

※ ※ ※

On my first day on the construction site for Visionarium (1993) at Tokyo Disneyland, I could tell that the electrician was having trouble locking down a light fixture. I wanted to see it for myself, so they asked me how much I weighed. What? Oh, the lift could only support so many kilograms (pounds), and they needed to send both me and the electrician up together. Well, the lift stopped about sixty centimeters (two feet) short of the target. The electrician reached up to the light pipe and did a pull-up to lift his weight out of the bucket and then gestured with his foot for me to push the button. It worked to get the lift to rise the rest of the way. Sadly, the conclusion was that all the light fixtures needed to be removed to have their C-clamps replaced.

It was not a happy thing to report on the first day, but I softened the blow by praising the electrician by name for his ingenuity. I repeated how much I was looking forward to working with him on the project, hoping the hint would help get him assigned to stay on. Instead, I was

informed the next day that he had been reassigned to another job. I shrugged and thought, oh, too bad.

Many years later, I was offered a cultural training class for Americans relocating to Tokyo. All the previous classes had been about business meetings, and who sits where, and how to handle a business card. This training went much deeper, and I learned the saying "The nail that stands up must be hammered down." This speaks to Japanese conformity and humility. When you praise someone individually, you make him stand out. In other words, I was responsible for having the electrician who cleverly defeated that lift removed from the job! What should I have done? Apparently, I should have praised the group, not the individual. Everyone would have known who made the impression, so there was no need to single him out.

I'm sure I have made many blunders over the years. I only hope none of them were quite as bad as that.

※ ※ ※

One day in the field in Tokyo, I lost it, and I lost it three times. One of my projects, Lost River Delta, was fairly complete and way ahead of the other lands, while my other project, Mermaid Lagoon, was way behind. I was working long hours, and I was under a lot of pressure to get my work done while keeping both teams happy. I guess I did learn a little bit about juggling after all.

I don't remember what it was about, but three times on the same day, I blew up at someone and was angry, or yelled, or was hurtfully sarcastic and mean. It was uncalled for. I felt so guilty at the end of the day. But then the next day, one of those people came back with great apologies and told me how they had fixed the situation. Hmmm. I felt

guilty, but I got action. I remember a time when a Southern woman told me that sometimes you need to throw a hissy fit. Maybe that wasn't such a bad thing, especially for us as women. Our mothers raised us not to be assertive, but sometimes it's necessary—and it does get results, especially when it's not overused.

On a large project, many families are relocated along with the Imagineers, but family members are never allowed on the construction site. Many of them are sent home long before "soft opening"—the period before the official grand opening, where Disney has a chance to see how things are working with minimal, invited crowds. Family members may never have a chance to see their loved one's work. Usually, the company holds a Family Day as soon as the project is substantially complete and the ride has passed the necessary safety tests. For whatever reason, the Oriental Land Company did not allow us to hold a full-on Family Day for TDS, so instead we had a day for escorted walk-throughs of each land. It was all planned out and was to be very orderly.

That morning, I was awakened by a frantic phone call reporting that the lights inside the Mermaid Lagoon attraction weren't on. All they had was the minimal, dim lighting that we leave on overnight for safety. I hopped on my bicycle and sped over to the office. I booted up the computer, but everything looked fine. I raced over to the electrical room and typed in the commands to release a manual override and run the show programming.

Meanwhile, the volunteer tour guides were waiting at the entrance, discussing how they would cope with a dark attraction. Fortunately, the lighting magically turned on just as the first group was approaching! I received many expressions of gratitude over the next few days for my

staunch efforts to solve the problem and save the day. Yet all I could think about was that if I had checked everything more thoroughly the night before, the lighting would have run smoothly. It seemed I got more recognition for screwing up and fixing it than I would have gotten for doing my job properly in the first place.

It's not easy to say, "Pencils down! You're done!" On my first few jobs, I was typically programming all night, until the very last minute. Then I had to scramble to get everything documented and pack up the field gear in time to catch my plane home. My last day was unfailingly loaded with stress until a programmer advised me to finish one night early, so the show had a chance to run a full day's cycle without any changes. After I took that advice, my last days were spent calmly making the rounds of the office to say thank you, taking photographs of my work, and riding or walking the attraction one last time just to appreciate it. Instead of leaving with a vague worry that I might have missed something, I left with a sense of accomplishment.

When I had only a few nights of work left at TDS before moving back to the United States, I had a long list of small items that needed to be checked and tweaked. Before attacking that list, I walked my lands, asking myself if there was anything major that I had missed. The clear answer was that the pond below the Fish Coaster was dark. There were ten underwater lights for a splashdown effect but no gentle glow in the rest of the pond. What a shame that those ten lights had such a small impact since the vehicle zooms by so fast. Hmmm. Maybe I could use half of them for the splashdown and repurpose the other half to light the pond? It was about 2:00 a.m. on a warm summer night, and I hadn't seen anyone from the custodial crews for at least an hour. After

making sure the coast was clear, I removed my shoes, socks, and jeans and waded in to re-aim the lights. It worked! I waded back out, used my socks to dry off a bit, got dressed, and reprogrammed the lights. I had felt a little embarrassed about wading around and bending over half-dressed, but when I was finished, I was really happy that I had taken that moment to step back, look at the big picture, and make a change that mattered.

⁂

I lived in a lovely suburban neighborhood near TDS/TDL, and the neighbors would often come out into the street at night to watch the fireworks. The Japanese woman across the street was an English teacher who occasionally invited me over so that her children could practice speaking with me, and we looked after each other's cats. When the neighbors were invited to the soft opening of TDS, she gave me the best compliment ever. She said she could see my smile in the lights shining down on Mermaid Lagoon.

⁂

I thought that all the culture shocks would be in moving *to* Japan. But moving back to the United States took more adjustment than I expected. While living abroad, I had discovered that there are numerous expats all over the world. Many of them move from one foreign assignment to the next. I came to see myself less as a citizen of the United States and more as a citizen of the world.

My American friends back home didn't have that point of view. While they were eager to listen to a few good stories, nobody wanted to hear me repeatedly respond to their comments with a comparison to

Japan. Conversely, my friends had had their own shared experiences that did not include me. The same was true for my husband, and I felt that we had grown somewhat apart. There was a vague feeling of estrangement, and although we were back in the same time zone, we weren't together just yet. (He had even reprogrammed the radio station buttons in my car!) But as we plowed on, we grew closer again as we spent more time together and built new shared memories. Both friendships and relationships take a little faith to maintain. I believe our marriage is stronger because we were reminded that while we are each capable of having a life on our own, we are happier together.

My next assignment, in 2005, was as the lead lighting designer for Fantasyland at Hong Kong Disneyland. The relocation was also for about eighteen months, and this time Jeff was relocated with me based on his own value to the project. We loved our life together in Hong Kong, and we could both take pride in seeing a Disney theme park take shape where there had been only landfill before.

The team spent several days preparing the site for Family Day at Hong Kong Disneyland. It would be our first trial day of operating the park as a whole, rather than just testing individual attractions. Moreover, we wanted to show off our fabulous work to our families.

The lighting team came in early so we could make sure everything was working properly. No repeats of my experience at TDS! When all was ready, as I walked to the main entry, I was accosted by a series of Disney characters eagerly standing by for their first guest interactions. I waved and high-fived and fist-bumped my way to the front of the park. And there I saw and heard the mass of joyous Disney family fans waiting at the entry, eager to experience Hong Kong Disneyland for

the first time as guests. When the rope dropped and everyone raced to their favorite attractions, my eyes filled with tears. It was the first rope drop for this brand-new theme park, and I still get choked up just thinking about it.

The big gala party and press event for HKDL was held the night before Opening Day. The festivities included televised celebrity entertainers performing on a temporary stage with temporary TV and entertainment lighting. There wasn't much room on the castle parapets, and they had turned my show lights up to face the sky, thereby creating a flat surface so they could put their own lights on top of mine. A crew was assigned to dismantle it all and restore the original theme park lighting after the show.

 I came in early before the grand opening to verify that everything was in order. I was stopped at the stairs leading to the upper floors of the castle by a man in Chinese army fatigues who said no one was allowed up there. Because Chinese vice president Zeng Qinghong was part of the ribbon-cutting ceremony, security was tight. I said, "But I'm the lighting designer for Disney, and I have to check the castle lighting!" To my amazement, he stepped aside and told me to go on up! The half dozen or so security personnel lounging around waiting for their call hardly glanced at me. I think that's the most influence I ever wielded as a lighting designer.

I continued to work on attractions at Hong Kong Disneyland until I retired ten years later. I designed "it's a small world" (2008), Grizzly

Gulch (2012), and Mystic Manor (2013). With the help of capable, hardworking Chinese lighting associates, I was able to schedule my fieldwork in a series of business trips with frequent visits home in between.

Hong Kong is a very cosmopolitan city with a wonderful mixture of old and new. The culture has evolved from an interesting blend of British and Chinese customs. I truly enjoyed the city and the friends I made there. It was also a rewarding experience to watch the park grow and mature. But eventually, it was time for me to retire and pass the torch on to the next wave of enthusiastic, talented young lighting designers. I follow their posts on Facebook, and I especially appreciate reading about their new experiences at WDI and hearing their fresh takes on the Disney Parks.

On the whole, it was a dream job and a perfect fit for me. I had so many opportunities to work with incredibly talented people, each unique in his or her own way. I was fortunate enough to live and work overseas, and now I have friends all around the world. I hope I have helped to make that world, or at least the Disney Parks, a little bit more fun for children of all ages.

When asked about my career, I am always extremely proud to say that I was an Imagineer.

Becky Bishop
Principal Landscape Architect (Part I)

The Tree That Eclipsed Discovery Mountain

I was on the hunt for the perfect tree. There was one lousy four-by-five-meter planter in the whole attraction. One measly little patch of soil set against the gigantic Discoveryland backdrop and an acre of water that housed the **Les Mystères du Nautilus** attraction. One singular tree specimen that would represent the signature seaside statement that I was determined to make.

It was a tall order, but I was like a dog with a bone: to find, purchase, and install the damn thing. I was Neil Armstrong, planting the flag on the moon.

Let me tell you how I found myself in this unenviable position. I was prepared to do literally anything to be a part of the Disneyland Paris (formerly known as Euro Disneyland) team. I did get a bit part in the initial launch, but my true gold nugget was the Advanced Capacity Projects (ACP) group that started up immediately after opening. ACP was in charge of facilitating how people moved around the park.

What I signed up for was the Paris version of the Storybook Land Canal Boats, my all-time favorite Disneyland attraction, designed by my

mentor Bill Evans (the original Disneyland horticulturist). In accepting the gig, I needed to wade through eleven other assignments—including finding the perfect Discoveryland tree.

So I found myself flying to Germany, to one of Europe's premier nurseries—Jan-Dieter Bruns Nursery in the lovely town of Bad Zwischenahn. I had to locate the one-in-a-million European tree that would telepathically transport our guests to the rough and rugged California coastline. One visual cue that would express the windswept cliffs overlooking the Pacific Ocean with the crest of the Nautilus submarine rising out of the crystal blue water. All my eggs in one tree basket, as it were.

It was the dead of winter, excruciatingly cold and with snow on the ground. I wasn't deterred and was determined I'd find it—my German nursery colleagues, who were at that nursery every day, were not so sure.

We searched more than twenty growing fields, with another ten to go, before my German friends began asking whether there might be another choice beyond the crude sketch I had drawn for them. Seeing my exhaustion and disappointment, they suggested we break for lunch.

An hour or so later, we bundled up again and faced the light snow to conquer the remaining ten fields. Lo and behold, toward what seemed like the very end of our day, we came across a small roadside public water reservoir. I cried out, "Stop the car! There it is!" The perfect tree arching ever so scruffily, angled and reaching picturesque branches over the water. It was just how I had imagined it would look in the Nautilus attraction.

Now I was delighted. My nursery colleagues were perplexed—happy that I was so pleased, but darting looks at one another, wondering how they were going to obtain this tree, which was clearly not on their property, nor was it one of theirs to sell.

Remarkably, the nursery was able to procure the tree from the local government, and I returned to Paris to await the arrival of what I was now lovingly calling My Tree.

Unfortunately, the first of many snags impeded my possession. Once the tree was removed from its lakeshore home, it was discovered that it was too large for the lorry (European-speak for "truck"). We needed to trim some of the branches for the trip to France. Since each branch was critical, and I was unable to leave the theme park, I had to rely on the artistic eye of my contractor to force the subject to comply.

I need to come clean here. My producer, the one I shall euphemistically call a perfectionist, had cautioned me early on to select a small tree, something that would not detract from the view of the surfacing submarine . . . hmmm.

Meanwhile, back in Germany, even with trimming, my tree was going to require a large truck. This presented all kinds of complications that I was not willing to acknowledge (higher transport costs, driving time needed to be in the dead of night, a complex route that could handle the increased height requirements). The cost of my tree was quickly doubling. I was getting nervous, but I held firm to my commitment. I was sure it was going to look great.

The day of the tree's arrival was at hand. It would be on-site by 4:00 p.m., with a planting time of 11:00 p.m. (The park was up and running, so we did our project work at night.) I was in a meeting with the Nautilus team, reassuring everyone that my specimen would *never* upstage the submarine, when my contractor slipped two photographs upside down across the table to me. I nearly died.

My tree, now dug up, balled, and burlapped, stood what looked to me at twenty-five feet tall. The root ball itself was taller than the man smiling next to it. I quickly flipped over the photos and saw my career implode. But I was so far pregnant with this endeavor that I

had no choice but to proceed, hoping against hope that the photo was misleading and not a clear representation of my tree's size.

The tree was completely covered in burlap, and I had instructed my contractor to leave it covered until everyone on the Nautilus team had gone home for the day. I thought by some miracle I could plant the thing, and it would look so fabulous no one would remember that it was supposed to be "smaller."

By 1:30 a.m., the tree was dangling from a crane—a little tired, its root ball sagging like my spirits. But I was still confident that my tree was the right cast member for the show. All I needed was to put it into place.

As I directed the last lift of the crane, the tree spun into the perfect position, and we set it gently down. I happened to look across the water—and to my shock, I saw both my producer and project manager, arms akimbo, shaking their heads in my direction. Talk about facing your executioners.

I pulled up my bootstraps and trudged over to accept my fate. I'll tell you, that was the longest three-hundred-yard walk I have ever taken. When I reached them, I braced myself for their admonishments. Their first words were "That tree is too big. We didn't think we liked it when we first saw it . . . *(pause)* but it grew on us." Then, after a longer, truly excruciating pause, they said, "Good job," and walked away into the French fog, like Bogie and Claude Rains in the final scene of *Casablanca*. I restrained my whoop of joy, but I did feel great.

Because of my exhilaration that night, I knew I would never be that designer who took the safe road or picked the easy choice. I vowed then and there to always take a risk in my designs, to take a chance on the unexpected, and to always move out of my comfort zone—the rewards were, and are, so much sweeter.

Karen Connolly Armitage
Concept Designer

I Made My Career

The breezy golden late afternoon was visually striking. I remember it clearly. My husband of six years, Frank Armitage, and I were heading to the Huntington Hotel in Pasadena to attend our mutual ten-year anniversary awards dinner for WDI. It was spring 1988. I had started in April of 1977, and Frank had been rehired in March of the same year. We, along with many others, were part of the buildup in creative staff for the construction of EPCOT Center in Florida. But work-wise, our paths had never crossed.

I was surprised and delighted that we were seated next to the head of WDI, Marty Sklar, and his wife, Leah. I remember Marty told me about his daughter, Leslie, who had gotten a job—first at the Disney Studios and then at Universal Studios—reading and proofing scripts. And no one at either place knew who she was! He was clearly so very proud that she was determined to stand on her own merits.

After the dinner, one of the execs from creative stood up to begin

awarding the ten-year pins. Since Frank's last name began with an A, he was up first. His many accomplishments were praised: he had been the head of the design team for EPCOT's upcoming Wonders of Life Pavilion and had done some fantastic art direction, concept paintings, and models for that.

Frank was asked to stay onstage as my name, Karen Connolly Armitage, was called. I will never forget what was said.

"Well, what can I say . . . for sure, the biggest achievement of Karen's career in the past ten years is that she managed to marry this man, Frank Armitage." And that was it.

I was startled. Confused. Shocked. I could hardly breathe, let alone talk. So I returned to my seat.

And my confusion continued when a delightful and imaginative team leader with whom I had worked came to the podium for his pin. That same exec credited this young man for much of the work I had done on The Great Movie Ride—specifically the tricky, technical timing of the ride layout, and the model for the Gangster Street scene.

I wondered how—even why—all my efforts, my journey thus far, seemed to culminate in this way, at this moment. I got up and went to the ladies' room. I did not see myself in the long mirror over the sinks. I saw bits of memories, going back ten years and more.

It was 1977, late January. I arrived at the check-in desk at the Bonaventure Hotel in downtown Los Angeles, mumbling several Hail Marys and still shaking from the drive (in a rented car) from the LA airport. It was my first trip west of the Mississippi.

Straight out of the University of Wisconsin grad school with an MFA in hand, I had gone to work in 1973 for (Grady) Larkins Associates in St. Louis, Missouri. This theatrical design and production company was doing interiors, graphics, props, and dressings, plus scenery for two rides, for a new Anheuser-Busch park in Williamsburg, Virginia.

Consequently, I learned a lot about the theme park business there. In January 1977, I was sent to a trade and gift show in Los Angeles to purchase African props and set dressing for Busch's next attraction in their Tampa park.

January in St. Louis was cold, with two feet of snow on the ground. Los Angeles in January was green and warm. I very much wanted to leave St. Louis. I had brought two portfolio books with me, and I had the name and phone number of Eric Westin, who was head of interiors at WED. Few memories of my interview in the front lobby remain. I know Millie, the receptionist, was eagerly listening in. I met Bill Martin, head of architecture, and George Windrum, head of show set design. I sensed all was well when Eric asked George to give me a tour—back into the secret halls of WED.

It hit me. I was going to move to California. I would take out a loan to pay for the move if I had to. I was going to live near Hollywood. I was going to work for Disney.

On the flight back to St. Louis, with a letter of intent to hire, all I could think was, *No more cold wet icy winters! No more driving on black ice! No more bad winter colds! CAL-I-FOR-NIA, here I come!* It was the promise of magic!

As I leaned against the wall in the restroom at the awards dinner that night, amusing and delightful moments raced through my head. When I began my Imagineering journey on Flower Street, I was teamed up with Dorothea Redmond on several remodels for Main Street at both Disneyland and Walt Disney World. I started to learn not only how this company produced its magic, but, from the amazing Dorothea, how to float in a ceiling or a floor or a sky in watercolors. I learned how a bit of salt on a wet watercolor wash could produce a surprise texture. And that foliage looked best with a wet raw umber shape and then drops of Prussian blue to "grow" into various clusters of leaves.

Dorothea's incredible WED legacy of beautiful watercolors for New Orleans Square was not her first portrayal of the Deep South. She was the first woman continuity artist hired by a major motion picture studio in Hollywood. In the late 1930s, producer David Selznick hired her to do initial production art for *Gone with the Wind*.

Oh, the stories I heard. I can still hear her elegant diction correcting me when I suggested we could use "bentwood chairs" in the new American Egg House in Town Square on Main Street. She shot me a dignified look over her reading glasses, and said, "Oh, dear one, you mean 'thonays.'" I learned that Thonet was the name of the man who invented these bentwood chairs.

Those early EPCOT days also introduced me to Harper Goff, who directed me, as well as others, to draw final layouts and facades—at one-eighth scale—to paste on his models for the Germany and Japan World Showcase pavilions. This assignment also introduced me to the historic Model Shop, the best playpen I've ever been in.

Bill Anderson was painting the geodesic pattern on that huge sphere on the full model of the whole park. Maggie (Irvine) Elliott and Kim (Toombs) Irvine built and painted the small themed buildings with—I swear—a one-hair brush. Such precision! Barbara (McGloughlin) Whiteman and I were working through the biggest set of interiors either one of us had ever seen—me on the theater and her the lobby for the American Adventure, in concert with and supported by the seemingly mild-mannered but wickedly funny architect George Terpatsi. I was also working with Harry Webster and Rick Rothschild on the France Pavilion's film theater, designing the theater's interior finishes as well as the front curtain to work with the opening film reveal. There was timing to consider, and theatricality—but that luscious deep burgundy velour front curtain with its heavy gold brocade fringe that I got to design . . . yum.

That takes me back to my ten-year anniversary. Early in 1985, I had been part of a team working on a concept for an entertainment pavilion for EPCOT. It was one of the first assignments from our new corporate leaders, Michael Eisner and Frank Wells. That concept would become Disney's Hollywood Studios.

That evening in the hotel restroom, I smiled. No one could erase my work—not really—any more than I could hijack anyone else's accomplishments. Those memories and that work were woven into my being. It was all a huge part of my truly becoming an Imagineer.

I returned to my seat with a smile in my heart, ready for the next decade and what it had in store.

It turns out that I had the time of my life in the next three years, working on the Euro Disney (EDL) project. Joining Jeff Burke's Frontierland team, my assignment was art direction for the interiors: merchandise shops, restaurants, and some preshows. We had a great, fun team guided by our charming storyteller and talented visionary, Jeff. Maureen Sullivan, one of my equestrian riding buddies—after work we rode our horses on the trails around Griffith Park—was the Frontierland lead for show set. Leticia Lelevier was head of graphics. I had the quintessential mining prop master, Pat Burke, in the next cubicle. Our land architect was the very talented Ahmad Jafari, who was also heading up Adventureland. We were all in cubicles in the un-air-conditioned, factorylike Chastain Building, down the road from the original WED building. We would all later enjoy long trips, or move, to France.

The EDL overall project architect was the great Dick Kline, who had originally created Disney's River Country in Florida and had coached me on Frontierland rehabs during my first year at WED. So when Ahmad needed to concentrate on Adventureland, Dick taught me how to draft the big-timbered buildings, like the Cowboy Cookout.

I had been trained as a scenic designer for the theater, but I had no formal architectural training. So Dick tutored me for hours after 5:00 p.m., two to three days a week, for months, teaching me how a big, barnlike building from the 1850s American West would have been built. He also showed me how to structurally incorporate Pat Burke's found mining equipment inside some of the shops. I learned how to hide steel supports inside distressed beams. I worked on sight lines, the functional layout, and the complicated roofline. Everything worked together to tell the story, just as in scenic design for a play—but here it had to be permanently architecturally sound, something I had never had responsibility for. To be personally tutored by someone like Dick Kline was nothing less than a blessing and a gift from the Disney muses.

I have realized that life, the universe, God, or ? has always given me what I need when I need it. It's not always served up in a way that's easy on my soul, but I have been miraculously, magically supported, by great teachers. Often when I thought I was giving all that I could offer, I was pushed, I was taught how to do more than I thought I was capable of. And there was a lot of joyful laughter. Oh, and we were in France!

By late 1990, it was time to hand over EDL to another team to finish, so I returned to California and joined the Port Disney/WestCOT team. Sadly, those two ideas remain in the WDI drawers among wonderful "might-have-beens." Nevertheless, the WestCOT team in particular was hysterically full of mischief. Under the guidance of my favorite dragon lady, Doris Hardoon Woodward, and the dry Scotsman, Jan Sircus, we designed a walled city combining concepts from EPCOT with hotels on top of the shops and restaurants and some of the ride buildings, all surrounding a wandering lagoon.

Never stuck in the doldrums for long, in 1997, WDI celebrated its forty-fifth birthday and Christmas at a party at Disneyland, around

the Hub and throughout New Orleans Square. Ten days before, a crazy dynamic and inspiring art director came to my office with a favor to ask. He and a bunch of "the guys" were redoing the Pirates ride for the party. For the evening, they were dressing as additional pirate figures and joining the scenes in the ride, lip-synching and really drinking alongside the Audio-Animatronics figures. They were combining the audio loop "Yo Ho (A Pirate's Life for Me)" with a techno version of the "it's a small world" soundtrack. *Oka-a-a-ay! Yikes!*

And would I . . . please don a skimpy waitress uniform from Club 33? And could I sing something in the Captain's Lair scene in the ride?! So I suggested "Big Spender" from the musical *Sweet Charity*, which I had done professionally in my previous life as an actress.

I was given a boom box with the music, and I sang my heart out as boat after boat drifted by. Lots of laughter, whoops, and hollers—even some catcalls! Afterward, I vowed never again to try to seduce a plastic skeleton stapled to a plywood bed.

In April of 1996, my husband, Frank, suffered a massive heart attack and underwent his second open-heart surgery. It was then that he told me he wanted to get out of LA. So I knew we were leaving . . . eventually. In 1997 we bought twelve acres of raw farmland in Paso Robles, California, and devised a six-year development plan for our future "ranch." I'm the first to admit I never could have done this without my education from the masters at WDI! Meanwhile, I continued to work on various projects.

One of my favorite parts of working at WDI was that I was able to wear different "hats." While there had been assignments where I was an overall concept designer for a land in a new park, there were other times when I would support others. For instance, there was much fun and delight working with David Brickey on a few interiors for the Safari Village in Disney's Animal Kingdom. And then, later on, again with David

and the themed lighting department, inventing fixtures and bronze doors for the Hotel MiraCosta at Tokyo DisneySea. It was like being asked to create exquisite jewelry for a beautiful architectural Venetian princess.

By early 1998, I was working with a very small team on preliminary designs for Hong Kong Disneyland. While this was a relatively tiny addition to the Disney theme park family, it intrigued me. Design-wise it was to be on the scale of the original Disneyland in Anaheim—only smaller. And because of the Hong Kong culture, we needed to acknowledge and support the design directives from the feng shui masters.

My assignment on this project was to oversee the front entrance to the park along with Main Street. Because of my rehab assignments early on, I was very familiar with the original Disneyland 1952–1955 architectural drawings. Further study revealed that these original architects, some of whom had been Hollywood film production designers and art directors, had been very clever and judicious with their detailing. They had been inventing the beginning of the then-unknown theme park industry.

At Disneyland, the designers had taken a fairly limited number of molding profiles and used the same ones over and over again in all the shops and restaurants. But they combined them differently, turned some upside down, and called out different paint and stain colors for wainscot and cabinetry and ceiling cornices. So with Hong Kong we had the keys to delivering an expected Disney quality product in an easy-to-understand method in a financially responsible way.

Tori McCullough's interiors department more than delivered. It was a challenge at first for everyone, but once it was acknowledged that this park presented a different kind of task, for many, it became a design challenge to figure out. Again, David Brickey came up with a brilliant idea for a Disney-themed miniature doll's house—which

I ended up designing and illustrating. I was told after opening that it was the first time in Disney history that Main Street had had an attraction with queues down the street! Bless David Brickey for his idea.

There is another point about this tiny park: it had a rough start for many reasons. Location. Demographics. In 1999, the United Kingdom turned over its control of Hong Kong to Beijing, while the park was already in the design phase. Beijing wanted it: it would be the first time Disney would build on a site related to a communist country.

Personally, I found this to be a profound and moving experience.

We were bringing the strains of "When You Wish Upon a Star" and "A Dream Is a Wish Your Heart Makes" to the children of Hong Kong (and later to the mainland in Shanghai). It seemed to me that Mickey had arrived to quietly suggest, to those Chinese who had only experienced the hard line of communism, along with those in Hong Kong who had not, that their own dreams were alive and well and still had power. And Beijing was supporting it. It's not very often that one can be part of shifting the world politic just a tick—in a good direction—for the right reason. It is called Hope. Regardless of how it eventually turns out.

To say I am grateful is a very small part of how I still feel about Imagineering. I was stretched and pushed further into my own potential than I had ever imagined possible as a young girl. There were times of exuberance and pride, and times of defeat and painful humility. There were high-flying successes and dark, deep failures. Sometimes it was miraculously easy; sometimes it was devastation. I learned so much about design, but also about myself: even in the face of a crushing failure, if you open yourself up, and study it, you will grow.

Frank is gone now. My time at Imagineering was not really wound around him—we just happened to work at the same fantasy factory—

but my memories of him, work, and myself are fused. I was already a designer when we met. He did his work, and I did mine . . . and we both understood each other. That exec at the anniversary dinner so many years ago did have a point. My marriage to that man was one of the best decisions I ever made. Not because he made my career—I did that. But because for thirty-five years Frank always had my back.

And so I am still working—designing in the Paso Robles area. I've done million-dollar homes, remodeled a few kitchens and baths in historical Victorian homes, supported local architects with commercial remodels of historical buildings, and helped to repurpose an Arabian horse breeding farm into a destination wedding venue. And I can do this because I have been allowed to stand on the shoulders of some incredible teachers and mentors—men and women.

I can do this still because of all I have come to understand. Imagineering gave me decades of priceless learning and experience, plus the mental, emotional, and psychological muscle to keep expanding. I still have a magical life—with the nickering of my horses, the purring antics of my barn cats, the excited yips of my dogs and other animals, and the blessing of great wine-making neighbors. And on many a late warm afternoon, I can still see the golden breezes and hear the leaves in the trees sing.

Lynne Macer Rhodes
Producer

Trust the Journey

I considered myself an odd fit for the entertainment industry. I had an undergraduate degree in political science and a graduate degree in public affairs. I had spent the previous seven years in the public sector, running a state-funded program to divert juvenile offenders out of the criminal justice system and into a more supportive environment.

One night while out with my college roommate and her husband, Eric, he asked me what I was doing. I answered that I was applying for several new jobs. I must have shown him a different side of me, because many years later he said that on that night, he noticed my laser focus.

It wasn't long after our evening out that I received a call from the personnel department at WED Enterprises, where Eric worked. I was puzzled. I wasn't sure what I had to offer them. Curious, I agreed to go in. It ended up being a grueling eight-hour day of interviews with the director of research and planning, all his direct reports, and the president of WED. The parting comment from the director of research and planning demonstrated that he understood me: "The government

talks about prototype public programs, but in the end, funding is not always forthcoming." He continued: "The Walt Disney Company is committed to building an experimental prototype community of the future because it was Walt's last dream. We need people like you to help us think it through." The hook was set. It was a serendipitous landing.

Six months after my first day at WED, I was offered a public sector job to lead a regional program in the field I had been in. It was a Monday. The gentleman offering me the job had given me until Friday to give him my answer. On Friday at 5 p.m., I still had not responded. I was torn. The phone rang. "It's the end of the day, Friday," he said, "We need your answer." To my surprise, the words slipped out: "I am not finished here." Thus began a twenty-five-year odyssey at a place I thought I'd stay for two.

As it turns out, the experimental prototype community was not feasible, and yes, it turned out to be a theme park representing a community of ideas about aspects of our collective future. It exists today as EPCOT in Florida.

Over the many years that followed came opportunities of a lifetime: working with bright, creative, mostly like-minded people, interfacing with some of the world's best minds, traveling to distant parts of the globe, preparing site studies and conducting market research for international projects, changing the way work was conducted, preparing agendas for executive workshops, helping launch the Disney Channel, working with the strategic planning group on new business ideas—and so it went.

As in the arc of any career, there were peaks that were energizing and valleys that were full of learning. I was hired as a senior research analyst in January 1977, became manager of research and planning three years later, and then director of program development, associate producer, and producer, my last assignment. In my case, this involved

planning the work and helping manage a creative staff, from conception to completion of a major theme park.

I wasn't bred for the corporate environment. I come from a line of caregivers and healers. Six of the nine members of my immediate family at the time were medical professionals, including a psychologist. There is a language and a way of interacting in the business culture that may have been learned in the locker room, or the military—a man's language. While WED had its roots in the creative disciplines, make no mistake: it was a business with the same imperatives and hierarchy as any business. Some colleagues had family members who worked at Disney, and they had a reference point. Others had boyfriends or brothers who knew the game. The father of one of my bosses had been a storied art director and chief operating officer of WED Enterprises at one time; Maggie Elliott was bred for this and she did a great job. She could read the landscape.

I was a searcher, a thinker, and an integrator. It is not a mystery that I was at home with artists and writers. I had a way of seeing and working that would serve me well over the years. Which brings me to my first story.

I had been sent to Japan for three weeks to be immersed in all aspects of Japanese culture. I was then to write a report to be circulated among Disney executives that would demonstrate that Disney understood the Japanese culture. This was a condition of the Japanese government's approval for Disney to design an entertainment center located at a train station adjacent to Tokyo Disneyland.

Somewhere in the middle of the trip, while I was still asleep, my boss called from California. He was calling to tell me that he was giving

one of my several projects to a guy in our department who needed an assignment.

I had developed relationships. I was proactive. I circulated. I took an interest in the work of my colleagues. As a result, creative teams invited me to join their groups. I had an instinct for navigating myself to places where I could add value. In fact, after I survived many layoffs, one of my bosses said, "You've just been in the right place at the right time." Developing relationships was crucial.

However, while I developed relationships with my peers, I did not always do the same with those above me. There was a part of me that thought of that as "kissing up." I thought it was manipulative. That wasn't me! I am *not* saying to be a kiss-ass, but I *am* saying take care of your relationships: up, down, and across.

I believe I had a shortcoming in cultivating relationships with top-echelon executives from other divisions of Disney, too. It is important to be mindful of human graces and common civility. If an executive you don't report to directly asks you to call them from abroad, call. If another assists you with a project, thank them, and give them feedback. I can think of two occasions where I believe my neglect—or it might have just been diffidence—worked against me. Relationships matter.

※ ※ ※

Yes, relationships matter, but there are lines that are best not crossed. To disregard the topic at this moment in time would be irresponsible.

As a new employee, I was seated next to one of the vice presidents on a flight to Florida. He offered to show me around when we landed and arranged that we meet for dinner. After dinner, he walked me to my room. I didn't think anything of it beyond that he was polite. When I thanked him for dinner and opened my door,

he pushed it wide open and walked in. He made advances. I said no. When it became clear that no meant no, he stormed out, slamming the door behind him. In an instant, I felt that my career was endangered. My instincts took over. I jumped up, went out, and called down the hall to him. I said, "Please, wait."

He looked around with a glint of hope. I approached him, and I said, "It's not you, it's me. I enjoyed dinner. It's just that I don't do this; in fact, I've never done this. Please." He seemed to soften. I still wasn't certain I wouldn't suffer consequences. When I returned from Florida, I made it a point to go around to his office and demonstrate that there were no hard feelings, particularly when I had an assignment that related to his division. He and I remained on good terms. I did not get fired.

There were other less-menacing incidents and innuendos. I felt good about how I handled the first incident and was able to navigate the situations staying true to myself and my craft. Being a strong woman would serve me well.

The first assignment I had when I started at WED was to write a proposal, on behalf of Disney, to a consortium of federal agencies, including the Environmental Protection Agency and the Department of Energy. We wanted money allocated to implement an experimental energy project in Florida as a precursor to the experimental prototype community of the future that was being planned. There were credentialed scientists on board for the project: astronaut Gordon Cooper and MIT-trained engineer Dick Fox. I reported to Dick on the project.

I was sent to Florida to meet with the engineers on-site to gather background on the project. The young engineer I met was clear with me that he didn't understand why they had sent a woman—with no technical background—to write the proposal.

He seemed as equally dismayed with the fact that I was a woman as with my lack of engineering expertise—two strikes against me.

I said, "Why don't you read what I have so far? Maybe I'm not the right person for this assignment." I handed him a page. He read it, handed it back to me, said something like, "Oh, okay," and never said another word. Did it bother me at the time? For some reason, it did not. I knew what I was doing.

On the other hand, I must give credit to John Zovich, vice president of engineering, who was an evolved and fair-minded man. He recognized the contributions of women at a time when women in the workplace were not universally applauded. After a day's series of presentations to a steering committee made up of vice presidents (all of whom were male), John said, "The two best presentations were made by women." It was validating and encouraging, but I hardly thought of myself as a woman—just as another employee with a job to do. Looking back, I see it as a sign of the times that a statement like John's even had to be made.

The only time that we brought up the issue of being women was among ourselves, when one of us was diminished.

Now women are in a moment when we are poised to make progress. The genie is out of the bottle. It is imperative to speak up. Be smart and strategic about it, but speak up. These things have happened to all of us.

✦ ✦ ✦

Speaking up can be important. Too often in the workplace, honesty is traded for ambition. My honesty wasn't something I was interested in trading, but it got me in trouble. As I was to learn, there is a time and a place and a way to deliver the truth.

My overdeveloped sense of justice once caused an ill-timed remark in a meeting with the chairman of the board. I had firsthand

information about a mistruth that was presented during the meeting. When it came up, I said, "They're lying." Oh boy. The chairman looked around quizzically and said, "What is she talking about?" None of my bosses knew anything.

The following day, I was due to leave on a business trip with a creative team to canvass Europe in search of leading-edge entertainment trends. The EVP of our division came to my office, closed the door, and said: "You fucked up; this is what you did; this is what you do next time. Now go get on the plane."

That was the first and only time I had a boss be that direct and honest. I had all the information I needed. My common sense had failed me, but in several firm sentences, he had righted my understanding. Shortly thereafter, I was sidelined for a period. It was a bewildering and painful time. I had no allies and no guides. If you become a political liability to those in positions of power, you will be ostracized. You have choices: you can leave, or you can tough it out.

I chose to tough it out. We women may have a hard time bouncing back when we stumble. We may take it to heart. I certainly did. The turnover in top executives in every business tells you that when the environment ceases to be supportive, men move on. It took me a while to bounce back from a misstep.

I was impressed by one creative executive who continually messed up. The next day, it was as if nothing had happened. He was emboldened. He forged ahead. I thought, *He just went forty million dollars over a twenty-million-dollar-budget. How does anyone survive that?* He didn't withdraw or beat himself up. You fall down, you get up. Fall down, get up. As I once heard a speaker say: "One word:

falldowngetup." Stay in motion. For *falldowngetup* to be one word, you have to know that we each have gifts, and our gifts differ; you have to believe in yourself and know that you are not your last mistake. When you get stopped, find a way to keep going without losing steam.

One of the best strategies for forward momentum is reframing. A story can be told from many points of view; Akira Kurosawa's film *Rashomon* shows us that. Instead of telling the story from the point of view of misfortune, ask yourself what else could be going on here. Tell the story in a way that shows you an opportunity, teaches you something that gives you leverage. Seize your power. Don't let anyone take it from you. Step into your largeness, not your smallness. Know what you do well. The opinion of you that matters most is your own. There is not one single person on earth that has your combination of gifts. Use them wisely.

·· ·✦· ✦ ·✦· ··

Some people have a parent who holds up a mirror to their strengths and reinforces them at every turn. Some people are fortunate to have organizational guides along the way. Within the organization, early on I trusted the director of research and planning. When he left for a position in strategic planning at corporate headquarters, I was crestfallen. It was tougher after that, and I had to rely on my wits. Another ally was Barry Braverman, who started working at WED six months after I did and was assigned to the cubicle next to mine. Barry became a trusted friend, and guide who recognized where I could serve. When he became executive producer, I would go on to support him as associate producer in the renovation of EPCOT and, later, as producer for Disney California Adventure.

Trust, as in any healthy relationship, is essential in the successful functioning of a project team.

·⋅✦⋅·✦·✦·⋅

Note that my mentors were men: a sign of the times, because there were very few women above me in the hierarchy. Later on, I became wary of some women on their way up. There was one creative executive who surrounded himself with what some of us called his "work wives"—girl Fridays who were territorial.

These women could be more devious and possessive than simply ambitious men. If they saw me as an adversary or a competitor, they tried to undermine me by deceptively misrepresenting me. What I should have done on two of the three occasions where I posed a threat was to either go to a superior (though I wasn't comfortable complaining or tattling) or seek reassignment. I felt that staying in such situations wasn't tenable.

Of course, it can be your friendships with women that spur you on. It was one of my close female friends at Imagineering who made a big difference. She saw me under fire from a "work wife." I was offered a position on another team where there was an opportunity to be a difference maker.

My friend Betsy Richman, a dauntless and direct woman, said, "Lynne, you need to be taken seriously." That was all it took. That kind of generosity and encouragement wasn't ubiquitous in a man's milieu. It was just the motivation I needed. Rather than get in a catfight, I accepted the opportunity to move on to an assignment where I would be taken seriously. I went to another project that would last until my retirement and had as much opportunity as I had appetite for.

Today, a male boss probably wouldn't ask a young female employee why she wore her pajamas to work. Of course, they weren't pajamas—actually, it was a nice outfit, but the pants were drapey, and the top was tunic-like. The material certainly was not something you would sleep in; it had a heavy woven texture. Was he trying to say that I should wear tighter clothes? Then came another innuendo: "Macer, why do you wear men's clothes?" Another, more direct hint: don't wear pants. I went out and bought dresses, and he promoted me to manager shortly after. I had been at WDI for three years when this happened. What I gleaned from this is that my boss felt I was worthy of promotion, but I didn't look the part.

As I walked down the main hallway where the executives' offices were, an executive vice president that I was on assignment to walked out and said: "C-c-c'mere. Ah, ah, ah want to ask you something: ah, you a little *haaaaard* a hearin'?"

Something told me the answer was yes, so I said, "Why, yes! I just had a hearing test, and I came up short in the lower decibels in my left ear."

"I *knewww* it," he said, "b'cuz you talk *laouuud*, and when you talk laouuud people think you're not listenin'." We parted.

I wondered what he was talking about. Do I talk loudly? Or does he think I don't listen? That I'm not picking up on his cues, or that perhaps I keep trying to convince him of something when he has already given direction? As with the example of the boss who asked why I wore pajamas to work, messages can be indirect. I was left to moderate my voice, listen carefully for meaning, and then follow his lead. I loved retelling this story because, to me, it was hilarious. "Ah, you a little haaaaaard a hearin'?" It does help to diffuse the discomfort to see the humor in things.

Speaking of humor, during my first six months at Imagineering, I was predominantly humorless, focused on proposal writing to the federal government. As it was drawing to a close, project executive Dick Fox wanted the grant submitted. There were still parts I wanted to fix. I said, "So, you want to send it in before it's perfect?" He broke into genuine laughter. "That's the first funny thing you've said; you are always so serious." More laughter. The thing is, I *wasn't* being funny—I *was* serious. And he was a serious guy, but he appreciated humor. It's important in the workplace. It has to be fun.

We were in Europe for three months, preparing for the conceptual phase of Walt Disney Studios Paris. We had a presentation we used to test our concepts in focus groups. We assembled about fifteen residents in each of five European countries (Belgium, Germany, France, Spain, and Italy) and presented our ideas. I was the moderator. In some countries, they were wildly enthusiastic, and in others, they were unreceptive, almost cynical. In northern Europe, people were largely unmoved, almost too highbrow for our fantasy and frivolity. The further south we went, the more upbeat and merry the responses. That caused our leader at the time, Bob Weis, to proclaim: "Don't build a Disney Park where they can't grow palm trees." I loved that. Bob was funny, and among his other talents, his humor has likely served him well on his road to his current role as president of Imagineering.

It wasn't too long after my promotion to director of program development that the executive vice president at Imagineering invited me to have dinner with him. He asked me what my goals were and where I saw myself headed.

He offered to help me. He asked if there was anything in The Walt Disney Company that attracted me at the film studio or anywhere. "Why me?" I asked. "Why are you taking this interest in me?" He said, "I've seen your writing, and I've seen you on your feet."

I was flattered. But the truth was, I hadn't given a thought to whether I wanted to pursue other opportunities within Disney. I was at Imagineering, remember, by serendipity. In the absence of having a singular goal at a formative age, I had moved forward intuitively. If an opportunity felt right at each turn, I turned. If not, I waited for clarity. I liked what I had been doing. I had been working with creative teams to help frame up the front end of projects and pull packages together. I could add value there. I told him I needed to think about it.

After a few weeks, I told him I wanted to stay on my Imagineering path. What I didn't realize then was that I had been promoted into a role that was likely being battled over at higher corporate levels. In retrospect, it dawned on me that I was a pawn in a much bigger game. I learned that when stuff happens, it's not always just about you.

You are a piece of a grand mosaic. At Disney, that mosaic was grand indeed. I had unparalleled opportunities in the form of inspirational encounters and transformative experiences.

It was a heady time between 1977 and 1982. Trying to understand an experimental prototype community of the future exposed many of us to seminal thinkers of our time. It was a potent and invigorating period. As a senior research analyst and then manager of research and planning, I was fortunate to be part of think tank conferences to sort out directions for the future. We met with Buckminster Fuller (author of the book *Operating Manual for Spaceship Earth*), science

fiction superstar Ray Bradbury, and writers Joan Didion, John Gregory Dunne, and Jean Houston. We held a three-day conference with futurist luminaries at Walt Disney World, and later on, we interacted with prominent contemporary architects, including Frank Gehry, Michael Graves, Charles Moore, and Robert A. M. Stern. We worked in a place where we had every opportunity to become "Renaissance people."

Much later, I learned that famous people always took your call when you said you were from Disney. In graduate school, I had read the seminal textbook on matrix management written by American sociologist and professor of organizational behavior at the Harvard Business School, Paul R. Lawrence. Matrix management was the model that Imagineering used to run the organization, and Lawrence was the guru. I was creating the agenda for an executive workshop and thought he would be an ideal speaker. Dr. Lawrence was staying at his cottage in Ireland for the summer when he miraculously received the letter I sent him with only the name of a village post office; I really never thought he would get it. He enthusiastically accepted our offer.

French novelist, screenwriter, actor, and Academy Award-winner Jean-Claude Carrière answered my letter straightaway when I wrote him and asked him to work with our team planning Walt Disney Studios Paris. He agreed to host our team when we were in France for three months, and I supervised two of his top students who came back to California with us as interns for six months.

Then there was the internal talent, and the nurturing thereof. Imagineering is full of talented people, the best in their fields, and the learning and exchange among us were galvanizing. The culture supported growth. We had a talent development specialist, Peggy Van Pelt, who nurtured all of us. She brought in people who were at the edges of thought to awaken and inspire us. Three unforgettable encounters triggered by Peggy come to mind.

She brought in Canadian illusionist Doug Henning. It was because of Doug that I was able to create space in my mental and conceptual map for why what we did at Disney was important. Doug underscored the necessity of possessing and creating a sense of wonder; the mystery and awe inspired by all things that we cannot know is indispensable. To a large degree, what we did as Imagineers was to inspire that sense of awe and wonder in people young and old. To this day, it is that sense of wonder that I covet. It is why I marvel at the mysteries of the cosmos, the stars, and of life on Earth.

Peggy also brought in a musicologist whose presentation included a discussion of an instrument that measures the vibrational quality of words and sounds. It was demonstrated that the word "love" vibrates at exactly the same frequency in every language. That definitely inspired a sense of wonder.

Then there were field trips. A group of us went to a sensory deprivation experience. You were placed in the equivalent of a wooden casket filled with six inches of warm saline solution (to simulate the womb). The box was sealed in darkness and you were left there for forty-five minutes. They piped *Pachelbel's Canon* into your environment to signal that it was time to get out, shower, and dress. My *Canon* never played. I could have been so far out (or asleep) that I didn't hear it—or they forgot me in there. But no matter. At one point during the experience, I was floating through the darkness of the cosmos, among the gleaming stars, and an overwhelming sense came over me (or maybe I actually heard a voice say) that no matter what happened, I would be okay. I never forgot the sensation. That, too, inspired a sense of wonder.

Two and a half decades of exceptional opportunity is what kept me in the saddle through the best of times and the worst of times.

In an innovative laboratory like Imagineering, I was fortunate to be invited to do things that hadn't been done in the organization before.

While not "rocket science," Disney projects did have a level of complexity that, at first glance, might rival a NASA project. There were lots of moving parts. There had not been a road map for how it all came together. There are many divisions and disciplines, and many stages of development on the way to completion. Hence, an assignment early in my career (in the late 1970s) to encapsulate the way that WED did business across divisional lines and throughout the life of a project.

I began by interviewing all the vice presidents and managers about the roles and deliverables of their disciplines. The result was a document entitled "The WED Work Process Matrix." It was a snapshot of interrelated disciplines, tasks, and steps that all fit together in the life cycle of making Disney magic. It was an indispensable learning experience. I was able to see how each department contributed to the whole of a project in every phase of development.

My early work paved the way for what would later become a massive endeavor to document the work of each division in detail. This compendium would become the bible or guidebook for how projects were assembled for perhaps a decade.

In the first stage of idea creation, called "blue sky," people from different creative disciplines are called together to "brainstorm" (throw spaghetti against the wall, and see what sticks).

In 1984, WED decided that these teams needed a plan, or program, that included an objective, a market, location, components, a size, a budget. The organization created a role called a program

developer. I was named as the inaugural program developer on a project called Pleasure Island, which became an entertainment, dining, and retail center located on the Walt Disney World property in Florida. In January of 1988, I was promoted to director of program development. This was a role that allowed me to use my wide-angle view of things, as well as my need to have parts cohere, and be strategic. Likely the subject of turf wars, this function was short-lived as a formal designation at Imagineering.

What sets Disney apart is its elaborate and unrivaled creative reenactment of fantasy environments. This requires an iterative process that can be costly. As in every profit-motivated company, Disney was always seeking ways to do things more efficiently and cost-effectively.

When we were challenged to design a park (Disney California Adventure) more efficaciously, I was tasked with charting the way for the creative division. I spent three weeks meeting with managers of each creative discipline to plan the work to a new target. I was weeks at my computer putting numbers in boxes. We created a groundbreaking budget and completed the design within that budget.

This work plan was used as a guide for future projects as other producers were sent to me for my template. It was a worthy experiment, though I retired before I would know whether it would stand the test of time.

I liked the challenge of doing something that had never been done before. Our project team had followed the corporate mandate. Straying from our formula for success was a healthy exercise in order to stretch the limits of our productivity. As with all projects, future enhancements would be made at the park to boost performance.

While I hadn't planned for this career, I found the world of creative people invigorating. It was like being in a zany extended family. (But do not mistake them for family.) The work was intense, and meetings were filled with energy. I found myself fully absorbed. Even though, in some regards, I was like those blasé northern Europeans.

I could have done other things: been a journalist, a public television producer, an academic, a photographer, a healer. I had many fascinations and urges. But when I was around this tribe, alternate paths ceased to be a chronic distraction. What connected me to this tribe was that they were on a mission. Their vision aroused a tremendous amount of passion and gave me a sense of belonging. The people and the process of creation and development had me fully engaged. I was a member of a passionate community. The shared value was around the integrity of the creative product.

When I worked at The Walt Disney Company, the word *synergy* was a mantra. It was a mandate across divisions: a film inspired consumer products, themed attractions, books, TV projects, and so on. But synergy within Imagineering was vital and widespread. Teams embodied the mysterious catalytic effect when a combination of creative energies leads to an otherwise unattainable commitment to excellence. This was possible because creative teams brought together different kinds of people with diverse but complementary talents: writers, artists, architects, thinkers, and integrators coming together in alchemical ways.

After decades, it's likely that anything loses its luster and it becomes time to move on. The thing I missed most immediately after retirement

was the tribe. During my twenty-five years at Imagineering, I felt largely, but not wholly, in my element.

If you let it, the Mouse will own you. I married for the first time at age fifty-three, and my husband, Terry, and I were both ready for me to retire. (I met Terry in late 1998 while on a trip to China. He practiced transactional real estate law and lived forty-five minutes down the coast from me. He is exceptionally smart, good-looking, adventurous, and kind.) We spent the first few years of my retirement traveling and resuscitating a new home.

After that, I needed to repurpose myself. I felt the tug to be involved with something that was personally meaningful. I joined a nonprofit that supported social justice in vulnerable communities in South Los Angeles. Since 2008, I've been passionately immersed in supporting gang intervention in impoverished communities and as a champion for those in need of economic, educational, and social justice.

Once the pressure of "making a living" was gone, I felt free to explore the more serious side of myself. What parts of me had I left behind? What was it that I needed to reclaim? What am I driven to do? What was I brought here to do?

It is ultimately up to each of us to know what our destiny is—that inner push to take action toward something valued. We each come in with a pull toward what is relevant for us. We each have different gifts and are destined to contribute in a different way. It felt like time to uncover and activate these urges.

When I was in high school, I took an aptitude test and scored in the 99.9th percentile in abstract thought. I had to somehow actualize this natural tendency. It took me a long while in our concrete, material world. Are there principles worth fighting for? Yes.

In the end, we must each pay attention to our enthusiasms and create our own way of connecting us with what matters to us. Retirement gives us that opportunity.

My husband gave me a plaque one Valentine's Day that reads:

Creative People:

1. Easily bored
2. Risk-takers
3. Color outside the lines
4. Think with their hearts
5. Make lots of mistakes
6. Hate the rules
7. Work independently
8. Change their mind a lot
9. Have a reputation for eccentricity
10. Dream big.

It is safe to say I am one of them.

Becky Bishop
Principal Landscape Architect (Part II)

How a 2:00 a.m. Phone Call Nearly Cost Me My Job

I was hired at WED by Scott Girard as the landscape architectural department's first intern.

I initially graduated from UC Irvine with a BA in art history and studio arts. I found work with the city of Newport Beach, California, as their bicentennial coordinator, assistant to the assistant to the city manager.

While languishing in the local bureaucratic quagmire, I met the director of parks and recreation, who suggested that I go back to school and become a landscape architect. Since I couldn't see myself as a self-supporting studio artist, nor as a professor of art history, and most certainly *not* continuing in a career in government, I took the gamble.

I graduated three years later with a BS in environmental design and landscape architecture from Cal Poly Pomona. From there, I was fortunate to win an internship with WED, which I happily held for two summers. Upon my graduation in 1982, it was my intention to become a full-time employee of WED. Unfortunately, 1982 was

the opening of EPCOT Center, and the company was undergoing significant layoffs.

I found a nice little ten-man landscape architectural firm in Santa Ana. (Let me say here that a motivating factor in studying landscape architecture was the preponderance of men in the field. I find them fun, funny, and simple to manage.)

I was learning how to design the landscape for model homes, community parks, and condominium projects. Fortunately, Scotty called me back to Disney in 1986. I was thrilled to accept his proposal and am forever grateful for the opportunity.

My first big project was taking over Splash Mountain Disneyland from Terry Palmer so he could manage show quality standards for the entire theme park. The project was still in the preliminary model phase with the initial understanding that the rockwork mountain would be planted in a single type of grass, red fescue.

I was excited to make my mark, so I made a bold suggestion to the producer, Bruce Gordon. I wanted to use newly available European multicolored grasses. At the base, we could use emerald-green grass; mid-level, we would use green-gray; and at the top of the mountain, we would use blue-gray. It would be colorful like a cartoon, and we could play with foreshortening, manipulating the guests' perception of the height and distance of the mountain. All the other plant material selected would yield to that color palette—and diminish in leaf size as the plants reached the pinnacle of the mountain. In other words, I wanted to both de-escalate the color levels and the texture from bottom to top, large to small, green to blue gray: the intensity of the color would fade, the leaves would get smaller, and the mountain would, from the ground, appear taller. The effect had the potential of moving the needle in how we could artistically use horticulture to help tell our story.

The risk was that the live material would be difficult to source and couldn't be replaced if damaged in shipment, and I would have to make an educated guess as to the quantity of four-inch pots required to cover the attraction.

I sweated buckets hoping for a good growing season and healthy plants by the time I was scheduled to plant. I was precise in how I placed the pots so visually they would get the most bang for the buck and was ever so careful that the young grasses were not trampled by other trades as they were working to install their parts of the attraction.

Which brings me to the crux of my story.

A sponsor wanted to shoot a commercial timed to the opening of Splash Mountain. It would be the public's first glimpse of the new attraction. The production company wanted to enhance their shot by using hideous giant plastic yellow poinsettias. They wanted them all over the planter beds, completely ruining my foreshortening and color tricks. Our team didn't like the idea and instructed them to come up with something else.

The night before the shoot, Bruce asked, "If I buy you dinner, will you come back at 9 p.m. and be sure that the production crew does not use those horrible artificial flowers?"

Seemed innocent enough, and wanting to make points with the boss, I agreed.

I returned to the site just as the commercial production crew was setting out the offending plastic species. I innocently said that there had been a mistake and that I needed to tell the assistant producer (the producer of the commercial was arriving at dawn to begin filming) that WDI did not want the phony poinsettias.

My work was done, and I thought I was free to go . . . until all hell broke loose.

The production crew got very angry, insinuating that I didn't know

what I was talking about and that they were going to put in the poinsettias regardless of what WDI wanted. Who did I think I was anyway? (As I found out later, this was a bluff, and there was no previous agreement with this filming strategy.)

I was stunned, a little panicked, and frankly wasn't sure what to do. Not expecting that I would meet with such animosity, I had to get in touch with Bruce for further instructions. But it was now midnight; dare I wake him up?

Now, if you will recall, in 1989, there was no such thing as a mobile cell phone. At the Disneyland theme park, there were landlines available, but you couldn't call out of the area code without permission, and you needed the operator to place the call. That night, she had long since left her station and gone home.

I had to think fast. Again with the history lesson: in 1989 our fax machines were connected to an actual phone. We had sent and received faxes from that little wonder from all over the world, without the interference of an operator. So I picked up the phone and dialed Bruce. (I had his number, and many others, in my trusty address book.)

Bruce, unfortunately, didn't answer. Meanwhile, the mountain was becoming ridiculously adorned with the poinsettias.

I marched back out to the site and valiantly tried to reason with the commercial crew. I pleaded with them using every high-ranking name on the WDI roster, including our overall art director, Tony Baxter, and president of Imagineering, Marty Sklar.

They actually said unless I could outrank Ron Dominguez (the park's president), then they were shooting the commercial, with the poinsettias they were vomiting all over the mountain, at dawn.

The hour was now hovering around 2:00 a.m. With all my courage, I picked up the fax machine phone once again. I called WDI Glendale

Security, hoping they would get in touch with Marty Sklar to give me some cover. I got half my wish: security answered. They gave me Marty's home number and said, "Good luck with the call."

I paced for a few minutes more, the clock now rounding 2:45 a.m. I had no choice. Would Marty fire me on the spot or applaud my tenacity? I won't lie that I was relieved when my call went directly to an answering machine. But it still didn't solve my problem.

To my utter surprise, at 3:00 a.m., the fax phone rang. It was Sally Judd, Marty's administrative assistant, asking me what the matter was.

In my amazement and sleep deprivation, I couldn't connect how my call to Marty could wake up Sally. I found out that security had routed the call to Sally.

Sally informed me that both Tony and Marty were in Paris for Euro Disneyland preliminary meetings. This is where my genius kicked in.

The fax phone was now my number-one tool. It was 11:00 a.m. in Paris, and I had the phone numbers of both the Grand Hotel, where they were staying, and the Pascal offices outside of Paris, where they were working. (I keep phone numbers—what can I say?) I first called the Grand to check if either Marty or Tony were in their rooms. Of course not.

I then called the Pascal offices and was headed off by a very efficient and very French secretary, who was not particularly helpful. She said in no uncertain terms that the executives were in a very important meeting and were not to be disturbed. I left my name and said it was urgent that they get back to me, but I had the feeling that my plea fell on deaf ears.

Another excruciating forty-five minutes passed.

The mountain was now bejeweled in yellow plastic, and the Anaheim sun was showing signs of rising. The filming would begin unless I got ahold of Marty and Tony.

Choosing the lesser of two evils, I gathered my courage and called my French secretary again. In my most assertive voice, I urged her to please slip a note into Marty's hand. She then informed me that they were no longer at the Pascal offices but had actually traveled on to the Euro Disneyland site, which was basically dirt.

I was crestfallen. I think she felt pity for me, and she said she would do what she could.

Within the next thirty minutes, the fax phone rang. It was Marty. Hallelujah!

I joyously explained the situation and asked what he wanted me to do.

He said, "Under no circumstances should you allow the film crew to shoot the mountain with that crap scattered all over it!" He told me to go out there and use his name, and then he handed the phone to Tony.

Tony was a little more animated. Between a few well-constructed profanities aimed at the film crew, he congratulated me for my obstinance and emboldened me to "Go out there and personally remove the plastics if you have to!"

I hung up the phone, feeling as if I could walk on water. I went to the assistant producer and explained as nicely and as firmly as I could that Marty Sklar, chairman of Walt Disney Imagineering, had personally told me from Paris, France, that he did not want the artificial foliage on the mountain. If they needed additional color on the mountain, they were to submit to me in writing the species they were considering, and I was to make the final call.

The assistant producer gave me the oddest Cheshire grin, which I took to mean he didn't think I had the courage to pull rank on Ron

Dominguez—if there was any truth that Dominguez had agreed to the artificials in the first place!

The film crew regrouped and caucused what they would say to their own producer, who was arriving momentarily. I left them to their dilemma, certain that they would uphold our agreement.

Just as the sun was giving off a wonderful glow and the camera operators were setting up for their shots, I walked out to find that the crew had done nothing to remove the offending artificials.

I had no choice but to climb on the mountain and harvest all 152 of them.

I couldn't trust the film crew not to put the poinsettias back, so with the mindset of an adolescent, all I could think of was to hide them. I went back to the site offices, awaiting Bruce Gordon to regale him with the previous night's harrowing events.

At 6:30 a.m., the diminutive commercial producer stormed into the office, making a beeline toward me and stopping within inches of my face. "Somebody is going to lose their job today," he said, and then let it be known that that somebody wasn't going to be him.

Since I towered over the guy, his chutzpah was lost on me, but I got the gist of his sentiment. He was going to do everything in his power to see that I got what was coming to me.

At 7:00 a.m., Bruce strolled in with his customary whistle and smile, without a care in the world. I couldn't wait to spill the events of the previous night, but he put his hand up and said he already knew. He had received a call from Tony earlier that morning.

I was a bit crestfallen that my thunder had been stolen. Then he smiled and said, "You don't know the best part of the story, Becky."

Apparently, my efficient French secretary did come through for me after all, and in a big way. She was able to send Marty a note via Euro Disneyland's park security. They drove to the dirt site with sirens

blaring. Stopping at the group of touring executives with the paddy wagon door open, they yelled, "Is anyone here named Marty Sklar or Tony Baxter? There is an emergency at Disneyland in California." Marty and Tony jumped in the car only to receive my note asking them to call me on my trusty fax phone. They thought that somebody had died on the Splash Mountain site, and I hadn't had the good sense to call 9-1-1.

Needless to say, the commercial crew filmed their shots without the offensive plastic poinsettias. The mountain looked amazing. And Marty sent me one of his famous personal note cards, which I proudly displayed on my office wall for twenty-eight years with fond memories of that fateful night.

Walt Disney Imagineering

June 23, 1989

To: Becky Bishop

From: Marty Sklar
Tony Baxter

Becky,

We really appreciate your dedication (at 3 a.m. yet!) regarding the plastic flowers at Splash Mountain.

Thanks for making sure they did not mess up all of the great work, including yours, that was accomplished in creating Splash Mountain.

Marty *Tony*

MAS:saj

Peggie Fariss
Executive, Creative Development

From Monstro the Whale to Marne-la-Vallée

"Welcome to Storybook Land, everyone. My name is Peggie, and we're on board the *Katrina*. Together we're going to relive some of the most famous fairy tales of all time. . . ."

With these words, I began my fifty-year adventure with Disney.

In the summer of 1965, I received some very disappointing news. The University of California, Santa Barbara, had rejected my application for admission. Since UCSB had been the *only* college I'd applied to, I realized I'd be staying at home in Anaheim for a while and enrolled in a local college for the coming fall. A close friend suggested that as long as I was going to be local, I might want to apply to Disneyland for a weekend job. I did, and the next thing I knew, I was dressed in an eyelet pinafore, guiding handfuls of guests aboard my little canal boat through the mouth of Monstro the Whale into the miniature world of Storybook Land.

I loved it. Though working Friday and Saturday nights might not be every college girl's idea of a good time, I was enchanted. I loved drifting along the tranquil waterway, pointing out the exquisite details of the miniature sets and interacting with guests one-on-one.

I might have stayed on Storybook Land a very long time, but my heart got in the way. I fell in love with my supervisor, and to see where the relationship might lead, I accepted a transfer out of his area to the Matterhorn Bobsleds, an attraction that terrified me. Gone were the leisurely hours drifting along the Storybook Land canal; the Matterhorn was fast-paced, with a bobsled dispatched every seventeen seconds and the potential to bring the mountain to a complete halt if you miscalculated the appropriate dispatch interval. I soon came to love the challenge of working on the Matterhorn; the relationship with my supervisor blossomed, and the Matterhorn assignment led to another significant Disney adventure.

In the fall of 1966, my foreman on the Matterhorn encouraged me to apply for the role of Disneyland Ambassador, a relatively new position open to young, single women to represent Disneyland, host visiting dignitaries, and visit children's hospitals. I applied, participated in a series of intense interviews, and was selected as one of five finalists. The "deciding interview" was with Disney's chief marketing officer, Card Walker. He asked me what I thought of a proposed title for a film currently in production at Disney Studios—*Bedknobs and Broomsticks*. I had never thought about films before they were playing in a movie theater. I'm sure I looked astonished. No doubt, my reply wasn't very coherent. No surprise, I wasn't chosen, but I was inspired to spend the next year preparing for the role.

I took out a small loan so I could enroll in a modeling school and learn the finer points of descending stairs, entering and exiting a car, and choosing the proper shade of pearls—"never whiter than

your teeth." And speaking of teeth, I put braces on mine. I studied Disney's annual report backward and forward. I fished project updates out of trash cans to learn about films in production and Disney's proposed ski resort in Mineral King in California's Sierra Nevadas. Then, in the fall of 1967, I applied and interviewed again for the Disneyland Ambassador role. And once again I made it to the finals, but not to the top spot. I was very disappointed, but I felt I'd given it my best shot.

However, it seemed that my efforts to learn all about Disney had not gone unnoticed. In the spring of 1969, I was invited to join nine other attraction hostesses and tour guides to participate in the press conference to announce details of the first phase of Walt Disney World, slated to open a year and a half later in the heart of central Florida.

That two-week assignment was eye-opening, and it changed the course of my life. As preparation, we visited WED Enterprises, later to be called Walt Disney Imagineering—the supersecret workshop where Disney Imagineers were creating the next generation of theme park attractions. Being well acquainted with the magic of Disneyland, I could truly appreciate how determined they were to create even more spectacular attractions for the Magic Kingdom at Walt Disney World. These would include many of Disneyland's most beloved attractions—"it's a small world," Jungle Cruise, and Pirates of the Caribbean—as well as some new ones like The Hall of Presidents and the Western River Ride.

When we arrived in Florida, we visited the future site of the Magic Kingdom theme park and learned about the many supporting facilities required to bring this project to life. We saw the tree farm, the forty-two miles of water control channels, the utilidor tunnel system, the wastewater treatment plant, the central energy plant, and plans for a

monorail to run directly through the Grand Canyon concourse of the Contemporary Resort.

Totally taken by the breadth and imagination of this incredibly bold undertaking, I was convinced they'd need people with my Disney experience to help pull this off. I returned to California, determined to find a position on the "Florida project."

In the meantime, Jack Lindquist, then head of marketing at Disneyland, suggested that I try again for the Disneyland Ambassador position. "Well," I thought, "I guess they have more confidence in me representing the company after these two weeks in Florida." So I interviewed a third time. Again, I made it to the finals, but with the same result as in past years—"always a bridesmaid . . ." Jack approached me after the announcement and, in a very kind and consoling tone, said, "Next year!" But by then I was finally ready to move on.

In the spring of 1971, following my graduation from Cal State Fullerton with a degree in English, I arrived back in Florida with a new job: leading the guest activities teams in the Contemporary Resort and the Polynesian Village Resort.

But I wasn't in Orlando yet. My boss, John Curry, a consummate hotelier and head of the Walt Disney World Hotel Company (a joint venture between Disney and U. S. Steel), had probably hired me for my five and a half years of Disney experience, but he also rightly noted I had absolutely *no* hotel experience. In fact, I'd never set foot in a hotel. My family vacations consisted of camping in the Sierras or renting a room in a motel somewhere along the highway of the Central Coast region of California so we could sneak our little dog into our room.

John and his bride-to-be personally drove me to Palm Beach to introduce me to the general manager of the prestigious Breakers hotel. I was to live on the premises along with the hotel's staff to learn the ropes of running a hotel. For the next three months, I worked seven days

a week, pouring tea for the social hour, calling bingo games, dispatching bellmen, stripping beds with the housekeeping staff, and learning to operate the hand-crank elevator. I was also tasked to organize a game of boccie ball for a convention group. Knowing nothing of the game, I found a group of seniors playing boccie in a Palm Beach park, and they very kindly spent a morning showing me how the game was played. I was a bit nervous that my lack of experience would be evident to my convention guests, but when they showed up for their tournament, it turned out they were as new to the game as I was, so we had a lovely and lighthearted afternoon.

I did have one disturbing experience in this particular hotel culture that did not align with my years of Disney experience. I found the staff meetings to be singularly unpleasant when the manager used the meeting as an opportunity to go around the table, berating each staff member in front of all the others. From my earliest Disney days, I had been told, "Praise in public. Admonish in private." As the end of April approached, I called John and asked if I could please return to Walt Disney World and help with the work leading up to the October 1, 1971, opening of the park and resort.

So by May, I was thoroughly trained and back in Orlando, working in the reservations office sorting through stacks and stacks of reservation cards for guests planning to stay in the Contemporary or Polynesian Village Resort. (Point of interest: the opening rate for a family of four in one room was $23.) By mid-July, I was planning the details for my guest activities department. We would staff guest information desks in each of the two hotels, and we would operate two Mouseketeer Clubhouses for children two to six years old. Now, this was something I knew something about. My mother taught first grade, and I was very familiar with lots of great books and play activities for young children. I selected all the materials and large play equipment for each location.

And then we started the search for guest activities hostesses. We found wonderful, smart, caring, articulate, energetic young women (and only young women) to populate our team. By October 1, we were ready for our Walt Disney World opening. My new dream was beginning to take shape when fate took another turn.

About three months after opening, I got my first taste of organizational change. My hotel group was absorbed into operations/recreation. But I knew nothing about "beaches and pools," so I was transferred to marketing and convention sales. This move hadn't been my plan, and I was very disappointed to be leaving the operations division, but I'd come all this way to Florida to be part of the Walt Disney World project, so I accepted the transfer and prepared myself to start learning something new.

As it turned out, I loved my five years of planning conventions and representing Walt Disney World in travel shows around the United States, but just as I was relaxing into my mastery of this assignment, my Disney adventure took another unexpected turn.

I ran into Marty Sklar. (We'd met at the press conference back in 1969, and he was now leading the creative division of WED Enterprises.) In the process of catching him up on how things were going, I told him I was looking for a position back in California so I could reconnect with my family and friends on the West Coast. What he said next changed my life.

He told me WED was beginning to make plans for building EPCOT (the theme park expression of Walt Disney's idea for an Experimental Prototype Community of Tomorrow). To start, Marty wanted to host a series of conferences on topics to be treated in EPCOT's Future World. He thought my knowledge of Disney and familiarity with Walt Disney World, coupled with my meeting planning experience, might be a perfect combination for this effort. So, in the fall of 1976,

I arrived back in California to continue my Disney journey—at WED Enterprises. I honestly can't say this was a dream come true, because I never dreamed I'd be lucky enough to be working in that fantastic place as an honest-to-goodness Imagineer.

There I was, working alongside the people who'd worked with Walt Disney himself—people who made the magic, who thrived on setting (and achieving) impossible goals, who loved doing what had never been done before. And EPCOT certainly fit that bill—an entirely new kind of Disney theme park.

Over the next several years, under Marty's leadership, we hosted a series of EPCOT Future Technology Conferences and introduced ourselves to leaders in business, academia, and foundations. We met amazing people who were interested in the opportunity EPCOT presented to showcase real-world topics and potential solutions. We formed EPCOT Advisory Boards peopled with a mix of remarkable experts—people like ocean scientists Bob Ballard and Sylvia Earle. We consulted with noted physicist Gerard O'Neill as well as acclaimed authors Alex Haley and Ray Bradbury. We developed a long-term relationship with Carl Hodges from the University of Arizona, who was doing leading-edge work in the field of sustainable agriculture and aquaculture. Marty's dedication to these efforts was tireless. He partnered with his longtime Disney colleagues, Jack Lindquist and Pete Clark, in the pursuit of corporate sponsors, and he relied on Frank Stanek, Pat Scanlon, and me for the conference and advisory board program.

I couldn't believe my good fortune to be interacting with these incredible talents. And I saw that one of the reasons these people were so willing to share their time and expertise was that Marty made sure they felt welcome and appreciated.

In addition to enriching EPCOT with input from so many people accomplished in their field, it was clear that Marty was intent on

nurturing a new generation of Imagineers; people for whom EPCOT would be their first but not last Disney project. There were hundreds of talented young people in this group, but the people I got to work most closely with during those early EPCOT days were Lynne Macer, JuliAnn Juras, Barry Braverman, Rick Rothschild, Tim Delaney, Eric Jacobson, Kym Murphy, Tony Baxter, and Tom Fitzgerald. They were smart, generous, and fun to work with. They helped and encouraged one another, and together, we all grew. I think we thought of ourselves as "Marty's kids"—at least, I know I did. And Marty was a pretty tough taskmaster. He worked incredibly hard himself and expected no less of us. There were deadlines and presentations galore. Fortunately, he had a group of very experienced old guard he could call on to help us youngsters along.

A couple of years into EPCOT's development, Marty asked me to lead the historical research effort for Spaceship Earth, an attraction whose story would trace forty thousand years of communication development—from Cro-Magnon cave drawings to Egyptian hieroglyphs to Gutenberg's printing press and NASA's flights into space. As you can imagine, this was a *big* assignment. Science fiction author Ray Bradbury had given us a story outline, but it was up to our team to create and define the scenes that would tell the story.

We had a very talented team of designers, engineers, artists, model builders, writers, and sound and special effects experts—experienced people trained in their fields. By contrast, I was a rookie. This attraction was my first, and I wasn't exactly a researcher. But I had a great role model: my little brother (who is now a research scientist). Back when he was five years old, he had a passion for trains. He'd come back from the children's library, his arms loaded with picture books, spread them around the living room floor, and spend hours studying them. He'd persuade my mom to take him

to the railroad tracks so he could watch the real trains go by, and he'd call out the name of each type of railroad car as they passed. His method of subject-matter immersion made a big impression on me, and I employed a version of his approach when I tackled this project.

I also had a lot of early help from a grad student of USC's Annenberg School for Communication, and together we filled conference room walls with three-by-five-inch cards documenting developments in the arts, culture, and technology. My favorite college courses had included Indian literature and mythology, Celtic mythology, and the geography of Southwest Asia, so diving into forty thousand years of cultural and technological development was a pretty plum assignment. I embraced it with gusto and loved delving into details, whether they related to the propping, music, costuming, or ancient dialogues to be spoken by the Audio-Animatronics figures.

I searched high and low for people who could help us infuse each scene with special touches that would enhance the story's authenticity: details like graffiti from the walls of Pompeii, an excerpt from the Roman Law of the Twelve Tables, music played on authentic Renaissance instruments, a printing press built from the drawings of the original patent application, and the actual audio recordings from the Apollo moon landing.

Luckily, the people I reached out to were enthusiastic and generous with their time and expertise. I remember one professor of ancient Phoenician who was thrilled to be helping us so he could tell his seven- and ten-year-old kids that "even Disney was interested in what their dad was studying." (Fortunately, I kept detailed records of all our sources, which was a good thing, because Marty eventually asked me to reply to all the guest letters written to Disney about Spaceship Earth for the next twenty years!)

My experience with Spaceship Earth taught me a valuable lesson. I learned that Imagineers don't care if you've never done something before as long as you are willing to embrace the assignment with your whole heart; to be curious, resourceful, and relentless.

Marty's work ethic was also a lesson in itself and set an example for the rest of us. So, too, was his playful sense of humor. I never felt that Marty was in it for himself, and that also was a lesson. He was generous in sharing credit and seemed to me to be driven by a deeper commitment to Walt Disney's dream. He was also well aware of the opposition we might encounter in the process of bringing these dreams to life, and he had his way of urging us to steel ourselves for the battles we'd have to fight for what we believed to be right.

On one occasion, Marty shared a quote with me that I found extremely telling. We had been using a quote from Pericles in some of our EPCOT conference material, provided to us by colleagues from the University of Southern California (USC). At one point, someone challenged the translation, and so I went searching for the source. This was in the days before the Internet, so no Googling.

I had to read everything I could find attributed to Pericles, and luckily I found it in Rex Warner's *Men of Athens: The Story of Fifth-Century Athens,* in which he translated Pericles's funeral oration for the Athenian dead originally recorded in *History of the Peloponnesian War* by Thucydides.

I wrote to Marty that it seemed our friends at USC had modified the quote, so he advised us to stop using it. As a lifelong UCLA Bruin, he was always delighted to be able to deliver a playful jab to our USC friends, but more importantly, he zeroed in on one part of Pericles's speech—and I never forgot it!

Others are brave out of ignorance; and, when they stop to think, they begin to fear. But the man who can most truly be accounted brave is he who best knows the meaning of what is sweet in life and of what is terrible, and then goes out undeterred to meet what is to come.

If Marty was the example, it was clear that dedication, hard work, curiosity, good humor, hospitality, kindness, teamwork, and courage were essential attributes of the successful Imagineer.

Following the opening of EPCOT, I worked on a variety of projects. One of my favorites was the Disney Gallery, a charming space above Pirates of the Caribbean, originally designed as a private apartment for Walt Disney and his family but converted into a showcase of Walt Disney Imagineering art. Here again, that great lesson about embracing assignments you've never done before proved invaluable. In this case, I had the enviable opportunity to interview first-generation Imagineers on the creation of their original art of Disneyland for the opening exhibition of the Disney Gallery. What a treat to be able to spend time with people like Dorothea Redmond, Marc and Alice Davis, Harper Goff, Ken Anderson, Sam McKim, Herbie Ryman, Collin Campbell, and John Hench, handpicked by Walt Disney to fulfill his initial vision for Disneyland.

I wrote plaque copy and certificates of authenticity. I researched the principles of art marketing for originals and reproductions and found an art marketing expert to lead a Disney Gallery training program. I promoted the idea of consumer relationship marketing to develop a Disney theme park art fan base, developed a catalog of the art, and implemented a program for Disney artists to sign their work and meet their admirers.

During all this time, I had the great good fortune to work with so many warm, wonderful, brilliant people whose friendships I treasure—people who made every day an adventure, whose creative brains could solve any problem; people who reveled in tackling the impossible.

With exposure to such diverse teams, I came to appreciate the limits of my liberal arts background. (Apparently, Celtic mythology can only take one so far.) In meeting after meeting, my colleagues were conversing in a language alien to me. They spoke of IRR and NPV and hurdle rates—the language of finance. Determined to crack the code, I sent away for the UCLA Extension catalog and started to round out my academic credentials. Over the next twenty-five years, I completed more than forty classes, including ones in finance, economics, organizational development, statistics, algebra, marketing, and business management. And the best part was that I was learning concepts in class on Wednesday night and applying them on Thursday morning. Such a satisfying experience kept me coming back for more and more classes.

In 1987, Marty gave me another new assignment. He asked me to be WDI's primary contact to corporate alliances, the folks who help corporate (participant) sponsors find the best way to showcase their affiliation with The Walt Disney Company and maximize their multimillion-dollar annual participant fees. From 1987 to 2010, I led a small team of intrepid Imagineers based in Florida and California who worked with park and project teams, corporate alliances, and major sponsors (Coca-Cola, Nestle, General Motors, United Technologies, Hewlett Packard, and Kodak, to name a few) to guide the implementation of corporate branding in our parks around the world. Well, actually, at first, there was no team. It was just me, working under Marty's guidance, to strike the right balance between relevant commercial brand exposure and the "magic of the show."

About eight or nine years into this assignment, I was promoted to director to fill the position vacated by a departing vice president. I felt well qualified for the role, even if I didn't get the title I wanted. I'd written the global guidelines for sponsorship identity, I'd guided many branding projects through the creative process, and I'd had many opportunities to implement sponsorship branding, guided by Marty's philosophy that the "show must come first" and that branding needed to be well integrated into the surroundings. We were keenly aware that every sponsor looked at whatever other sponsors had regarding exposure, and so we adhered to a principle of fairness and parity on a global scale. It was a great philosophy, but putting it into action wasn't always easy, and our role could be regarded by some—in our company and in the sponsors'—with suspicion.

One day at Walt Disney World, someone offhandedly invited me to a meeting with the head of a sponsoring company who was talking about his brand and how it was represented in seaside resorts and amusement parks around the world. His presentation was polished and consistent with his company's brand. There must have been thirty Disney people in the room considering the range of products his company offered, which ones would be right for our Florida guests, calculating the profit margins, etc.

But I could see right away the clash with Disney's brand. No one else was too concerned that this company always used a particular color of blue, and always had a distinctively whimsical way of illustrating their product names. Presumably, their corporate branding worked well for them in the typical amusement parks, but it would never work for us. In Disney parks, each themed land has a distinctive color palette, architectural finish, and font style. There's blue color and font that will look great in Adventureland, but it will not be the same one we use in Fantasyland, Tomorrowland, Frontierland, or Main Street. These unique elements give our lands their unique flavors.

It would have been easy to sit quietly and let this slide. I hadn't been officially invited to this meeting. But there I was, and I felt that if I didn't speak up on behalf of Imagineering's approach to sponsor branding in Disney parks, I'd be letting us all down. I'd be giving the impression that what I'd seen was going to be okay. And I'd be denying what Marty had taught me about speaking what you know to be true—even when it might be uncomfortable. So I took a deep breath and spoke—and began to find my voice. It actually was well received by everyone, and I'd crossed an important bridge.

These sponsorship interactions were quite serious and garnered the highest levels of executive attention. Fortunately for us, Marty Sklar had a keen interest in protecting the show, tempered by sincere respect for the significant financial contribution of corporate sponsorships. He understood how difficult these discussions could be. With so much at stake, tensions often ran high, and these tensions often reached the highest executive levels of Disney.

I was enjoying a very relaxing Christmas 1999 vacation on Maui *until* my office sent me a note from the chairman of Walt Disney Parks and Resorts, Paul Pressler, that had also gone to Marty Sklar. Paul had heard that the head of a very significant sponsor was complaining about how long it had taken WDI to implement their branding on stroller cards (a very tiny part of their overall branding initiative). I felt terrible that Marty and Paul had received this negative feedback without knowing how challenging the project had turned out to be and how closely we'd communicated with the sponsor throughout the process. Now, you might roll your eyes and say, "Don't these guys have bigger issues to focus on than stroller cards?" But to me, this was extremely painful because this had been my little "bonus" idea, and instead of making our sponsor happy, it had attracted negative attention at the highest levels.

Of course, this branding project had sounded so simple when we first thought of it. The implementation proved far more complicated. The idea was that each stroller rented in the four Walt Disney World parks would come with an illustrated card, about the size of a license plate, carrying the renting family's name and an invitation to visit the park's Baby Care Center. But each park had a different style of a stroller, which required four unique designs.

In one park, the cards were slipped into a vinyl sleeve on the top of the stroller canopy. This seemed like a good thing because guests could see the card and the sponsor ID all day long. But it also turned out that guests would set their soda bottles on the canopy. Invariably the bottles would tip over and soak the card in the sleeve. Then the Florida sun would bake the card, drying it out and transferring the ink to the inside of the vinyl sleeve. Operations had to hire extra people to clean the sleeves every night.

We finally worked out all the kinks, but it did take longer than we'd ever imagined. How to convey all this to Paul and Marty? And how to get it to them before the computers all shut down on New Year's Eve? (Remember, this was Y2K, and the globe was terrified that all computers would cease operations forever.) My window of opportunity was quickly closing, because I had to get my messages to the West Coast by early afternoon on New Year's Eve, and they were three hours ahead of me.

I spent the morning frantically crafting an e-mail to explain to Paul how complicated the project had become; how we had worked with all the principal parties to find a mutually satisfactory solution; and how sorry I was that this had caused Disney any embarrassment. Once I finished the draft, I sent it to Marty so he would have a chance to see what I was telling Paul about our efforts. Marty gave me the go-ahead, and I sent my e-mail to Paul just ahead of the (nonexistent)

Y2K shutdown. This was, admittedly, a lot of energy expended over something so small (and I was on vacation)—but so many of our sponsor projects were an enormous collection of small things attached to significant sponsor relationships (and annual fees). No detail was too small, and as they say, "Walt is in the details." Weeks later I saw Paul at WDI, and he gave my shoulder a little punch and chuckled about how earnest and timely my e-mail had been.

Now with all the classes I'd been taking through UCLA Extension, I wish I'd been more diligent in my study of French. At the time, I thought it would be nice to be able to correctly pronounce items I might find on a fancy French menu. So the last thing I was expecting was the phone call I received in January 2010, asking if I'd be interested in leading the Imagineering team at Disneyland Paris. The prospect was appealing, but a better command of French would have come in very handy. Leading an Imagineering team anywhere is an honor, but the possibility of leading a team and living in one of the world's most exceptional cities was irresistible. There were personal considerations. Who would look after my ninety-year-old dad? How would this affect my relationship with my longtime love (that supervisor of Storybook Land days)? What the heck were people expecting of me in this job? I'd led a team of five—but never twenty-five.

In the end, many people dear to me encouraged and supported me, but what tipped the scale was thinking of my two nieces. They are smart, talented, capable young women who I hoped would embrace opportunities and challenges life might bring their way. If I intended to encourage them to make a leap, I needed to model that behavior myself—and that realization made all the difference.

I moved to Paris in the fall of 2010 and met a team of Imagineers whose dedication to their craft, to the quality of the Disney show, and to one another was truly inspirational. They were so kind, so inclusive,

so willing to partner with me throughout my five years in Paris as we charted new ways to strengthen our ties to our operating partners and our fellow Imagineers around the world to create ever more magical experiences for our Disneyland Paris guests—and grew the Paris Imagineering team to about fifty people.

This Disney adventure of mine began on a canal boat drifting into the maw of Monstro the Whale and drew to a close fifty years later and half a world away in Marne-la-Vallée. This wasn't a journey I planned. And how fortunate for me—because it took me places I'd never have imagined for myself. I learned how to embrace the unknown, how to follow where my curiosity would lead, how to make sense of what I discovered. The multitude of amazing people I've met; their talent and dedication to excellence; their courage and heart; and the breathtakingly ambitious projects we all contributed to leave me with a boundless sense of wonder at how unexpectedly lucky I've been.

But I'm also reminded of how very limited the opportunities for young women were in those early days, and how unimaginable my future journey would have seemed if I had thought about it that first summer in Storybook Land. Fortunately, much changed in society and in Disney during the next five decades.

In 1965, when I was a young attraction hostess, there were only men in supervision and management (with the single exception of Cicely Rigdon, who managed the all-female department of tour guides). In those days, attractions like the Matterhorn Bobsleds, "it's a small world," and the Haunted Mansion were coed, but the foreman or lead was always male. Not surprisingly, the all-male attractions like the Jungle Cruise had a male foreman, while the all-female attractions like Great Moments with Mr. Lincoln, Carousel of Progress, and Storybook Land also had male foremen. That began to change in the late 1960s,

when Disneyland began to entrust women with the responsibility of leading single (all-female) attractions.

The big breakthrough for women in theme park operations management came with the opening of Walt Disney World in 1971. As the company expanded, women joined men as supervisors. Managers, directors, and vice presidents were still primarily men. But it was a start.

The change didn't come everywhere at the same rate. When I arrived at WED Enterprises in the mid-1970s, it was populated primarily by men, many of whom had come from the Disney studio (a traditionally male-dominated enterprise). But "the times, they were a'changing." In the late 1970s and early 1980s, the demand for lots of new talent to design and build EPCOT and Tokyo Disneyland provided the impetus for hiring talented men *and* women, and these women were beginning to attain the rank of manager and even director. There were no women at the vice president level until Marty Sklar asked Maggie Elliott to lead the creative division.

Fast-forward to 2010. When I arrived at Disneyland Paris, I was the first female director to lead the Imagineering group there. But even more telling was the fact that all three of our Imagineering art directors were women, as was the senior manager. These women were talented and dedicated and did a great job. And most inspiring to us was the fact that the president of The Walt Disney Company's theme park division (worldwide) was an amazing woman named Meg Crofton, who had spent thirty years working her way up through the Disney organization. Yes—"We've come a long way, baby!"

By the time I returned to WDI headquarters in late 2015, there were women in every department and at every level: vice presidents, directors, managers, project leaders. They populate a bustling place bursting with creative energy. It all seems so natural and so obviously right. We are all lucky we've come to this place together.

Acknowledgments

MANY, MANY THANKS

Below is a list of people—colleagues, family, mentors, friends—who helped us thrive, work, grow, and succeed. You empowered us, taught us, supported us, and pushed us to be our best. Apologies in advance to those whom we inevitably forgot—heartfelt gratitude to all for your sense of humor, your example, your creativity, and your patience!

Yoshi Akiyama
Joel Andrews
Alexis Andrieux
Annie Andrieux
Frank Armitage
X Atencio
Aquil Basheer
Rich Battaglia
Tony Baxter

Ray Bradbury
Barry Braverman
Patrick Brennan
Lindsay Broderick
Nick Bryson
Jeff Burke
Angela Carter
Alain Chailloux
Muriel Chailloux

Acknowledgments

Pete Clark
Francis E. Connolly
Gordon Cooper
Rolly Crump
Pam Dahl
Susan Dain
Keith Dawson
Sharon Dawson
Tim Delaney
Dusty Dill
Mom and the Dinkel-Cooper
　Family
Jonathan Duff
Maria Duff
Tracy Eck
Hani El-Masri
Jim Elliott
Maggie Elliott
Ed Erlandson
Bill Evans
John Ezell
Joe Falzetta
Bob Fariss
Dick Fariss
Ginny Fariss
Hannah Fariss
Julia Fariss
Laura Fariss
Tay Fariss
Orlando Ferrante

Pam Fisher
Tom Fitzgerald
Daniel Flannery
Karen Fleming
Kelley Forde
Fred Foster
Victor Gadjanoff
Brian Gale
Joe Garlington
Frances Geisen
Larry Gertz
Harper Goff
Mary Gooch Wallis
Dan Goozee
Yale Gracey
Susan Gurman
Kris Haggard
Susan Hallman
Doris Hardoon
Ruth Irvine Hauer
Gordon Hayes
John Hench
Greg Holleran
Abbey Rosen Holmes
Gralyn Holmstrom
Elizabeth Weis Hopper
Vanessa Hunt
Sam T. Hurst
Michelle Iacobucci
Ann Irvine

Women of Imagineering

Dick Irvine
George Irvine
Joe Irvine
Kim Irvine
Mike Irvine
Pat Irvine
Rich Irvine
Tom Irvine
Eric Jacobson
Bob Jolley
Sally Judd
JuliAnn Juras
Lily Karson
Corita Kent
Joe Kilanowski
Jason Killelea
Jerre Kirk
Kathy Kirk
Steve Kirk
Kathryn Klatt
Dick Kline
Aileen Kutaka
Tom LaDuke
Grady Larkins
Fyfe Irvine Lavin
David LeBlanc
Wendy Lefkon
Leticia Lelevier
Jack Leynnwood
Rose Likes

Jack Lindquist
Bobbie Lucas
Laura MacArthur
Dr. and Mrs. George Macer Sr.
Dr. George (Bud) Macer Jr.
 and Family
Dr. James Macer and Family
Dr. Jemela Macer and Family
Lynne Macer
Melody Malmberg
Donovan Marley
Dick and Mary Mastain and Family
Kelsey McCullough
Mike McCullough
Sam McKim
Jodi McLaughlin
Gene Miles
Ivan Minceff
Nevenka Minceff
Kim Minichiello
Mae Turner Moody
Michael Morris
Tom Morris
Todd Muffatti
Lisa Nahimson
Vessela Notchev
Cathleen Nunez
Richard Odle
John Olson
David Ott

Acknowledgments

Terry Palmer
Greg Paul
Walt Peregoy
John Polk and Family
Bob Radabaugh
Kevin Rafferty
Andrea Randall
Jeff Rank
Dorothea Redmond
Terry Rhodes
Betsy Richman
Steve Roach
Kathy Rogers
Mary Ann Rogers
Wathel Rogers
Joe Rohde
Heidi Rosendahl
Rick Rothschild
Ali Rubinstein
Craig Russell
Herb Ryman
Alec Scribner
George Scribner
Barbara Sellers
Cory Sewelson
John Shipley
Regina Siam
Jan Sircus
Marty Sklar
Bob Smith

Jack Martin Smith
Frank Stanek
Georges Stamon
Peter Steinman
David Stern
Lynne Stith
Carol Studier
Carol Svendsen
Frederik Philip Svendsen
Julius Svendsen
David Taylor
Brock Thoman
Jim Thomas
Jane Irvine Turner
Val Usle
Peggy Van Pelt
Kevin Van Schaick
David VanWyk
Monica Vasquez
John Verity
Gae Walters
Marilyn Waters
Harry Webster
Bob Weis
Emmett Wemple
Eric Westin
Linda Westin
George Windrum
Laura Yates
Stan Yukowicz

Bibliography

We are often asked to recommend books about our various fields. Here are some titles to explore. All are print titles; some are available as audiobooks as well.

Alcorn, Steve. *Theme Park Design: Behind the Scenes with An Engineer.* Theme Perks Inc. Orlando, FL 2010.

Alcorn, Steve, with Green, David. *Building a Better Mouse: The Story of the Electronic Imagineers Who Designed Epcot.* Theme Perks Inc. 2007.

Belasco, David. *The Theatre Through Its Stage Door.* New York: Harper & Brothers. 1919.

Graham, Donald W. *Composing Pictures.* New York: Van Nostrand Reinhold Company. 1970.

Bibliography

Hartman, Louis. *Theatre Lighting: A Manual of the Stage Switchboard.* New York: D. Appleton & Company 1930; reprinted by Dbs Publications Inc. (Port Orange, FL), 1970.

Hench, John. *Designing Disney.* New York: Disney Editions. 2003.

Imagineers, the. *The Imagineering Workout.* New York: Disney Editions. 2005.

Jones, Robert Edmund. *The Dramatic Imagination.* New York: Theatre Arts Books. 1941.

Lowell, Ross. *Matters of Light and Depth.* New York: Lower Light Mfg Co. 1992.

Moss, Roger W. *Lighting for Historic Buildings.* New Orleans: Preservation Press. 1988.

Pilbrow, Richard. *A Theatre Project: An Autobiographical Story.* Eastbourne, England, United Kingdom: PLASA Media. 2011.

Rosenthal, Jean and Lael Wertenbaker. *The Magic of Light.* New York: Theatre Arts Books. 1972.

St. Clair, Kassia. *The Secret Lives of Color.* New York: Penguin Books. 2017.

Thomas, Bob. *Walt Disney: An American Original.* New York: Touchstone/Simon & Shuster. 1976.

Treanor, Nick, ed. *The Feminist Movement.* San Diego: Greenhaven Press, The Gale Group. 2002.

As of this writing, some of our authors can be heard in industry-related podcasts and seen in productions like The Imagineering Story, *first streamed on Disney+ in 2019.*